*Lucky to
be an Artist*

If you dig beneath the surface of any life, you find the richness of human interaction on so many levels; and if you are the daughter of two uniquely talented, obsessive, unconventional parents with very strong spiritual convictions, who eventually parted in unusual circumstances, the richness and inherent difficulties you encounter are amplified.

This is the situation that Unity Spencer has faced with stoic good humour all her life, and this is her story.

David Inshaw

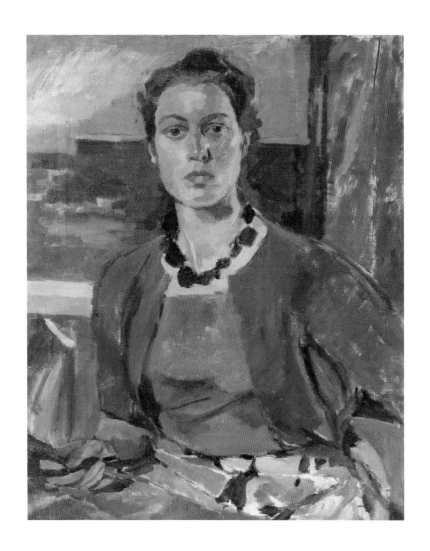

UNITY SPENCER
Lucky to be an Artist

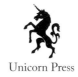

Unicorn Press

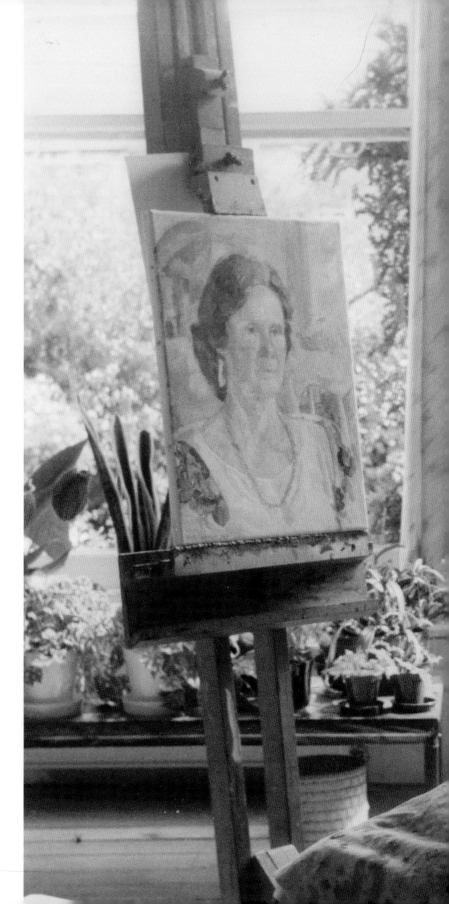

First published in 2015 by
Unicorn Press Ltd
66 Charlotte Street
London W1T 4QE
www.unicornpress.org

A catalogue record for this book is
available from the British Library

ISBN 978-1-910065-60-0

Editor in Chief: John Spencer
Assistant Editor/Transcriber:
 Jo-Anne Fraser
Project Editor: Johanna Stephenson
Designed by Baseline Arts Ltd, Oxford
Printed in Slovenia for Latitude Press Ltd

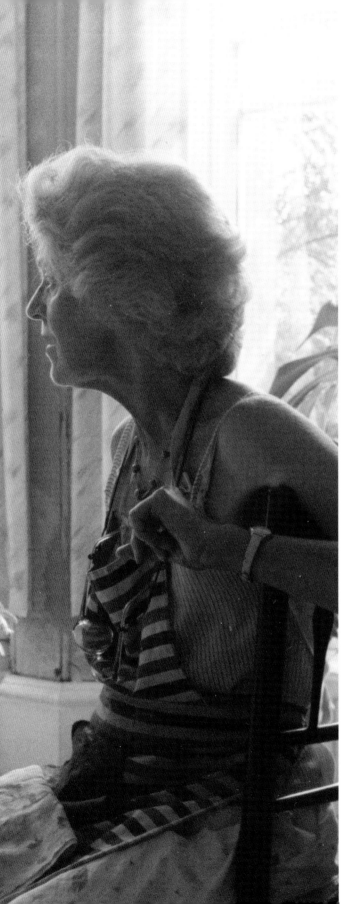

Contents

Foreword by Jon Snow

I FIRST MET UNITY SPENCER, by chance, on one of my regular pilgrimages to her father's remarkable murals in Burghclere Chapel. I could not believe that I had encountered my favourite English painter's very own daughter. Better, she even had vivid memories of playing here as a tiny child whilst her father toiled on a ladder above her.

Had Stanley Spencer painted his great murals in a Wren church in London, instead of within a chapel in the remote English countryside, his mark on the British artistic landscape might have been even greater than it is. 'What-ho Giotto!' he cried upon being commissioned to create the murals. Giotto in his own age? In my book he was. In effect he was the author of our own Sistine Chapel, which to this day remains one of the country's best-kept artistic secrets. Some of the paintings at Burghclere are amongst his very finest work.

That his daughter Unity should have lived an artistic life can be little surprise. Filming for a documentary on the British war artists, Unity met me again at the chapel. This time she was accompanied by Shirin. Now in their eighties, they remain the most gorgeous sisters – beautiful, funny and with a wonderfully vivid account of what growing up with one of the more eccentric British artists was really like.

In this book we have a chance to get Unity's insights into life with and beyond Stanley. The great man's social arrangements were complex. Unity tells it as it was.

Perhaps the most wonderful aspect was that both girls knew how good Stanley was, even if he ever had his doubts. The narratives of his pictures pick up elements of his own life. Unity spots her mother sitting discreetly in one of Stanley's very greatest works, the vast Cookham Resurrection. It cannot have been easy to have been a Spencer girl in the Cookham village community when Dad had gone and painted recognisable residents, rising from the tombs in the parish churchyard.

Unity, like her sister, is a strong character, as this book testifies. She had the huge challenge of trying to understand and live with her mother's mental illness. At the same time she gives us a glimpse of her trips to galleries with her father, and moments when Stanley and Hilda gave her advice on working in oils.

Unity and Shirin must surely be the last first-hand witnesses to one of the very few British war artists who painted in both World Wars.

Unity has provided a collector's item – a daughter's direct and candid memories of a brilliant painter and the often chaotic world that surrounded him. Some of her memories she recorded contemporaneously in her diary, lending an added authenticity.

I have interviewed both Shirin and Unity, as near as I could have hoped to get to talking to Stanley himself. Unity has not let him down, and neither has Shirin. We have here an important and touching insight into Stanley's world.

Shirin, Unity and Jon Snow, Sandham Memorial Chapel, Burghclere, July 2014

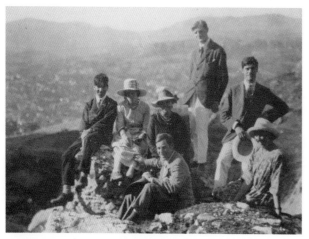

Left to right: Stanley Spencer, Hilda, Granny Annie, Sydney, George and Dicky Carline, May Piggott (friend), Bosnia 1922

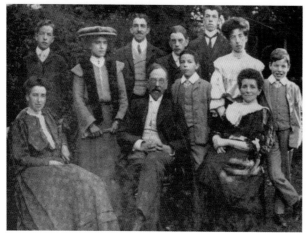

Left to right: Florence, Sydney, Natalie (Harold's first wife), Horace, Pa, Harold, Stanley, Percy, Annie, Ma, Gilbert

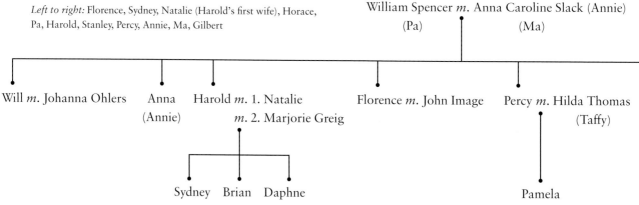

CARLINES

George Carline *m.* Annie Smith
(Da)　　　(Granny Annie)

George　　　　　　　Roland
　　　　　　　　　　(Roly)

SPENCERS

William Spencer *m.* Anna Caroline Slack (Annie)
(Pa)　　　　　　(Ma)

Will *m.* Johanna Ohlers　　Anna　　Harold *m.* 1. Natalie　　　Florence *m.* John Image　　Percy *m.* Hilda Thomas
　　　　　　　　　　　(Annie)　　　　*m.* 2. Marjorie Greig　　　　　　　　　　　　　　　　　(Taffy)

Sydney　Brian　Daphne　　　　　　　　　　　　　　　Pamela

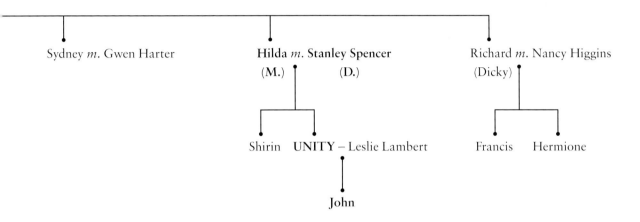

Sydney *m.* Gwen Harter

Hilda *m.* **Stanley Spencer**
(M.) (D.)

Shirin **UNITY** – Leslie Lambert

John

Richard *m.* Nancy Higgins
(Dicky)

Francis Hermione

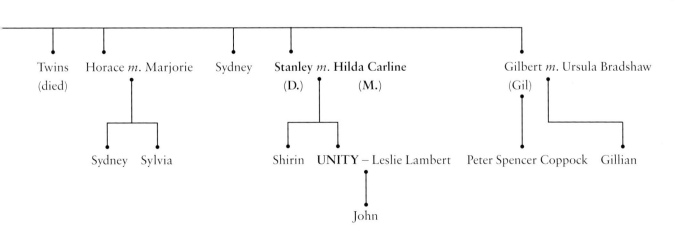

Twins (died)

Horace *m.* Marjorie

Sydney Sylvia

Sydney

Stanley *m.* **Hilda Carline**
(D.) (M.)

Shirin **UNITY** – Leslie Lambert

John

Gilbert *m.* Ursula Bradshaw
(Gil)

Peter Spencer Coppock Gillian

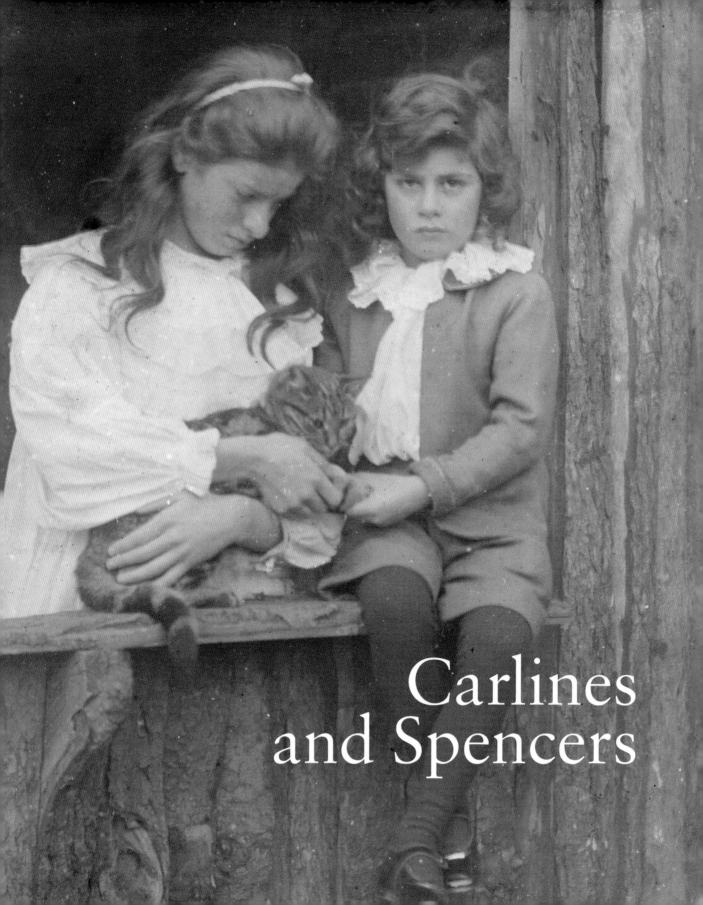

Carlines
and Spencers

I DID NOT KNOW MY GRANDFATHER 'Da' because he died of a heart attack on the road to Assisi. This was in 1920, ten years before I was born. It was a terrible blow to all the family and I know his death affected my mother Hilda very much: she was very close to Da, who gave her her first lessons in watercolour. In fact she painted a sad little watercolour of a row of Lombardy poplars against an empty landscape, and wrote on it 'I painted this the day they took Da's coffin away'.

George Carline, Da, was a professional artist who in his youth studied at the Académie Julian in Paris and then at the Royal Academy schools in London. He wasn't a great artist but he was an extremely competent one, technically brilliant, producing beautiful pieces that were full of feeling. Along with his Victorian technique there is a rather gentle, slightly impressionistic feel to his work. At one point he tried his hand at 'modern' art because he thought his sons, who were also artists, didn't think much of his paintings – although they were at pains to reassure him over this.

Because Da earned a living as a portrait painter, among other things, he visited his clients' houses; on one occasion, when visiting a particular lady, he met my grandmother, Annie Smith, who was a kind of companion to her. He fell in love with Annie and they got married. When their five children grew up there was a lot of speculation as to why at least two of them didn't look at all English. Neither did Granny particularly. My mother told me as a child that Granny's grandmother was found in the woods with another little girl and the only languages they could speak were Spanish and Welsh. Years later, when my Uncle Dicky was an old man, I reminded him of this; he dismissed it as a fairy story. However, a few years later a Quaker friend told me that at the time of the Industrial Revolution, at Ironbridge on the borders of Wales and England they employed Spanish workers! There was certainly something about Granny that wasn't typically English: her features and her body shape could easily have belonged in a Spanish village. Of her five children, George and Sydney Carline, the eldest and third brothers, were fair-haired, and George in particular looked like Da, with wide, Nordic foreheads and high cheekbones; but my mother, Hilda, and her younger brother (by seven years), Richard – Dicky – looked Arabic. M. (Mummy) had thick, rich red hair and a strong arched nose, full lips and deep-set, slightly slanting eyes, strong cheekbones and eyebrows that nearly met in the middle. She was in fact beautiful, though she didn't

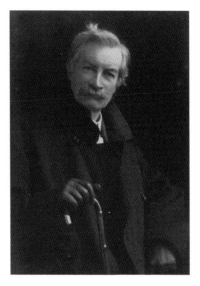

George Carline (Da), about 1915

I think he was a gentle soul.

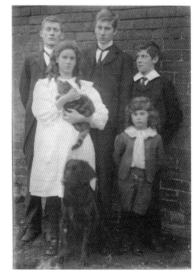

Hilda and her brothers, about 1901 (*clockwise from top left*): George, Roly, Sydney and Dicky

Hilda and Dicky Carline, about 1901

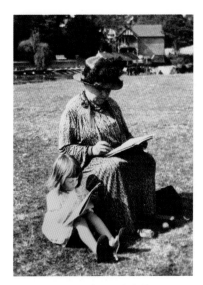

Granny Annie Carline and Shirin on
Odney Common, Cookham, about 1930

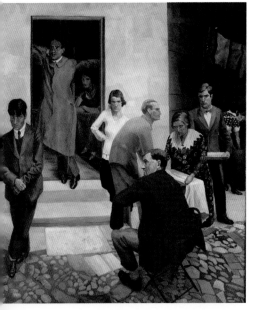

Richard Carline, *Gathering on the
Terrace at 47 Downshire Hill*, oil on
canvas, 1924–5 (Ferens Art Gallery, Hull
Museums) (*Left to right:* Stanley Spencer,
Jas Wood, Kate Foster, Hilda Carline,
Richard Hartley, Henry Lamb, Granny
Annie and Sydney Carline)

think she was. Dicky was an exceptionally pretty child, with thick, dark curly hair, a strong arched nose, full cupid's bow lips, high cheekbones and handsome eyes under his dark eyebrows. Evidently the family didn't talk about Granny's background and ancestry, so friends continued to wonder.

During the First World War, Da and Granny bought a big house on Downshire Hill, Hampstead. This became the Carline family home and, in the 1920s, a popular place for artists to gather and discuss their art – and life in general.

Granny Annie was a gifted person without knowing it, a dutiful and loving wife and mother. It was only after Da died that she started to paint. Her paintings were naïve but really interesting and imaginative, all from life, but with her own ideas and feelings about what she saw. I remember her asking Miss Arnfield (our housekeeper) to collect a saucer of water from the lake in the Jefferson Gardens in Leamington, where we were staying during the Second World War, so that she could see the colour of the water. She also wrote some lovely stories for children, which Uncle Sydney illustrated delightfully. Granny was also tough. She had an iron fist in a velvet glove: she was kind, loving and generous with meals, but I don't think she understood my mother very well.

Uncle George, Hilda's eldest brother, must have died when I was two years old. I remember him standing on the swing at the bottom of the garden in Hampstead, by the pear tree just in front of the raspberry canes, and smiling at me. I was standing on the steps by the kitchen door that led into the garden. Dicky's painting *Gathering on the Terrace* shows the artist Kate Foster sitting in the doorway at the top of these steps. I remember Dicky telling me (in the 1950s) how Kate would, on seeing him or some other man approach her in the corridors of the Slade (School of Fine Art), cringe into the wall, to give the impression that you were making advances to her. I enjoyed Dicky's clever observations and dry wit. When he damaged his eye cutting the branch of a tree, I cried from fear as he went to the hospital; that evening I read him the story of the

'Three Blind Mice', because I suppose I thought it appropriate. I must have been six or seven. I still remember the slightly amused expression on Dicky's face: he was, after all, a very sophisticated and clever man.

Uncle Gil, Ursula, Auntie Florence, Hilda and Stanley, about 1925

Da painted a large-scale back view of Dicky as a naked child of about three, holding out a crab. It hung at the top of the stairs outside Granny's bedroom. Dicky found it acutely embarrassing, so after Granny died it was replaced by *Harvest Moon*, his painting of a young farm labourer in breeches and a white shirt, carrying a scythe over his shoulder and approaching a stile on which sat a young woman gently silhouetted against a pale, glowing sky, with tall dark trees to her left. She looked like Granny when she was young, so the young labourer must have been Da.

I loved Da's paintings. Dicky's wife, Nancy, said they were a bit sentimental. Perhaps they were, but they were marvellously executed. His technique was flawless and a joy to behold. There were a few exceptions: his beautiful tall women in white among blossoming trees,

Grandpa William Spencer, about 1906

Shirin was taken to see Grandpa in his bed shortly before he died. Grandpa said, 'Poor little thing, she's frightened.'

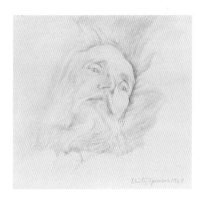

Uncle Will, pencil on paper, 1949

I did this drawing a few months before Uncle Will died; D. did his own drawing at the same time. Uncle Will said, 'Unity will be a good artist because she concentrates so well.'

again painted on a large scale, representing Spring and Summer didn't really appeal to me. But when running down the stairs one was greeted by a charming watercolour of a woman's smiling face looking out through a window; there was also a side view of a woman in a pale dress against a dark background, holding flowers in her scooped-up skirt.

Living in Fernlea as a single mother in the 1960s, I sometimes thought about my many Spencer uncles and aunts – D. (Daddy)'s eight brothers and sisters – growing up in the same house with their father, William, and mother, Annie. William taught the piano and played the organ at Hedsor church, over the river near Cliveden. He ran a library from Fernlea, which gave his children a wide appreciation of literature. He also regularly read to his family from the Bible.

William's brother, Julius, lived in the adjoining semi-detached house. Both houses were built by their father, another Julius Spencer, who also built the local school.

Uncle Will, William and Annie's eldest son, grew up to be a music teacher in Bern, Switzerland: he lived in Thun.

D.'s sisters, Annie and Florence, ran a little school from a studio in the garden next door. When Annie was mentally unwell later in life, the only person out of all the family who went to visit her was D., her brother Stanley. This was a comfort to her and he did this until she died.

Harold, the second brother, was a violinist. He met and married Marjorie when he was touring with an orchestra to Belfast, where he then stayed, lived and worked.

Percy, who played the cello, was D.'s third brother. He was a London builder and architect and disapproved of my having a child out of wedlock.

Then came Horace, who was a brilliant conjurer. Unfortunately he would get waylaid in Cookham pubs, where his friends would say, 'Come on Horace, a drink a trick!' which meant that he failed to keep his London appointments. He met a tragic end when he rode his motorbike into the river.

Next was Sydney, who studied to become a clergyman and tragically died of an illness while a serving soldier in the First World War. He kept a diary from 1911 to 1916, which gives a picture of family life at Fernlea:

1911
April 14 Easter Eve
Fine and sunny all day.

Got up a little late to-day. After breakfast I think we all felt in a mouchy mood … Finally Percy, Gil and I went for a walk down to Cliveden. Here we stopped for a while admiring all that there was to be admired which was a lot. We picked some lovely violets coming home which I took in to Aunt Jennie and gave her. After dinner I sat for Stan right on to tea-time. He did a pretty good sketch… After tea I sat again for him, and for the rest of the evening mouched around – up and down the Village etc. … Mother sang 'I know that my Redeemer liveth' and sang it very nicely too. Went for a walk after supper, and then bed.

Gilbert was D.'s younger brother. Also an artist, like Percy he disapproved of my having a baby, despite having his own illegitimate son, Peter.

D.'s sisters, Auntie Annie and Auntie Florence, ran a little school together. Both were clever, but I don't know what their relationship was like. Auntie Annie looked after the two youngest children, Stanley and Gilbert. She was also a gifted and promising viola player. But her life was tragic. She ended her days in an asylum, and none of her brothers and sisters – at least none of those who were still alive when I was born – ever mentioned her name. The only person who ever did, in a soft and tender voice, was D. I don't even know whether Auntie Florence ever visited her sister; she certainly never spoke of her. I never understood how such a warm, loving and lively person as Auntie Flo could be so negligent of her poor sister.

I loved my uncles and aunts, and wish that they had loved each other. Of course some of them did, but as in all families, there were jealousies, rivalry and power games, some of them unrecognised.

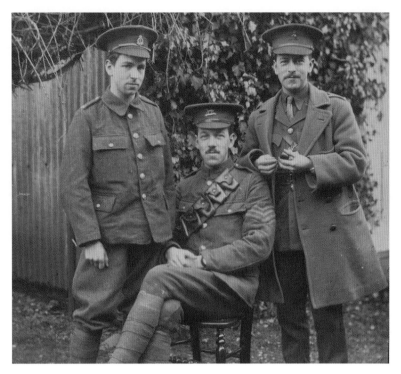

Stanley, Percy and Sydney in uniform, about 1916

My darling mother, Hilda. This was D.'s favourite photograph of her.

It was while D. was a soldier in Macedonia during the First World War that he suddenly thought of the idea for a Resurrection scene. This theme was to be important to him throughout his life and often helped him recover from loss and difficulty later on.

He didn't talk much about the war, apart from two stories. In the first he remembered standing on sentry duty one night on the Macedonian Hills. He was small and slim – he was only five foot two, like me – and was standing motionless in the darkness when some soldiers came up, thinking they had arrived at a latrine, and began to undo their trousers. It was only when he shouted 'Hey!' that they realised their mistake. D. was very good company and often told amusing stories: he was a good mimic and could see humour and the ridiculous in everyday life.

His other war story involved losing his water bottle: it was terribly important to have your water bottle with you at all times in Macedonia because you might not survive without it. When he dropped his and it rolled down the hillside, he left his position and scrambled after it. The next thing he knew was a soldier pointing a bayonet at him, shouting 'I have orders to shoot you!' This was always a very vivid memory for him: it must have been terrifying.

My father fell in love with my mother when he was invited to dinner at my grandmother's home in Hampstead in about 1922. She was remarkable-looking, beautiful and striking to look at, but not in the Greek Goddess type of way, more interesting than that. D. wrote that he 'felt a longing for her' and immediately 'saw a life with her'. It was around the time he was painting *The Cookham Resurrection*, which captures the feeling of the new day and sunlight, and M. features in it in several places. The painting is full of flowers, which are a feminine symbol with suggestions of opening up and giving birth. At one point someone said of it, 'Aren't you rather overdoing the flowers, Stanley?' to which he laughingly replied, 'Not all Suttons seeds, or Carters seed packets would be enough!' In the middle of *The Cookham Resurrection* is the arch of the church porch, with M. sitting beneath it, in the dark hollow of the doorway. Behind her, emerging from the darkness, is the face of God, rather indistinct and looking like a newly opened flower – a symbol of femininity. The fact that he should give God a face as mysterious as an unfurling rose somehow brings together the whole subject of sexuality and love of creation, religious feeling and human love, and the creation of new life. The arch festooned with flowers, which echoes the shape of the woman's leg to the left, is a mother shape

Stanley Spencer, *The Cookham Resurrection*, oil on canvas, 1924–7 (Tate)

I think the figure on the red tomb bottom left is D.'s friend Jas Wood and he is looking at Hilda. I find it intriguing that D. put him in, because at one time Jas and M. were in love but M. felt that it wasn't the right kind of love.

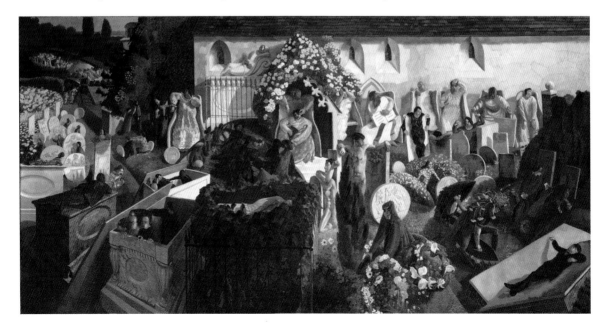

Stanley and Shirin, 1926

D. was very proud of his abilities as a father.

Hilda and Shirin, 1926

that protects the face of God beneath it. Thus femaleness is shown to be integral to the connection with God: 'God is Love', but Stanley takes this a step further by linking love and sex together.

They were married in 1925. D. was thirty-four and M. thirty-five. It was very significant that he was still a virgin and had never had a relationship with another woman; indeed, M. later wrote that her greatest joy in him was that he was pure and had never known any woman but her. My sister Shirin was born exactly nine months later. In photos of that time, M., D. and Shirin are all smiling; I get the feeling that that was a happy time for them.

My father talked about marriage a lot, in the context of true marriage as a welding together of two beings that inevitably want to belong to each other, although many people get married and it's not quite like that. I suppose there's a deep yearning to find your soulmate – although not many people do. But, I do feel that D. had a kind of understanding of human sexuality, that it wasn't something to be frightened of or alarmed by. Birth, death and resurrection are a continual

cycle, yet we are brought up in a way that separates us from our sexual awareness, as though this is a part of us that we should ignore. D. was aware of this separation. For him, marriage and sexuality concerned him deeply, stemming from his own inner feelings. He believed that one's mind and body, one's physical, sexual, spiritual and emotional aspects, were all intertwined and belonged together. Marriage was quite an extraordinary revelation to him: he loved M. deeply and then there was this whole sexual experience as well, so it must have been quite overwhelming.

He felt that his own parents were very happily married and secure together. When the children were little they would go into the bedroom and climb around their parents' knees and sheets, rather as he painted me and Shirin doing as small children in *Going to Bed*, although the children in the painting could equally be Stanley and Gilbert, and the adults Ma and Pa Spencer rather than Stanley and Hilda. There was a sense of continuity, with marriage being a kind of resurrection and sex, part of love, connecting us to God.

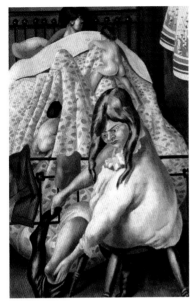

Stanley Spencer, *Going to Bed*, oil on canvas, 1936 (Private collection)

Letter from Stanley to Mrs Behrend, 23 November 1925

D. writes from Hampstead giving news of Shirin's birth and describing his early ideas for the chapel at Burghclere.

In 1923 D. had had the idea of painting a chapel like the Arena Chapel in Padua by Giotto, whose work he loved and admired. He was delighted when Mr and Mrs Behrend agreed to sponsor this (when he heard the news he exclaimed 'What-ho, Giotto!'), and it was built according to his specifications. The Behrends also built a small house for D., M. and Shirin, a short walk away. Chapel View stood in an open field with trees around it and had a productive vegetable garden. The house had a natural, homely feeling; they lived there until 1932. Shirin remembers D. holding her up to the looking glass and she would ask him, 'What's the little girl in the looking glass saying now?' D. would invent what the 'other' little girl was saying, to Shirin's great delight. They would also play together with her cars amongst his canvases. We have some lovely photos of her asleep in the pram – the same pram that D. used many years later to carry his canvases about.

For about six years D. was engrossed in painting his murals for the chapel at Burghclere, under the kind and generous auspices of Mr and Mrs Behrend, who kept and supported our little family during that period. Everything seemed to be coming together for D.: he had achieved recognition and some financial security, and had the family he loved around him.

Hilda and Shirin at Burghclere, 1928

Hilda, Shirin, Aunt Gwen and Granny Annie at Burghclere, 1929

This picture was taken shortly after the death of Gwen's husband, Sydney Carline.

Hilda and Shirin on Odney Common, Cookham, 1928

Hilda and Stanley with Shirin at Burghclere, 1929

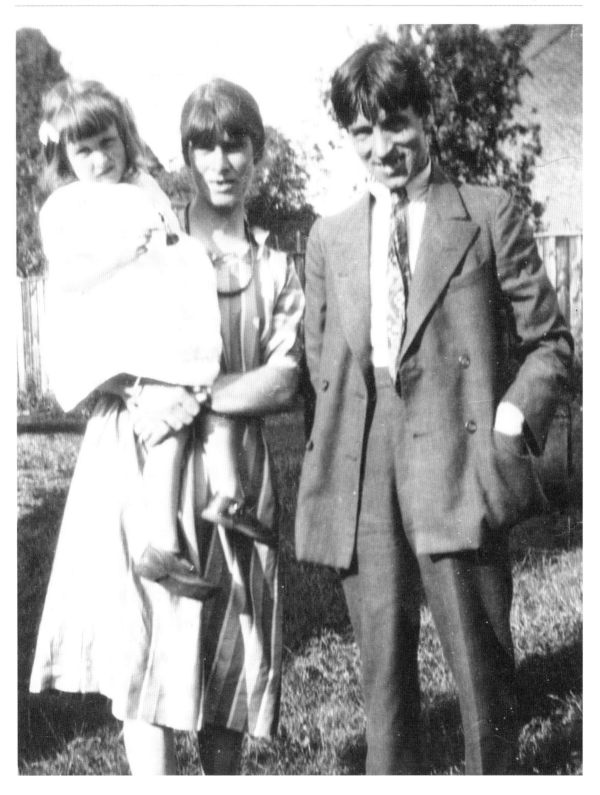

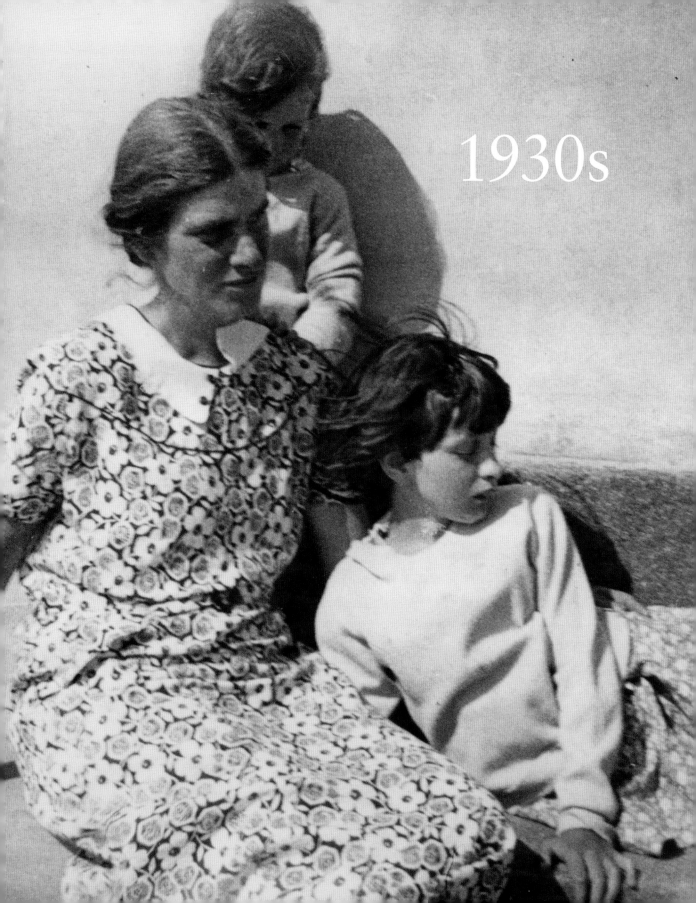

1930s

1930s · **23**

As a Christian Scientist, M. needed a Christian Scientist practitioner to attend my birth. So I was born in Downshire Hill, Hampstead, on 24 May 1930. It was only in 1961 that I discovered, in conversation with Mrs Behrend, that I was supposed to be – in fact, should have been – born at Burghclere. However, because M. was taken ill ten days before I was due to arrive, Mrs Behrend had her driven up to Hampstead to see her practitioner. Back at Burghclere, D. would wrap me in a shawl as a small baby and take me to the chapel with him, laying me on a chair while he painted.

To make life easier for M. with her new baby – and because everyone had coughs and colds – Shirin was sent to stay with Mrs Harter, whose daughter, Gwen, had married M.'s brother, Sydney. Although at that point Mrs Harter lived close by in Hampstead (she later moved to Epsom), Shirin was only five years old and must have felt the separation from her mother very keenly. Although Shirin came home from time to time, she never came back to live with us permanently again.

My earliest memories are of Chapel View, with rooms leading from one into the next. I can remember M. singing me to sleep in a small room with a sash window: I looked out at the evening sky, while she sang 'Now the day is over'. At the foot of my bed was a door leading into my parents' room and I could see their bed, which was the brass bedstead type with a white cover. I would often remember this scene when I was about ten or eleven years old, and always do, even now, when I hear 'Now the day is over'. As a child I would visualise a deep blue sea and sky and sailors rising and falling on the waves. There was a glow of sunlight of indefinable day or night time, like sunshine in the middle of the night, as well as sunset. And the figure of my mother was dark against the window, but she was by my bed and I looked past her to the window. She was a warm, dark colour against a blue evening sky.

M. used to give me a bath in a tin tub in front of the fire in a corner of the cosy dining room, when it was chilly outside. I had some beautiful little toys in those days: my little metal black and white pigs and a doll in a tiny wicker cradle. Many years later, in 1955, my father resurrected this scene in his painting *Hilda and I at Burghclere*. M. is holding me, a baby, and D. is bringing the bath in, a great round tub; my sister, Shirin, is hauling in the rolled-up bath mat. At first glance it seems like an idyllic scene of cosy family life, but to me it's a sad picture, the symbolic shapes of the big, round, womb-like tub carried in by D.

Stanley Spencer, *Hilda and I at Burghclere*, oil on canvas, 1955 (Private collection)

Hilda, Unity and Shirin on holiday in Jersey, 1934

and the long, cylindrical rolled mat dragged in by my sister together convey a feeling of loss. The pattern in the carpet is anything but a dream of domestic bliss. Many of D.'s later paintings were similarly retrospective and conjure up scenes from his memory. They were like wishful thinking, recreating an imagined past. These could be intensely personal, such as *Hilda Welcomed*, with M. at its centre, or scenes from the Bible set in Cookham High Street.

One day, when I was a tiny baby, the hunt came to the house at Burghclere and asked to ride through our garden. D. picked up a brick and threatened them with it. He was only just over five foot, and only armed with a single brick, but he was very angry – he disliked foxhunting and he wasn't going to have the hunt coming through his garden.

We had a big old-fashioned car with a hood top and leather seats: I can still remember the smell of the seats. I must have been two or

Jas Wood, Stanley, Hilda, Shirin and Granny Annie with the Spencer family car (a Clyno bought for just under £300)

Years later I took my three-year-old son, John, to visit Jas in Hampstead. They sat just looking at each other for a while. It looked like recognition and friendship between an old man and a little boy.

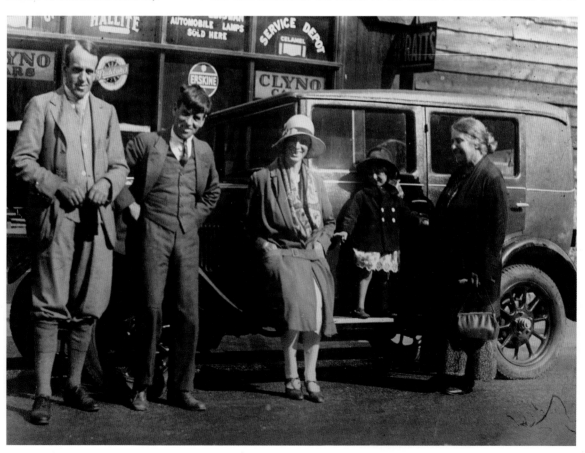

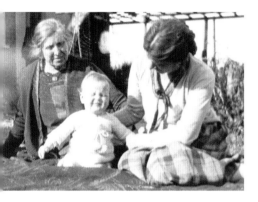

Grannie Annie, Unity and Hilda, 1930

I look absolutely hideous. When I was born D. said 'the baby looks awful but will improve with time'.

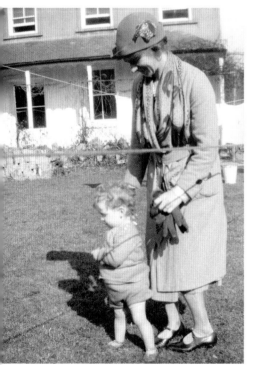

Hilda and Unity in the garden at Lindworth, Cookham, 1931

I love the way M.'s feet are slightly turned in.

three years old when I was taken to the house of some friends to choose a kitten. I chose a tiny, pure white one, Tiddles, which I held close to my heart, as gently as I could, as she meowed all the way home in the car. My earliest memory of D. is when Tiddles had her first litter of kittens. There were five of them in all; several of them were tabby and one was black. D. was fond of little animals: he picked up one of the little tabby kittens and held it out to me on the palm of his hand. I was standing at his knee and just gazed at the kitten; it, in turn, gazed back at me with its large kitten eyes. I was amazed that an animal could sit on somebody's hand, and was charmed that this little kitten was all on its own, as it were just for me. Tiddles was a lovely cat, but sadly, when M. and I left Cookham when I was three, Tiddles stayed behind. But I was glad that she kept D. company: she even appears in one of his paintings, *The Dustman (The Lovers)*.

When I was very little I would sit in the garden at Downshire Hill and make daisy chains. Nowadays it seems a rather cruel thing to do, but it kept me occupied. I also loved helping Miss Arnfield with the washing up at the tender age of three.

In late 1931 M., D. and I moved to Lindworth, a large semi-detached house with a big garden in the middle of Cookham. I often played by the back door with broken bits of crockery. I remember finding a dead frog in the water butt; and also how much I liked the smell of the greenhouse. There were little bantam hens among laurel bushes in an enclosure leading to Bernard Smither's house, which was attached to ours. His younger daughter, Yvonne, very pretty with red hair, was a ballet dancer.

Another local family we knew were the Gardners. The father was a professor of Greek and he had two daughters called Phyllis and Delphis, who went out and about with leopard skins draped over them. It must have been an interesting place to live in those days.

The church bell-ringers practised on Tuesday evenings. Apparently when I was about three years old I would sit up in bed while bell-ringing practice was under way and rhythmically intone, beating time on my

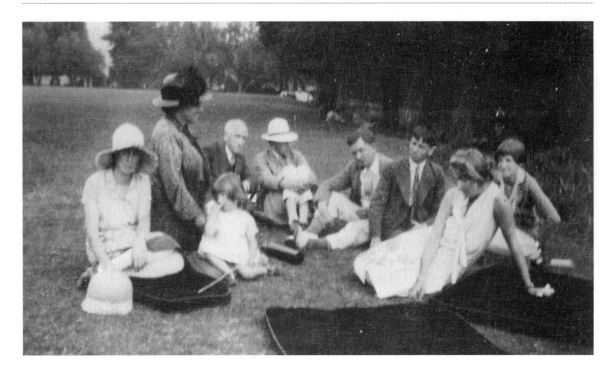

Hilda, Granny Annie, Shirin, two friends, Richard Hartley, Stanley, Patricia Preece and Dorothy Hepworth, Odney Common, 1928

Richard Hartley was an artist friend of my parents. He called Stanley 'the little 'un', Shirin 'the littler 'un' and and me 'the littlest 'un'.

Poor M. was too good about Patricia. I think at first she thought Patricia was all right. When she discovered she wasn't, she felt very angry and let down.

pillow, which I placed across my lap, 'Don't-like-a-bells, don't-like-a-bells, don't-like-the-mot-a-cars either, don't-like-a-bells'. D. said he was impressed that I managed to insert the piece about the 'mot-a-cars' very quickly but clearly, without disturbing the rhythm. In the smaller bedroom where I remember sleeping, there was colourful wall paper of Japanese ladies. I can remember lying in bed and hearing the cock crow.

The wooden bridge leading over the stream onto Odney Common had slats of wood fixed across it so that the cows and horses could get a grip as they walked. This was replaced by a concrete bridge that cars could use. Yet the water, which D. thought of when he was out in Macedonia during the First World War, still flows through and over the weir, down Odney Common.

A short walk from Lindworth was Moor Thatch, where Patricia Preece and Dorothy Hepworth lived. I think that Patricia fascinated and flattered D. and, although he made light of it, I believe that he fell down particularly heavily because of her flattery. I think he was naïve more than innocent: he was no longer sexually innocent because he'd been with M., but he was naïve about Patricia. I don't think he knew much about lesbians – very few people did at that time. By this time he was a

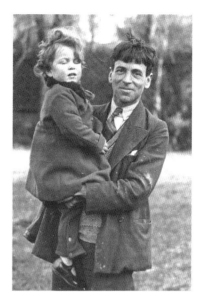

Stanley and Unity, about 1933

I'm amused by my floppy hair. M. tried to make me tidy, D. liked me to be untidy.

man of nearly forty, so the shock of losing his innocence at this time of life must have been very disturbing. Later on, when everything had fallen apart, M. was ill and Patricia was nowhere to be seen, he expressed his misery in his *Christ in the Wilderness* series. These were terrible times but D. certainly emerged much more mature than a lot of people would think.

My parents separated when I was three or four, and M. took me back to live with Granny Annie Carline in Hampstead. So from then until I was about nineteen there were big gaps when we saw little or nothing of D. He painted my portrait when I was seven. It's strange because, although I can remember my portrait being painted, I don't actually remember D. painting it. So maybe I was angry, or I put it out of my mind.

In the autumn of 1934 M. took me to Switzerland for a holiday, which I remember vividly. It must have been shortly after the final separation from D. There was a boat trip: M. sat on a low seat on deck, wearing her beautiful brown suede jacket, with me beside her, resting my head on her lap. I remember being on the night train 'sans couchette' (M. was too poor) and the indignity of having my nightie put on in the semi-public carriage; but apparently I slept well. Most of all, I remember the special, Continental smells: the soft smell of pale chicken soup with herbs, and the dusky smell of cigars. During the days we went on long, arduous walks in the mountains, with a sense of bitter disappointment reaching the top of a steep climb, only to be faced with another horizontal mountain path leading on to our destination. I remember the delicious-looking rowan berries growing there, which would make people or animals sick if they ate them.

In one pension our bedroom was lined with black wooden panelling, but was quite cosy. However, I didn't like going to bed: I probably felt a bit lonely in a foreign pension. So I said to M. every evening, as she kissed me goodnight before going down to her supper, 'Poor little Unity, doesn't know what to do'. I would repeat this, to no avail, as M. tried to hide her amusement, a twinkle in her eye. In another pension I was fascinated by the pale red-orange papery Chinese lantern seed-pods in a vase.

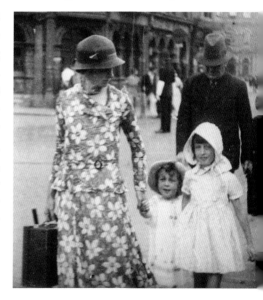

Hilda, Unity and Shirin on a trip to Jersey, 1934

Hilda, Shirin and Unity with a friend on
Odney Common, Cookham, 1933

We spent much of our time with M.'s friend Muriel Ellis, whose
very nice flat had a balcony, on which we had our daytime meals. Muriel
would place me furthest away from the window, in front of the balcony
railing, so that I was sitting bang over the road, with hundreds of cars
whizzing past below me, which was very alarming. But Muriel didn't
seem to understand children very well – either that or she wanted to
toughen me up. On another occasion she swam into Lake Geneva,
saying 'Come in, Unity, follow me', which I trustingly did. The next
thing I remember is blowing bubbles under the water, then M. rubbing
me down with a towel on the shore, with Muriel in attendance. My trust
in water having been betrayed, I did not learn to swim properly until I
was fourteen years old.

I would be put to bed in the little spare room in the flat while the
grown-ups had supper and talked together. At the end of the evening
Muriel would wrap me up in a shawl and carry me, a sleepy infant, back
to the pension, with M. alongside. That sleepy infant still remembers
the shiny lights rushing along the busy road.

Muriel was a Christian Scientist, like my mother: although they
were good friends, they were very different people. When my mother
was really ill, Muriel abandoned her. Perhaps she thought M. had let
the side down: not so much was known about mental illness or cancer
in those days.

While we were in Geneva we went to the League of Nations
Building, where I was left with a kind woman while M. and a friend
went to another part of the building. When I became frightened, she

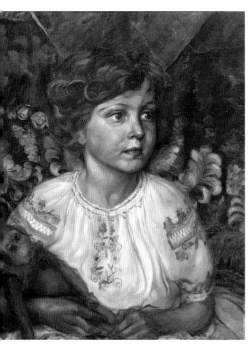

Hilda Carline, *Portrait of Unity*, oil on board, 1937 (Private collection)

Miss Arnfield reading to Hermione and Francis, lithograph, about 1953

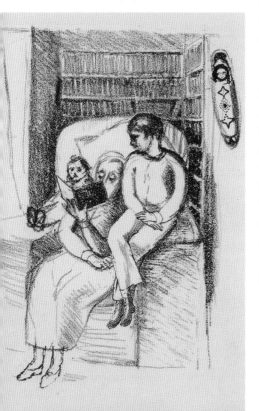

said that I could telephone my mother, which seemed very mysterious inside a building… We also visited the St Bernard Monastery, where St Bernard dogs were bred (no longer, sadly – they use helicopters instead). I was very impressed by these strong but gentle dogs and their wonderful work in rescuing people. I still have a little wooden carved St Bernard dog, a souvenir of that visit. My other memories of that early holiday include Uncle Will falling, the shock on his face and my upset for his loss of dignity; and, the swing by Aunt Johanna's house; and Constance Oliver and Guy Pullman – his parties, her raspberries and cream.

On 24 March 1937 M. wrote to Shirin to tell her about the portrait she was painting of me, saying 'I think I have got it over the worst hill, and that it will probably be quite all right and perhaps even rather nice.' In fact it is a very fine portrait, exactly like me, except that she made me very dark in colouring. Perhaps she used too much of a certain kind of oil with the paint: oil and turps can go dark in time. A friend of mine once remarked that the colours in the painting were like jewels. I remember M. telling me 'Brer Rabbit' (Uncle Remus) stories from memory to keep me contented while painting my portrait. And Miss Arnfield, when she had a minute to spare (probably good for her to rest her legs), read me stories from *The Yellow Fairy Book* by Andrew Laing.

My mother also tells Shirin that 'Unity is dancing again at the People's Palace Theatre this week.' My sister was disappointed that Mrs Harter would not allow her to see me performing at the theatre: two other little girls and I were dancing the Hornpipe in white sailor suits, in a grown-up play. I remember it so well and how my legs ached after a long rehearsal. But what amazes me about this letter, written just before the war, is reading that the manageress of the theatre was 'very enthusiastic' and told Miss Oliver (who was in charge of me that evening) that 'Unity was quite exceptional and much the best of the children, she was so naturally a dancer and so full of music and rhythm.' There are times when I wish I had been a dancer, but Shirin said it would have been all-consuming.

I have often wondered why 1937 was such a landmark year in my childhood. I now realise that it was the year when our family moved from 47 Downshire Hill, the house I loved so much when I was little, to 17 Pond Street, several roads away (but also in Hampstead). Pond Street was a much larger house and had a big garden, but to me it felt gloomy and dark. Playing in the garden at Downshire Hill was like being in the countryside, and the road, to me, was the most beautiful in the whole of London. The blossom in spring was like being in heaven.

Also in 1937 I turned seven, which is a significant age for a child. And my parents also divorced that year. I didn't realise this at the time – they had been separated for a long time – but children do sense these things.

I gradually got used to 17 Pond Street, but later – in the late 1950s, when I became depressed for the first time – it became like a prison to me, and has remained a frightening place in subsequent years.

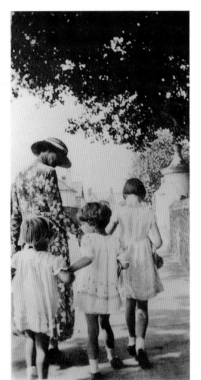

Hilda, Shirin, Unity and a young friend going to the Christian Scientist Church on a trip to Jersey, 1934

Page from a notebook, about 1936

Page from a notebook, about 1936

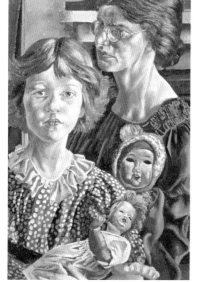

Stanley Spencer, *Hilda, Unity and Dolls*, oil on canvas, 1937 (Leeds City Art Gallery)

I connected with D. and am looking straight out at him. M. was so livid with D. that she couldn't face him.

I remember certain incidents very clearly. When I was a child during the Second World War I asked D. to draw me a face. He didn't think he could do it but I begged him, refusing to believe that he couldn't. And he did. It was a tender little drawing. I think the girl he drew didn't tally with my idea of beauty, but I probably also learnt something from that incident, as I did from all my contact with D. as a child.

At another time, when I had tonsillitis, I remember him sitting on my bed as I read *What Katy Did* while I brushed my hair. I think D. was rather intrigued, so I asked him about his hair because I knew he never brushed it and at that age I had rather conventional ideas. Poor D. said 'Perhaps I ought to brush mine'. I felt rather sorry for him when he made that remark, as though I had gone too far. It is strange how 'The child is father of the man'.

There were several other occasions when I felt I had said too much, that I had unintentionally put myself in a place of authority over my parents, and this used to hurt me deeply. It was extraordinary, a child pitying a parent, yet there were many times when I did. When M. was in bed, when I was three or four years old, I remember her crying very bitterly and saying some harsh things about D. She rose out of bed with her dark hair pigtailed down her back and reached out her hand towards the door, saying: 'I hate him, I hate him!' All I could do was to put my arms round her and show that I loved her. Some years later, when I was about eleven, she was again in bed with a liver attack and a bad headache, but no one was taking any notice of her. So I went in and asked her what the doctor had said. Apparently the doctor had suggested that Christian Science would make her better. I took this as unpleasant sarcasm and said so, but M. interpreted it in a more Christian way and felt that the doctor had meant it sincerely. She was determined that Christian Science would help her. All I could do was to get a wet hanky and sprinkle it with eau de cologne and put it on her forehead. I felt that my poor mother was being neglected, and that she was isolated and alone, but I loved her and stood by her in my heart. I said very little of what I really felt to anyone, because I knew Mrs Harter did not approve of M. lying in bed and being inactive: of course it was bad for her, but she stayed in bed because life was too sad for her to get up and face it. I'm sure there were many other reasons as well, but that must have been one of them: one feels safer in bed.

Although I respected and loved M.'s otherworldliness, I was acutely embarrassed at her talking in a normal voice on the top deck of a bus so that people nearby could hear what she said, and I couldn't think clearly, partly because of my embarrassment and partly because I was slightly frightened by her cry to me across space. And the fact that she seemed to expect me to have heard her: 'Didn't you hear me calling to you? Who is your mother, me or Mrs Harter?' This came to me as rather a shock, because I never thought of Mrs H. as a replacement for my mother. I remember Shirin bewailing this problem of how no one could be her mother except M. This may have been in reference to a nice and interesting friend of ours saying that she felt like a mother to us. Personally, I didn't mind, thinking that the more 'mothers' I could collect – 'hand-holders' more like

– the better. Significantly, Shirin saw it differently, which emphasised her terrible and deep sense of loss at losing her mother by being removed from the family at the tender age of five.

On the surface, Shirin and I got on quite well together as young children and we often felt very close. But we were not brought up as equals. She was nearly five years older than me, and for my first three years I lived with M. and D. in Burghclere, then Hampstead with M. until I was nine, while Shirin was living with Mrs Harter in Ashley Road, Epsom. This created a schism between us, which continued for many years. She often gave me a hard time as a child, but this was understandable considering her separation from M. I felt that Shirin had entered into a sort of conspiracy against me with Mrs H. and others. But of course, I didn't understand what lay behind our troubles at that time, and felt that I was the one who was always punished. On top of that, Shirin and I probably had some guilt lurking as a result of our parents' separation and Mrs H. compounded the problem.

<p style="text-align:center">✳✳✳</p>

I learned a lot about painting from M.: she gave me my first oil painting lesson – I still have the painting. I remember walking on Hampstead Heath with her before the war, when she told me that the colour yellow goes green in the shadow. I was so surprised that I didn't believe her; so she plucked a buttercup and held it up inside the shade of her coat so that I could see exactly what she meant. Shortly before she died she said to me: 'When you draw, you must feel the form.' She was right of course. It's no good simply copying shadow; you have to *feel* the form. When drawing form I learned to feel it in my inner self so that I could then create it on paper, giving the illusion of a solid mass, not from technique alone but from an inner sense that comes through the arm and hand onto the paper. This kind of feeling, in my opinion, requires love.

D. used to talk about the rhythm of a painting, indicating the design. He once said to me quietly that design is the image of the soul. How a thing comes out in a true way would be my interpretation of that, a kind of natural, uninhibited flowing of what is inside you onto the page or canvas.

<p style="text-align:center">✳✳✳</p>

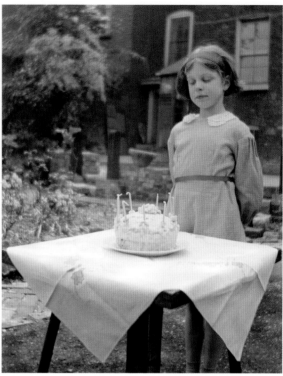

I remember visiting the Leicester galleries with D. when I was about ten. Nevinson was there looking quite portly. D. was pleased to see him and introduced me as his younger daughter. C.R.W. Nevinson looked at me and said, incredulous, 'But Stanley, she can't be your daughter, she's so good looking!' which I thought was very rude. D. responded, with a bright smile, 'But I'm good looking too, aren't I Unity?' and I said, 'Yes, of course'. But you know there may have been something underneath that: he wanted some reassurance that he wasn't the plain little odd fellow that people thought he was. M. also remembered being a child who was not obviously pretty and asking her nanny, 'Well am I pretty nanny?' She used to get so frustrated because nanny would say, 'Well my dear, all little girls are pretty', which she thought was totally useless!

My First Oil, oil on canvas, 1941–2

Unity on her eighth birthday in the Pond Street garden, 1938

M. was in Paris and I was feeling sad.

Until the beginning of the Second World War I was a happy, reasonably confident little girl living with M., Granny and Miss Arnfield in Hampstead, with Dicky blowing in and out from his travels in the USA. But in 1939 I was sent to Epsom, to live with Mrs Harter – 'Minnehaha', as we called her – which for me was a disaster. I was very close to M. and had been her constant

companion for the first nine years of my life. But she was worried about my safety when war broke out, and wanted to move me out of London. Epsom was no safer. We were on the route to Croydon aerodrome: the vicarage was bombed out three times. Shirin had been living with Mrs Harter since 1930. Suddenly, at the age of nine, I felt that I was alone in the world: I lost touch with the early childhood friends I had made in Hampstead and with all our relatives except my mother, Uncle Dicky and my grandmother – and, luckily, Miss Arnfield. I don't recollect the feeling of losing touch: I was so shocked by the extradition to Epsom that I became numb and bewildered. Children are not good at writing letters and need encouragement to do so. But Mrs Harter never asked me about my friends, she never talked to me about my relatives, to keep their memory green for me. She did absolutely nothing to enable me to keep in touch, but instead overpowered me with daily duties, problems and punishments. She didn't mind me having my little friends from the local school, so long as they were from Epsom. It was as if she was terrified of my sister and me slipping out of her grasp. Why we were so important or precious to her, I can't imagine.

I received plenty of physical security, despite the War, but no emotional security. Mrs Harter was a powerful and domineering woman and I was very frightened of her. She put me down continuously and punished me a great deal; it was many years before I was able to stop punishing myself as a result. At first I tried to stand up to her, but the trouble was that I believed Mrs Harter and all the bad things she said

Scene at Mrs Harter's, pencil on paper, 1939

Mrs Harter is on the left, Gwen at the curtains and me on the right, in front of Mrs Harter's boring pug-dog, Johnny.

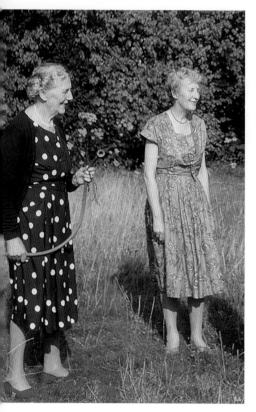

Mrs Harter and Gwen, Epsom, about
1950

about me: she really was like a hard Victorian father. I learnt the piano
with Mrs Harter and didn't, as far as I remember, feel frightened of her
in the lessons. Perhaps it was because I was a good pupil.

I shared a small bedroom with Shirin. One night, when I was crying,
Shirin let me get into bed with her. Then Mrs Harter put her head round
the door, looked severely at me but said nothing. However, the next day M.
came to see me. I suppose Mrs Harter had thought she should call M.

One day, when I was unwell in bed, Aunt Gwen came into the room. I
looked at her and asked, 'Where's Mummy?' Gwen looked uncomfortable
and said 'She's on holiday.' I knew it wasn't true.

When I was fourteen, coming out of my bedroom, I met Mrs Harter
coming up the stairs. She clasped me to her bosom and let go, walking
away embarrassed. Nothing was said. I think she was a frustrated
lesbian but maybe did not know it. There were no conversations about
relationships or sex, full stop.

Gwen used to visit her father, a retired army colonel, once a week.
I never met him but I got the impression he was a gentle soul.

I never talked about Mrs Harter to my family: it seemed disloyal.
For the same reason, I have never talked clearly about other members
of my family. Our upbringing shapes and forms us for life. Of course I
know all about my parents' weaknesses and faults – apart from anything
else, they've been written about in numerous books – and Shirin and I
have both given my parents a lot of thought over the years. But whatever
their faults and failings, they were deeply loving people.

Looking back, I realised that I was not allowed to have any natural
feelings; I was not allowed to feel disappointment; I was not allowed to
feel homesick for my mother; I was not allowed to show anger of any
kind and therefore not allowed to feel the jealousies that flew around
among the adults over Shirin and me. It is pathetic and tragic. I am not
saying that I was all good and never to blame for what went wrong –
that would be ridiculous – but that I was not treated openly or honestly:
everything was powerfully hidden from me, but my own faults seemed
clear as day. Looked at from another perspective, Shirin and I had
become a problem that had to be managed by the various adults in our
lives: our parents did not take responsibility for us, so we were picked
up by Dicky (which must have been quite irksome for him) and Mrs
Harter. As a result, I felt unimportant and unwanted, and, by the time
I had reached my twenties, completely bewildered and panic-stricken.

Mrs Harter had her own family, separated from her quiet and gentle and possibly inadequate colonel husband, so why she had to meddle with our family I do not know. Perhaps it was frustration. She tried to play M. and me off against each other. She couldn't, as our love was far too strong, but she persistently tried to impress on me how odd, peculiar, inadequate and bad my mother was: she both admired and disapproved of M. She also made it quite plain to me that Shirin was a different kettle of fish from me, with a mind and will of her own, able to be more detached from her mother than I was. But deep down I'm sure Shirin's heart was crying out for her mother.

Later on I began to understand that M. was mentally ill but because no one in the family or outside it liked me championing my mother, I said nothing. I just believed in her, and since no one told me what she had done to prove that she was mad, I ignored them. I asked Shirin what was wrong with M. but she wouldn't tell me. I can now see that if Mrs Harter had told me about something specific concerning M.'s illness she would have had to implicate herself. I have been firmly convinced that the last straw for M., which tipped the scales from sanity to irrational behaviour, was the loss of her children. I am convinced this is what caused her to go mad, and I believe that D. thought the same.

Every time people ask me about my father I experience a physical trauma because it irresistibly touches on my own personal feelings and my own life experiences. When people say 'Put it all in the past,' I can't very well because people are constantly bringing up my past – and my painful past at that. Not the happy bits. There have been many happy bits, like walking in the snow with Gwen, Mrs Harter's daughter, on a winter's evening in Epsom, wrapped up against the cold to sing carols. The snow clung in lumps to the wooden soles of my wartime boots.

1940s

ALITTLE OVER A YEAR AFTER ARRIVING AT EPSOM I received a long letter from my mother. I was sitting in the breakfast room, which was cosier than the dining room and abutted on to a pantry where we did the more 'polite' washing up – tea things, pudding bowls, cutlery, etc., as opposed to dinner plates and pot and pans. I realised Mrs Harter was observing me as I read the letter, because when I happened to look up, she was looking at me in a certain way and asked if she could read it. I don't recollect her asking such a thing on other occasions, so she must have seen the slightly puzzled, worried and absorbed expression on my face. I instinctively said 'No'. I can't remember how I said it, but I do remember that my urge to protect M. was greater than my fear of displeasing Mrs Harter.

The letter was long and involved, all about God, as her letters often were. She would write down her thoughts, about God, explaining how she arrived at a certain conclusion; the frightening part – or the most difficult to understand – was the element of unreality in some of what she was saying. Some of it was logical, from her source material, but sometimes she said things as though they were really 'how it is' and yet somehow you knew even the most spiritual person in the world would know that it couldn't be the way M. said it was, or hoped it was, or wanted it to be. Yet she ardently searched and searched inside herself, and in her Christian Science book *Science and Health*, and so on. Often, before her illness began to take over, she knew certain things, such as that the essence of who we are is pure (but she didn't quite say that) and the rest of us is in error, which seemed very advanced. I think she was ahead of her time, but without the balance of this world that we all have to live in, learn from and harmonise with. She expected her spirituality to have no basis in or relationship with nature, so if she believed in mind over matter, she did so at the expense of her body. If we believe that most of our illnesses are psychosomatic, then we need to address or consult our psyche to clear up the problem. But at the same time we need to take care of ourselves, without mollycoddling our bodies, to give our psyche a chance: we all know that bad food, unbalanced diet and lack of sleep or exercise contribute towards illness, mental or otherwise. M. also knew that these things were necessary, especially for children, and she was conscientious about these things where we were concerned, but she did not, I think, make the connection with her own spiritual realm.

Hilda Carline, *Portrait of Unity*, pastels on paper, 1940

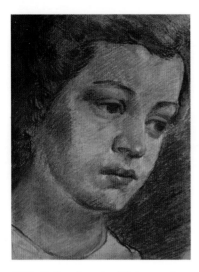

Hilda Carline, *Portrait of Unity*, pastels on paper, 1940

M. was talking to me about religion while she was drawing me, and I became very upset.

M. was more introspective than extrovert but her genuine interest in people and real love for some of them, plus her warm and gentle manner and thoughtfulness, drew her to people and them to her. Even if they did not always understand her (one or two people might mistakenly have thought she had a superior attitude), they felt love and respect for her. Her laughter, chortles and awareness of ridiculous situations I can still remember, and although she was, no doubt, often depressed, her nobility of mind also brought with it a freshness, and an ability to see the real person, the real *good* in a person. In the end, though, I think it was this that caused her to become ill. She put too much pressure on herself to love, against all the odds – not only Stanley, but Patricia as well, and finally Mrs Harter. I think it all just became too much for her, expecting things of herself, that even a saint would find difficult.

Although M. may have been heading that way (as, indeed, D. may have been in the last decade of his life), she never intended it, because all her spiritual energies were about finding God, reaching God, and being 'at one' with God, as she and D. wanted to be with each other. This desire of theirs to be at one with each other made all their differences stand out like sore thumbs.

Between 1936 and 1939 I went to Miss Osborn Smith's school, a dame school in Hampstead. My reports were very good (on the whole). The day I first entered the school the children were reciting 'All the birds of the air fell a-sighing and a-sobbing / When they heard of the death of poor Cock Robbin'. I remember an interview with the headmistress of a Hampstead school I might have gone to, if the War hadn't intervened. She asked me questions, which I couldn't answer: I was obviously not clever enough for her school.

I was happy, even very happy, at Sherwood School in Epsom. There was an old chalk-pit overgrown with trees, with a natural stage where we put on *A Midsummer Night's Dream*. I was a fairy and can still recite my speech.

In 1941, when M. was visiting Shirin and me in Epsom, a neighbouring house was destroyed by a stray bomb. M. was already worried about us living so close to Croydon aerodrome when German bombers were attacking, so she decided to move us to a boarding school in the country. Badminton School had been evacuated to the Tors Hotel, Lynmouth, so in spite of Mrs Harter, who wanted us to stay in Epsom, first Shirin and then I were sent away to boarding school.

When I arrived at Badminton School I was moved down from my age group to a form full of dim-wits like myself. This was another blow to my self-confidence. Though I loved the opportunity to learn everything, I found maths a huge problem and struggled with geography and science. I excelled at art and was good at gym, dancing, singing and piano, to the point where I was held up as shining example when I played at school concerts.

Granny Annie, Unity, Hilda and Shirin in the garden at Pond Street, about 1942

M. built a beautiful herringbone path but did not set in it cement so I was always having to weed it. Years later I built another, simpler path set in cement and brickbats. By that time I had to mow the lawns and do the weeding at Pond Street. I never enjoyed gardening.

Janet Cook, a schoolfriend from Badminton, pencil on paper, about 1943

One of the teachers at Badminton, Miss Gordon, did me a grave disservice, crushing me at every opportunity. There was one pupil, Joan Lavesher, who was always bullying, pestering and nagging me. The girls asked me why I put up with it. I didn't know what to say so I said nothing. One day we were all lined up along the corridor and Joan started teasing me again. I nervously lifted my paint box and timidly hit her on the arm just as Miss Gordon was passing by. She reprimanded me for defending myself: 'You must never do that, not under any circumstances.' I was aghast and frightened, and took her words to heart, so that throughout my youth and into my adulthood I have always found it impossible to speak up and defend myself. It was only much later in life that I understood why I have always found it so difficult to change myself into the person I was intended to be before the people around me began to crush me. It has been a long, hard struggle.

Letters from Unity at Badminton School to Hilda

Letter from Unity to Granny Annie and Dicky, 1943

Dear Granny and Dicky, … I liked playing marbles with you and I rather wish I had some here, but I don't know as to whether Shirin would want to play much …

At the end of December 1943 I decided to start a diary, and I have continued to do so, off and on, until this day. The following extracts give a picture of life at school, my anxieties and enthusiasms – and my relationship with Shirin, to whom I was very close during these years at boarding school together. (Some of my rather idiosyncratic spellings have been corrected, for ease of reading.)

Dec. 28 1943

I have started a diary for the third time 'oh dear'. I do hope this will be the last time and I want to try and keep it up all my life. Shirin has just come in sucking a sweet. She's sitting in front of the fire reading a book. The fire needs some more coal. I think that's done.

Shirin was in great difficulty this morning because one of the pedals of her harp was stuck so I had to come and help her, we could not get it right.

Last term wasn't bad, I moved down to group 2. My work isn't much better. I will have to try much more next term because I am about the worst in the group. Arithmetic 16% French 33% geometry 87% science and biology 45%. The children seem to think me what they call 'feeble'. I don't think I really am very – anyhow I try not to be. But it does not help you if you know that this is what people think of you. I am going to be better next term, one thing that made up for it was that I got first prize for drawing. I was the only one of the juniors to do a drawing of a building. It was Shirin's idea for me to draw Keats House in Hampstead.

Diary, 1944

I slept near the black piano on a rather uncomfortable bed, so next night we made a great effort: I was now sleeping under the brown piano. It felt much safer. And the bed was wider too.

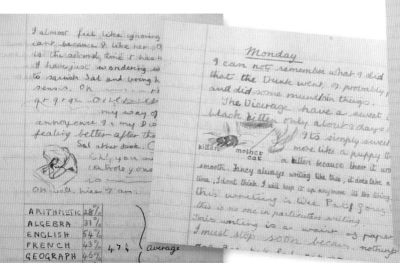

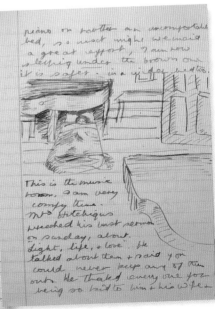

Dec. 29

News! Shirin has made her pedal alright. She is learning the harp at the college, as well as the piano and violin, it is the one that M. had when she was young.

Dec. 30

This morning I practised my pipe. I think it got on Shirin's nerves a bit, she was making the fire. I made it at school and it was a pretty tricky business.

This evening Minnehaha played at the parish church for a memorial service. Minnehaha played very well. I suppose I will have to do some arithmetic soon. I do find it so difficult and such a bore. I wish I didn't.

Dec. 31

Gwen reminded me to say 'hares and rabbits' to welcome in the new year. How strange to think this is the last that I will see of the old year.

I went on the bus to Tatnam Corner to see Maureen Potter who I have not seen for three years. She looks rather pretty in a sharp way, her hair is long and fairish. The naughty girl does not get up till ten o'clock.

Jan. 1st 1944

I did forget about hares and rabbits, but it does not really matter. I got up very early, had to go back to bed, and wait till seven. Minnehaha told me to.

I made breakfast and everyone wished each other a happy new year.

Diary, 1944

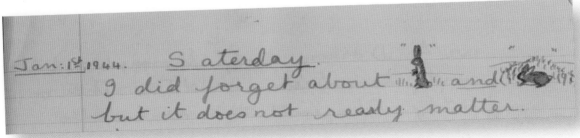

Shirin went up to London to hear the Messiah for about the third or fourth time. Minnehaha thinks it is about time for her to go to something else.

This evening I told Shirin that I did not feel I would be able to read the Bible at school because children would laugh at me. Shirin said I would have to if I thought it right. She said that I was too self-conscious, and that I was not really humble like Paul and Jesus, and I don't know but my eyes got so blurred and I simply cried and cried in a dumb way. After that Shirin kissed me goodnight on my hair which was clean and dry, a contrast to my face, and we both went to bed.

Jan. 5th

Mummy and I met Gwen in London, we went to see Alice in Wonderland. It was very very good. Roma Baumont was Alice, Sybil Thorndike was the queen of hearts and the white queen. The white knight was most extremly good. Afterwards Mummy went home, and I went to Epsom with Gwen.

Jan. 6th

I had lunch with Mummy in Hampstead and Daddy had been invited too. Much to our annoyance Daphne was there as well. She went out to get some food so we were able to have a little talk together, but Daphne was a nuisance, she said after lunch that she would go but she took ages and Daddy got terribly annoyed because he was trying to have a nap. I carried on with my painting. Just as we were happy and settled, back came Daphne, saying softly that she was feeling ill. Daddy had to go back with her. Before he went he said that he would like me to go to Cookham all by myself the next Easter holidays. I said goodbye and finished my picture.

Now I am writing about going back to school, I had only been with Mummy a few days, which was not a nice feeling, I felt very unhappy.

We have started school, the timetable is the same as last term. Very annoying. It seems so strange to be back at school.

I am sleeping with Pat, she is head of dorm, Pam and Sal. I don't like Pam very much she is rather silly. In fact she is a sheep, Pat is much the same only more decent. The sad thing is they all

seem to think that anything good is silly, and anyone who is good is silly. Sal is the best of the lot.

What a fool I am, I am writing this as if it was happening which is not true. I must write in the past. Sal's going to help me recall the days.

Sun. 5th Feb.
Oh hurrah, I have caught up at last, I would not have done it if it had not been for Sal's diary.

There has been a fuss about us not singing in church, so I tried very hard but one does not get any inspiration from that church.

We have to go for a walk this evening, why aren't we allowed to have the whole evening free? I'm going to try and read my Bible every evening, it is a nice one, plain black with gold lettering, the cover overlaps a little and the edge of the leaves shine red and gold. Oh bother we have got to get ready.

It was quite a nice walk, I sat on a rock for a while waiting for the others. I would love to be able to take a little bit of lunch and go where I liked in Lynmouth and think.

Tues. 7th
Gym was very boring, it is always the same, exercises, running about, balancing, sometimes there is a change but none of the really nice things.

Drawing lessons have not been very nice, I have not got much inspiration for it.

Senior choir sang a lovely thing by Mendlessohn, about the strength of the hills, and praising the Lord.

I was looking out of the window and watching the sea on the rocks, and the sun was shining very much. Last night I made up a poem about the sea, here it is.

The Sea
I heard a minotinouse sushing sound
of the sea as it beat on the shore
the waves rode up and fell down again
and seeced to be seen anymore.

Hurrah, I am going to do extra art the same as Jill, I am so pleased.

Nov. 9th 1944

I do think Christmas is a lovely season, it always makes me feel all happy and cosy and the thought of it links me up with older days when Mummy was little and George and Roly and Sydney were all alive, though I do wish I could've seen them all and talked and done things with them. Granny is such a homely person and so was Da and yet I never saw him. Nor Daddy's father or mother. When I was small I did not know much about Daddy, because we didn't live with him and Mummy never told me much about him. Oh! Why can't Mummy and Daddy and Shirin and me go and live happily together in Hampstead or Cookham, but then that's not going to be yet, oh I do hope that we can all come together and for everything to come out beautifully and happy for ever. I think it probably will in the end.

Sat. 18th 1944

No art. Very sad. I look forward to it all the week. Writing, keep neat, you must not sprawl so. Just think of it, Shirin is 19 today. Poor thing I hope she doesn't think I have forgotten her. I will have to apologise. Exams soon, Oh woe.

Thurs. 23rd 1944

Science, eeeya, nasty. I wish MacDough would explain things better. Griffy was much nicer. I didn't have a very nice music lesson. We looked at some nice slides of ancient art.

Oh woe, woe, what shall I do, I have done a very bad thing, I mean that everything is horrid. You see I am too weak. I'm not strong enough to keep the dorm in order, oh I do wish I had some personality, and make people respect me, but I don't know, I'm too irresponsible. I don't know what I will be like in the sixth form. Oh God. Please please help me all you can to be less feeble, help me to be strong and not mind what people say, if I know that I am right. God, I will be hopeless if you don't help me,

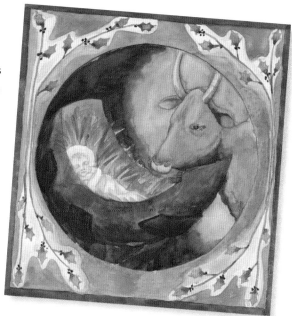

To Mummy
Wishing you a very Happy Christmas
and Happy New Year
With lots of love from Unity
Christmas 1944

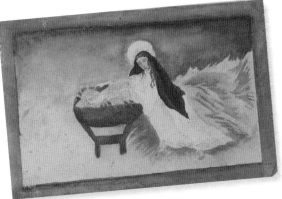

To Daddy
Happy Christmas and Happy New Year
With lots of love from Unity
Christmas 1942

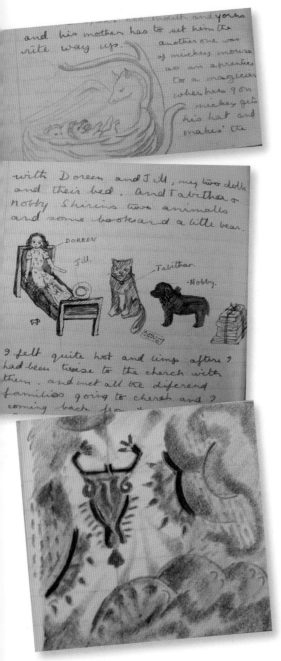

Diary, 1944

I have tried as hard as I should but I am going to try to be more responsible for things and you will help me all you can.

Anyhow, what happened was that we were playing a lovely game in the dorm and Ski heard us and reported us to J.R. [matron] We had to go down to B.M.B [headmistress] who told us to get out our arithmetic and she said we would be there a long time and gave us a little talking to, and was very angry. After an hour B.M.B said she had been consulting J.R. And had come to the conclusion that Alice and Jill were the least offenders, so they went to bed. Diana had a row, but went.

B.M.B said 'Unity I am disappointed' and things like that, though I did feel bad and she said she had taken half price because she was sorry for Mummy and Daddy, and then I had gone and thanked her by being bad. She said I was a nuisance but she was sad more than angry. I didn't cry until the end, and then I didn't show it. I hope and pray that she knew I felt bad about it.

Friday 24th 1944
All today I felt bad and sleepy in fact it was horrid, I felt that J.R. was angry with me all the time.

Ski fetched me at break to speak to a man called Mr Weelern who has done a great deal for the League of Nations, he knows Daddy and the Burghclere Chapel, and Mr and Mrs Behrend. I felt honoured he chatted to me about it, I said one or two silly things because I was shy, I knew that B.M.B was watching me. Mr Weelern gave a very interesting lecture about the time he was made prisoner. He had a nasty time but said people were kind to him because he was old, he was very amusing when he told us what happened when Paris was liberated, which I saw on the film. I was so happy because he went straight to Hampstead where he had a nice meal round a cosy fire.

I did something tonight that was wrong of me but I told B.M.B. I want to forget it on the spot. B.M.B told me I took everything to heart too much.

Sunday 10th Dec.
Home. Daddy came to see us this afternoon we had a lovely chat together. Daddy always has a lot of lovely interesting things to say

about all sorts of things. He likes my pictures. We ended up with Shirin and Daddy playing the piano. Then we went as far as the crossroads together and then parted company into the mist, all romantic like.

[After Christmas, no date]

I went up to London, I was a bit worried about Mummy but I had a long stay with her. I felt so sad because Mummy looked so awful when she was standing up in her family dressing gown she looked a bit pathetic and I felt unhappy. I was able to go out and buy her something that she wanted and the second time I said goodbye I felt happy about it. Poor Mummy. I love Mummy more than anyone else in the world, then comes Daddy and then comes Shirin and I love them all very much indeed. And I am not a soppy girl, I mean it.

I haven't kept my diary up, so many things happened in the holidays, I'm already longing for the end of term, so silly because I'm right at the beginning of it and we are back at Bristol.

Shirin and I had plucked up courage to go to the 30 Club [a youth club in the church hall]. In the end Shirin wasn't well so I went by myself escorted by Gwen. I didn't dance with many boys but I danced with Mr Payne three times!

Forest and Carol were pleased to see me, Colin Sturx was there. He danced with Forest a lot. They are great friends. The next time I went with Shirin she felt extremely shy, I do rather too. All the girls somehow get into bunches and so do the boys, except for the ones which aren't shy. I was very pleased because Colin asked me to dance with him, and afterwards when I was dancing with Leah she said that I danced well, so that bucked me up a bit.

On the Sunday we had a discussion on punishment for young children, it was very interesting. I went red because Shirin spoke and I always feel funny for her when she speaks.

Mrs Payne, she's a psychologist, said never punish a child when you are angry. Be great friends with your husband for some time before you marry him. When the baby comes you have to sacrifice a lot to it, and you must give it everything it wants until it comes to discretion. E.g. You must feed it regularly.

On the Friday we had dancing lessons downstairs. Colin came up to me and said 'I've lost my partner so will you dance with me?'

Diary, 1944

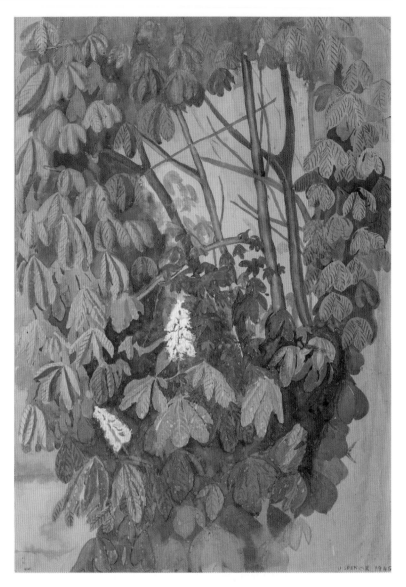

Chestnut Tree at Ashley Road, Epsom,
watercolour on paper, 1945

*I painted this sitting on the loo seat,
looking out of the bathroom window.*

I said 'yes certainly'. I can't help talking about Colin because I like
him and why shouldn't I, after all I bet lots of people like boys.

I saw Colin on his bicycle I called out hello, he said hello Unity
and went on. He has got an amazing voice, and Gwen thinks he is
very good looking, I agree with her. If anyone read this diary they
might get the idea I was a flirt, but on the contrary I am a bit shy, and
poor Shirin is a bit worse, but I am going to do my best to get over it.

I got an inspiration near the end of the holidays for a picture
so I did the chestnut tree out of the bathroom window for the art
competition. I love drawing and painting.

I wonder if Colin is interested in drawing and art. I wonder what he is interested in, I must pluck up courage next hols and ask him.

[New term, no date]

I wrote to Forest and she wrote a nice letter back. It's so hard to decide things, I had to decide whether Mummy was sane or insane. Well she wrote me a very long letter about it all, and I'm sure that a person couldn't have written a letter like that if she was insane. I wrote back several letters telling her what I think and she seems to be much happier about things. She sent one of my letters to Shirin with the end part mostly about what I thought about boys. Mummy also asked me if I would like to have a few lessons with Tudor Hart. Well I said I would but I thought he was dead, I haven't had an answer yet.

Summer hols

Saturday Aug. 11th

I seem to shake inwardly when I see Colin. I rushed up to my bedroom, as I do every afternoon at a certain time because I know he will cycle past.

Sunday Aug. 12th

Saw Mrs Sturx going to church. Disappointed 'cos Colin didn't go as well, I suppose he is being nursemaid. When I looked out and just caught sight of him coming after his mother, I thought strange, why didn't he go with her? Gwen and Minnehaha said he was looking rather truculent lately. It is a pity. Also, he never goes about with his family now. I do wonder what is the matter with him. I do hope he gets out of it. God, please make it that Colin grows out of being peculiar (if he is) and that his family think that he is nice and that I get a chance of talking to him quite a lot please dear God make it so, amen. Oh and that everyone who ought to, thinks he is nice as well, amen. This prayer I would like for everyone that it concerns including me, amen. The weather has been lovely lately, only not quite the heatwave.

Mr Payne [the curate a lovely man] gave us a marvellous sermon which he would have liked to have shouted from the

On Saterday 2nd Feb. Polar Nirenski came to dance to us, she was lovely, it wasn't her technique so much as her expre[ssion] and all that she put into it which was [good].

Diary, 1944

rooftops of Epsom. I wish he could. It was all about the atom bomb. For the lesson he read the story of Adam and Eve, how they ate from the tree of knowledge. Then he said that we were to use this atom bomb for good not for evil. He was more forceful than that and you could tell that we felt it very much. I felt very worried because I thought that he meant that the whole invention was wrong. Outside the church Mr Payne came along and Gwen said 'Unity is thinking very deeply about your sermon'. 'Oh is that how she looks when she's thinking deeply?' he looked at me quirkily.

Wednesday Aug. 15th

Today is a marvellous day. This morning at eight we turned on the wireless and THE WAR IS OVER!!!!!!!! Isn't it wonderful. Japan has been a long time in accepting…

We listened in to the description of the great victory procession, good old English weather, but everyone's spirits were as high as they could go and the King and Queen were in an open carriage. They went to Westminster Abbey to thank God. We went to the parish church, we had a lovely service, I felt like smiling an awful lot but then during one of the hymns I said to myself 'I'll never forget this day, God, and I do so mean it' and then I felt my eyes getting red so I looked down for the rest of the hymn, although I felt like looking up. And I kept on saying that I was really thankful, and 'oh God this is sincere', we rarely are you see, I wanted God to know I meant it, of course he knew I meant it, but that wasn't enough I had to tell him so.

We listened to the King's speech in church. He spoke extremely well and didn't stammer at all.

Mon Aug. 20th

Oh dear. Time does fly so quickly. Haven't seen Colin for ages. I do want to ask him about camp. Took 24 bus to Hampstead. Mummy seemed happy and she looks so much better than before but I do wish she would try and make herself look nice. Hair is going a beautiful silvery grey. Of course the significance of grey hair isn't

Diary page, 15 August 1944

The war was over. Shirin and I joined the crowds going on to Epsom Downs. It was very exciting.

nice but hers is lovely. The front bits have still got a touch of dark reddish-brown. But Mummy, oh darling I do wish you could get better in mind and health and be happy and do something, and make something of your life, perhaps you will, who knows. Anyhow if God has carried it out so far he will carry it out completely and if things don't come completely right in this world they will in heaven.

Wed Aug. 22nd
Auntie Florence came this afternoon, weather horrid. I went for a walk with F. along Woodcote Way, coming back I saw Colin with some friends of his, I said 'hullo'. 'Hullo Unity.' It's funny he usually says my name when he sees me, probably he thinks it's a funny name. Auntie F. asked if he was an old friend of mine, I said no. I told her a little about the 30 Club. Poor Auntie F. she has got the atom bomb on the brain. She can't talk of anything else.

While I was away at boarding school, my mother was living in a rented flat in Finchley Road, London, and was in a state of depression. She was under the care of Dr Bierer. He wanted to see me to talk about M. He didn't think she was mad. I was surprised: 'Neither did I,' I said. Everyone was telling me she was mad. Shirin was very secretive about her thoughts (that was the way she had power over me).

I would write to M. from boarding school at least once a week, but her letters back to me were sporadic. In one of them, sent on 13 July 1944, she gives an idea of her state of mind at this time, feeling isolated from her children and becoming obsessed with daily tasks:

Finchley Road, NW3
13 July 1944

Darling little one.

When am I going to hear from you? I am so behind hand with news as I have not heard from you since soon after your birthday, and as I have not seen Shirin all the term I have not had any news through her.

I keep longing for a letter, every Tuesday when your letters usually arrive I rush down in the morning, for weeks and weeks now and never any comes.

Well that sounds a sad picture, as I have not written to you also. I ought not to expect a letter if I cannot send you one. I know you write every week to someone, that is why I hope that one week it will be to me.

I am writing this early 7 o'clock, I should not spare the time as it makes me so late, I have the shopping to do before getting round to Pond St. So I will explain why I am so extra busy at present. Mummy and Miss Arnfield went to Seamington some weeks ago and I had the idea that I must spring clean their house. It would never get cleaned any other way, it was beyond words dirty as you no doubt realise. It's like a junk shop, it is in a truly terrible state, Granny cannot do anything about it and Miss Arnfield has not the time to.

I began in the drawing room, am still doing it. I have washed all the walls, every bit of paint, every ornament every book in the bookcase everything in the drawers and inside the drawers, I have had to wash the furniture inside and out. Every chessman and Halmer man and draughtsman. I have had to wash every picture, all the furniture coverings and the curtains, and the carpet after beating it. Really it is endless. However it is going to be perfect – when done. I have even washed the dolls, polished every book with leather soap after washing them…

… With all this to do I get home so late and have to get my meal for the day, I don't finish eating until about 12 o'clock at night, so as you can see I don't get much time for letter writing. The portrait I have been painting is not completely finished, but if I stop to do things here I get to Pond St so late and then I get back later and later and so it goes on…

… Dick has written to Miss Baker to ask wether there is any holiday camping or farming you could do for part of the holidays, for he does not like the idea of your being about where the flying bombs are. I don't think there is anything to worry about but I know you don't like the air raids, so perhaps it would not be a good idea to be in Hampstead or Epsom. Maybe you could stay at Muriel's with her children; you would enjoy them.

With very much love my darling and forgive me for not having written all this long time. Mummie.

Letters from Hilda to Unity

A letter she wrote to me four months later shows her to be in the same obsessive state, feeling cut off from her children and D.

12 Nov. 1944
Finchley Road NW3

Unity darling

I wonder whether you are sitting down to write to me as I write to you. It is now five minutes to three as I start this letter to you. I expect you do your letter writing after tea, and have a walk on Sunday afternoons. I wonder how the art mistress teaches, how the concert went all the news of work and play and everything.

I saw Shirin at a concert at the Royal College we had tea at Victoria Station. She still has not managed to come here to see me. I was so glad to hear she was enjoying her piano lessons, her teacher seems very encouraging to her.

Today I have taken a day off from work at the house. I have done all that needs to be done to fruit now, made the last jam finished the bottling and sold the last that can be sold.

I have done the front garden for the last fortnight. As it is to be a surprise I won't tell you what it will be like. When that is done I really must get down to tidying and cleaning the house a bit more I hardly have done anything to it. Dicky doesn't want the family to come back until all the V1s and V2s are quite finished.

I often think of your visit in the summer to see me. Granny keeps asking for news of you and Shirin.

I am sure that Daddy would love to have a letter from you, I can send it onto him. I never hear from him and yet it seems that he continually writes me letters, but he does not ever send them.

Well now darling write and tell me everything about yourself and all the news of school of every sort. A really long letter that will be a lovely birthday letter for me. So make it very long and full of news of every kind, I will get it the day after my birthday because your letters always arrive on Tuesday. I shan't feel so much older on Tuesday than on Monday.

With lots and lots of love my darling, from Mummy.

M. had a very lonely road to tread through her life. She had an excellent brain; I think her trouble was that she had to work things out too much instead of taking things on trust. What she really needed was a friend to understand and be sympathetic to her, as well as to love her. Re-reading her letters, I found some of them heartbreaking and wished to goodness that I had been older and more knowing so that I could have helped her. I know I could have helped her, because I loved her, and that's what she needed. It was her children – me and Shirin – and our love for her that she needed. Some of her writings are filled with such intense feeling, whether about politics and religion, about fanciful ideas, or about personal problems. Sometimes they are repetitive or go into such deep and precise explanations that they need several hours' concentration. The degree to which she could explain a feeling, a relationship, a picture, an idea, a philosophy, is quite remarkable. It is so sad that a lot of it is really too involved for most people to be bothered with, and I know that it isn't good for me to read too much of her writing, but I find so much of it completely absorbing. Some of her writings are like confessions, which reveal her as a wonderful person, full of love and warmth but continually rebuffed – and far too sensitive. Of course the sad thing is that this sensitivity of hers was right, and if we were all equally sensitive we would probably be far more understanding of each other. But in the hard and callous world, M.'s sensitivity laid her open to too much.

What caused her introspectiveness I don't know, except that if you have an enquiring mind and strong feelings but either no one to be sympathetic to those enquiries or to reciprocate the feelings, you automatically turn in on yourself. As she said in one of her letters, M. strove too hard for things that were beyond her. When she was light-hearted and gay, she was glorious. There was shininess in her eyes when she smiled, which was heavenly, and she could laugh and laugh until she was convulsed with laughter. She loved animals, including insects, and was never afraid of them. In fact, D. used to describe how he would get behind M. when they went through a field of cattle in Marsh Meadows together. It is interesting how alike and how different they were.

When M. was alive, the stigma against mental illness was even greater than it is now. As a child I did not believe my mother was mentally ill, and I championed her in my heart. But the pressures brought to bear on me by various members of the family were so great that by then, in my late teens, I began to think she was.

On the occasions when I was allowed to visit M. when she was mentally sick, she would ask me what I would like to do, such as visiting Madame Tussauds. I rather vaguely said 'No' to these suggestions, because what I wanted was to be with her, but I could not say this to her, because the feeling was too deep.

In my diary I wrote of a rare meeting with D. on Wednesday 12 September 1945:

> I have other things which I ought to put before this but I haven't time and this is more important. It is so wonderful, DADDY IS IN HAMPSTEAD. If Shirin is alright tomorrow we will go up and see him, if she is not he will come down and see us, Oh! I want to tell everyone about it, it's so wonderful. I was reading his THREE letters this afternoon the only ones I've ever had from him but they are such lovely amusing and serious and kind and homely and Daddyish letters.
>
> Dear Daddy, he looks so sweet coming past the barrier, I thought 'how amusing that I'm kissing Daddy and fetching him among all the posh people (compared to Daddy)'. What did I care? Nothing! Daddy is Daddy and no one else. After lunch we talked and then went to the music room for Shirin to play and me to show him my pictures I think he liked both. He loves my chestnut tree.
>
> When we were on the platform waiting for the train I said how I found I wanted to paint something but didn't always know what. So D. said 'don't think of what you could paint but what you like, what you are fond of', e.g. he was always very fond of the atmosphere at Fernlea, when his Mother was there, and Uncle Will was playing the piano and he and Gil used to crawl under it and listen to it, well then he would try to draw it. I was so glad that he told me that, and wanted something from Daddy like that, what he said just then meant masses to me.

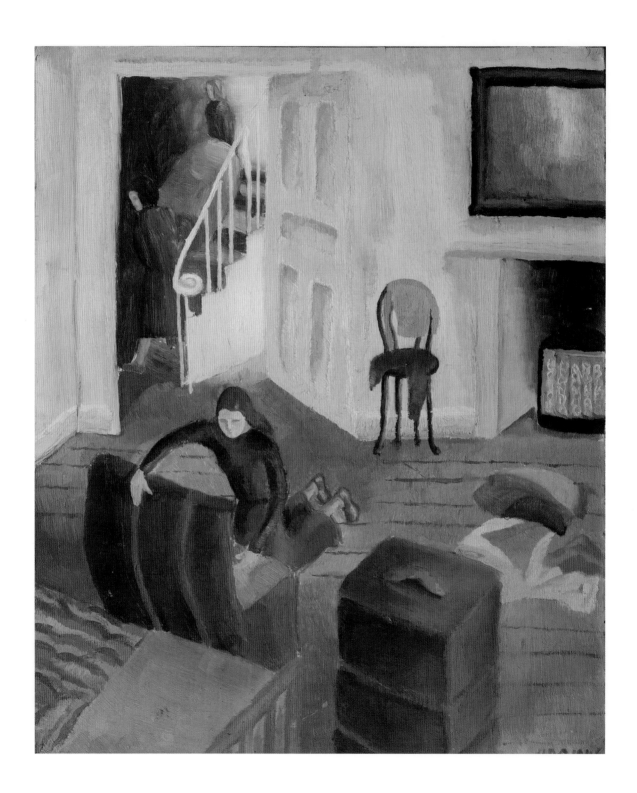

<center>＊＊＊</center>

My diary entry for Friday 28 December 1945 reveals my love of music and painting – and irritation at a new book published about my father:

> We looked at the new book about Daddy. The reproductions are quite good, but the introduction by Elizabeth Rothenstein was very bad, the facts about Daddy were wrong, and she said things about him and his pictures which are not true, and she was sloppy, and she knew Daddy didn't want her to write about him because he said that she knew nothing about him and we are all very annoyed about it.
>
> We went to a lovely L.P.O. concert conducted by Albert Coates, he has a marvellous face. I felt so thrilled, and I had a lovely feeling, rather a curious one something like this happening inside me [curved drawing] I don't know what to do it's a dreadful lovely feeling. Oh Tchaikovsky's Pathétique Symphony, I love it. We are going to a Beethoven Mass on Thursday, I do love Beethoven, poor man, I feel terribly sad when I think of him sometimes, imagine being deaf and not being able to hear music.
>
> Only a fortnight until the END of TERM. I've been painting a Chinese lady and I'm going to try and paint the sun set coming back from Grantchester.

<center>＊＊＊</center>

In the entry for Monday 15 May 1946 I describe a photograph of D. with his family (see p. 8):

> It was so interesting to be able to look at the family group, it was the Spencers of course, Grandfather and Grandmother look so calm, and different from all the children, Percy looks rather fine he is in the background with all his hair sticking up in a bush like it always does, and Horace, has a kind smile on his face, and his moustache makes him look like a Frenchman (as Shirin says) … I love them all, Auntie Florence looks very composed like her father and mother, she is sitting down with them, Gil is the only one who is really grinning, his enormous mouth!!! … But Daddy … I do think he looks such an

Packing our Trunks at the End of Term, oil on canvas, 1946

interesting little boy, Shirin thinks he looks as if there is a great force behind his face, it shows in his eyes and round his mouth.

In July 1946 Beatrice May Baker, headmistress of Badminton School, retired. As the pupils lined up to say goodbye to the teachers at the end of term, B.M.B. had tears running down her face. She was always such a self-controlled and somewhat severe woman that we were shocked.

That year I had the most wonderful summer holiday. I went to camp for the first time in my life, which I described in detail in my diary:

The camp was really to give young people a chance of becoming Christians, if they wanted to. Every morning we had prayers in the Pavilion and if it was sunny we sat on tarpaulins to eat meals. The boys had to collect water and the girls had to find wood for the fire. Every day we went down to the beach.

One evening we had a quiet party in the marquee after cocoa at 9 o'clock. It was great fun walking back to our tents not quite knowing who the various figures were walking about in the dark.

I was feeling very energetic and Carol and Vera were too. Suddenly I started doing handstands and cartwheels and gradually others joined in, and then several of us tried doing handstands with

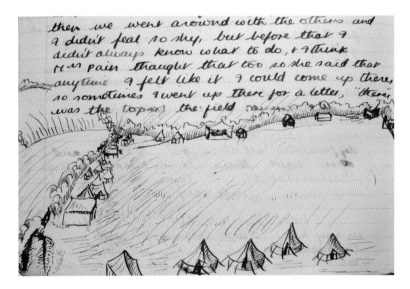

Diary, July 1946

our arms under each other's tummies … Then some of us crouched down on the ground in a row and others would try and jump over all of us and poor Beryl got hurt in the side and had to have it strapped.

Another day Colin, Forest, Andy, Roger, Joan and I went for a ride in a motorboat, it was super fun because the sea was fairly rough. We got gorgeously wet, especially Forest and Colin.

On Thursday evening we went to a dance in the village. I'm glad I brought my yellow dress, otherwise I would have to dance in a blouse and shorts, which wouldn't have been at all correct. I asked Colin to dance. He was very kind, he said the sun has caught my face! Poor me, I'm always being told that my face is red and I cannot help it. My nose suffered very badly and is peeling…

We sat outside our tents in the dark drinking hot cocoa with the warm glow of the fire. I wished I could pluck up the courage to say good night to Colin, I think I am getting less shy. Carol says I will grow out of it but one hasn't a chance when one is at a girls' boarding school.

On our last day we went for a walk along the cliffs. We looked down into a small valley which was thick with rocks and brambles and bushes, the other side of the valley wasn't a mountain but a jutting out peak with rocks sticking up against the sea. I have tried to draw it but it is very difficult anyhow it is like enough to remind me of the place…

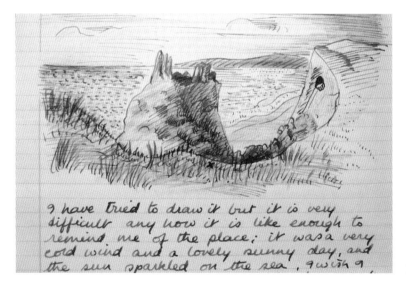

Diary, July 1946

Portrait of Aunt Gwen, pencil on paper, 1948

Gwen was an actress and dancer. She was always graceful.

The following spring I received some devastating news:

Feb 1947
Badminton School
Bristol

Miss Sanderson, the new headmistress, asked me to her room. Gwen and Mrs Harter had called the school.

'I'm afraid I have some sad news. Your friend Colin committed suicide with a home-made bomb.' When Miss Sanderson told me, I just hung my head and said 'Oh.'

A day or two later in the science lesson I was sitting at the back of the class with my friend Heather. Heather did not know about Colin's death, and gave me a valentine card with a 'CS' and a cupids arrow pointing at 'US'. I burst into tears.

I was surprised that Gwen knew how I felt about Colin. She must have known because early every evening I would run up to the bedroom because I knew I would see Colin riding by on his bicycle.

The times I felt I knew my father best – in fact, the first time I really got to know him at all – were towards the end of the war, when he got a home of his own and M. and Shirin and I were able to visit him there. This was in 1946, when he was in his mid fifties. It gave us a feeling of self respect to be able to see him in his own home at last. I was sixteen by this time and this was the first time that we had been able to visit him properly together since he and M. had separated twelve years earlier.

I can remember Dicky being irritated with me for defending D., declaring that he was hot-headed and selfish as a young man, and that I didn't know him properly. D. was a very hard worker, an early riser who painted every day if he possibly could – unless he was interrupted by social gatherings or visits to an exhibition or errands to be run – occasionally, for instance, he'd go for a walk to get his groceries from Mrs Mackey's shop, or down to the butchers to get his cutlets. He was always bright in the mornings – and on into the evenings. He'd wake up at six, sit up in bed and read for a bit and then get up and go downstairs to have his breakfast before he started painting. When I stayed with him I always found Cookham very

soporific and I found it difficult to wake up, so it was probably eight o'clock before I came down to breakfast. He was always down there, and he'd cheerfully say 'Oh here's Unity!' We'd always have breakfast together. It was usually white toast, tea without milk or lemon and sugar and a bacon rasher or occasionally a boiled egg. He'd cook while I helped out: there was cold running water for washing-up but no hot, so he boiled a kettle and used plenty of soap to wash everything very thoroughly. It was a very important matter, this washing up. The water had to be boiling, the soap had to be bubbly, and he always used a mop. It was all very methodical and he worked quickly and efficiently. Then he'd work through until lunchtime, when he'd have a lamb chop, the inevitable white bread and butter, and a cup of tea with lemon or milk and sugar and a short nap afterwards.

He didn't really have a studio as such. As far as I know, the only studio he ever had was in the garden at Lindworth. I think that Patricia commandeered that eventually, but for a time he did have that place to work in and store his canvases. He was certainly not precious about his work: he allowed Shirin to play with her cars in there, between his canvases. Otherwise his studio was always the biggest room in the house, which was often the front bedroom. At Cliveden View, the cottage he had in Cookham Rise after the war, he used the front bedroom – it wasn't a big room, far from it, but it was the largest he had. He had his bed in the corner away from the door. There was a table between the door and his bed. He had a purpose-built trolley to keep his tissue paper drawings for the *Cookham Regatta* series. He had an oil heater, but when it was discovered that the oil was damaging the canvases he changed it for an electric fire. Then on the end wall he would pin up his large canvas, whatever it was he was working on – *The Apotheosis of Hilda* or *Christ Preaching at Cookham Regatta* – half of it rolled up so he couldn't see the whole thing, but that's the way he worked. He had a wonderful facility for squaring things up: he knew what the whole composition was, so he just worked away in that fashion. The house had two spare rooms, but he must have liked to sleep and paint in the same room; or perhaps it was just practicality – cheaper to keep just one room warm.

Having had his lunch, he'd then go upstairs to his bedroom, the studio room, and prop himself up in bed with a book and read. He'd go off to sleep for about twenty minutes. He did that every day, even when he was away from home. In Peking, when he went out to paint all day, he was driven out to the Ming tombs in a limousine. He painted all morning, then he went inside one of the tombs and squatted against the wall, read

Portrait of Stanley, pencil on paper, 1945

This is quite a good likeness of D. but I've made his face too broad.

something and went to sleep. Then he'd wake up, carry on all afternoon, probably on a different picture and then the limousine would drive him back to Peking. If he stayed with patrons – to paint their portrait or garden (or even their dog!) – he would always have an afternoon nap of about twenty minutes or half an hour. He'd usually have a cup of tea at some stage and perhaps a little supper, but he'd sometimes paint until midnight back in the studio. He had to have a blue daylight bulb for that, because if he was out painting a landscape or someone's portrait he'd do that in the daylight hours. Then he'd come back and then carry on painting the *Regatta* or whatever large scheme he was working on, until quite late in the evening and go to bed. The next day he'd start the whole routine all over again. He had phenomenal energy and also tremendous concentration.

To get himself into the frame of mind he would read or play the piano – and when he had a break from his work, it was usually to go and play the piano. Occasionally he played Schumann or Chopin, but his favourites were Bach preludes and fugues, which he played slowly and carefully, with a lot of feeling and thought. Some of his brothers were musicians: Gilbert and Horace were good pianists and Harold was a violinist. D. had had no formal training as a pianist and had a lot of tension in his hands, but he had great concentration and would really persevere, tackling quite difficult things. Shirin always said he could have been a conductor because he could sing you an orchestral concert, bringing in the double basses here and the violins there, then the horns and so on: he would sing it all at different levels to convey what the music was about.

I was quite surprised that he sometimes had the radio on when he was painting slightly tedious bits of his pictures like the pebbles. It was usually something like Radio Two crooners: once I remember him saying 'Oh God, these male singers are such a bore, they're such egoists! Women are so much better!' That was very funny.

Usually I only stayed for a weekend, because he didn't really want people to stay for longer – he'd got used to being on his own. But he admitted that he would sometimes come downstairs because he thought somebody had knocked on the door, only to find that there was nobody there. So he did like company, he didn't always like being on his own. People were very kind to him in the 1950s, asking him for dinner and so on. He was often very good company, the life and soul of the party. But he did need a confidant – and confided a great deal in me when I went to stay with him, perhaps because he was a bit desperate. He once said

'I wish I hadn't made that mistake over M.' I think he deeply regretted it for the rest of his days. And he did want to remarry her.

D. was brought up partly in the Methodist Church and partly in the Anglican Church. His father was rather suspicious of the Anglican Church, although he loved the Old Testament, the stories and the beauty of it all, so it was the Old Testament that he regularly read aloud to his family. D. didn't go to church regularly at all. I don't think that he had anything overtly against it, but he felt it was too conventional, it hadn't been thought through and people just behaved a certain way without thinking. Yet religion was very real for him, very much a part of his imaginative life.

I remember standing next to him in our family pew as a young woman. D., small and compact but slightly bulked out by his navy overcoat, stood to sing the Psalm, hands placed on the pew in front of him. He wasn't exactly conforming, despite standing up with everyone else. He mouthed the words with no particular expression on his face or in his eyes and saying as much as singing: 'if Lord – Da-dee-da-dee-da may be da-dee-da-dee-da hmmm hmmm as in hm day of our re-hmmm-tion. Amen.' He was looking slightly up and around the church, not so much out of interest so much as for whatever thought was going on inside his head. He was unaware that I was finding this amusing.

On another occasion D. and I went into Cookham church on a weekday and he read to me, most beautifully, the words on the seventeenth-century brass memorial to Edward Woodyore:

> His sovle discharged from bodies bvssie thrall
> Heer Edward Woodyore wayts th'archangels call …
> Whose fashion gentle & whose dealings ivst
> Whose constant frendships & whose faithfvll trvst
> In life & death made Woodyore trebel deer
> To God & men & to his loving pheer …

He loved this inscription, and particularly the final bit.

Another brass plaque, which was cleaned up to shine because it was a mini-Cookham attraction, was on the cottage where my great-grandfather lived with his family: 'All fighting to be over by 10 pm'.

In July 1947 M. was admitted to University College Hospital in Hampstead for a mastectomy, when I was in my last term at Badminton. I was desperately worried about her and wrote to her as often as I could with news of life at school. From time to time she wrote back to me. I loved getting her letters, which were always brave and positive:

17 July 1947
University College Hospital, London
Private Patients Wing

Darling Unity

Thank you for your lovely letter. All your letters are so interesting. I gave your last letter to Miss Arnfield to read, so when Daddy came I was not able to show it to him or to Shirin when she came on Monday. It was lovely seeing her and she was so sweet.

This is the first letter I have attempted to write. I am getting better slowly. They are trying to build me up and have given me a blood transfusion. And they give me all the foods they can think of to make me better. I am doing my best. I walked a bit yesterday with Daddy holding me one side and the nurse the other.

The operation won't be anything much and they will manage it in such a way that I won't even know anything about it at all, but they can't do it until I am strong enough. Everyone here is so nice. The nurses are so pretty and bright and the doctors are very nice and kind and thoughtful.

You seem to be having a very happy term and I am so glad.

With all my love, darling
From Mummy

 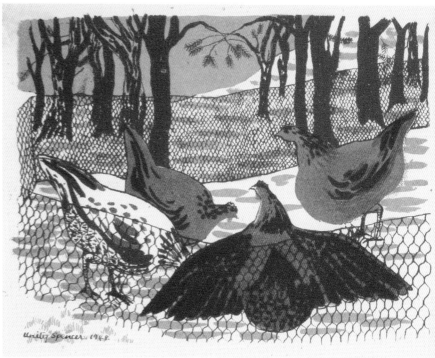

November 20, 1948

To Mummy dear

Wishing you a very happy birthday. Do you remember when we went up to the Tower of London? Well this is what I remember it to look like in my imagination. I am standing against the wall of the Tower looking into the moat where the chickens are … we are looking over the river to the buildings on the other side, only unfortunately I drew onto the stone the right way round so that the picture is now back to front so you will have to hold it to a mirror to see it the right way, not that it matters much!

With lots of love from Unity

After leaving Badminton School I went straight to Wimbledon School of Art. Among my friends were Margret and Félise, the sculptor David John, and Eric Rimmington. We did a lot of life drawing and every week we had to produce a small figure composition. This would be criticised on

Chickens in the Moat at the Tower of London, lithograph, 1948

Chickens in the Moat at the Tower of London, colour lithograph, 1948

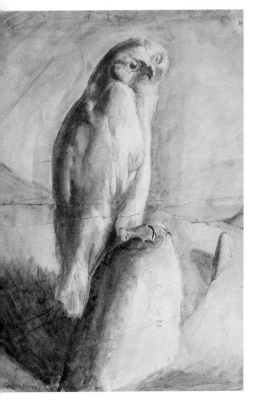

Stuffed Owl, watercolour on paper, 1947

I think I was trying to give it some life...

Wimbledon School of Art Life Class, wash drawing on paper, about 1948

Angel, watercolour on paper, 1948

D. said that I had tried to give the angel a good face.

Monday mornings. On one occasion I produced a sketch of a girl playing a cello on a hillside; this was criticised because 'It was not a realistic setting.'

The school organised a trip to Burghlere for third-year students. They thought I should go too but I was too embarrassed, not wanting to appear to show off about my father. The head criticised me for even thinking such a thing.

Life Painting, oil on canvas, about 1948

Christabel, watercolour on paper, 1950

She is the heroine of the poem by Samuel Taylor Coleridge. I tried to make her eyes look like the eyes of a snake:

> *A snake's small eye blinks dull and shy;*
> *And the lady's eyes they shrunk in her head,*
> *Each shrunk up to a serpent's eye*
> *And somewhat of malice, and more of dread.*

In 1948 or 1949 I dreamed I was in Berlin, and for some reason or other had to be Hitler's mistress. I didn't want to be, but had to. I remember some tall buildings arranged in a kind of block or circle. It was night. Just as I was turning into the entrance, I met a man and a woman smartly dressed in black who told me they were going to the opera house to see the ballet. They were hurrying along and I was glad to join them. The woman's head was bent slightly as she was holding her hat on. Inside the opera house was a red carpet leading down the main aisle and I was near the stage, facing the auditorium. There were ballerinas in long white tutus dancing gracefully. My father was standing at the end of the aisle and I suddenly felt that he was alone and that I must protect him and take care of him. I was struck by how small he was and I put my arm round his shoulder. I don't remember any more.

A year or two later D. and I were walking along the road to Hiltenfingen, near Thun in Switzerland. He was talking rather desperately about something, and I was thinking critically about him. I suddenly realised that he was desperately in need of my thinking lovingly and wholeheartedly about him, and strange to say, my whole attitude towards him completely changed from that moment onwards.

✳✳✳

I used to love watching D. drawing when I was a child, when he stayed with us in Mrs Harter's house in Epsom. She had offered her large living room to be his studio, so I'd come in every day after school to see his progress. When drawing a portrait he always started with the eyes and then worked out from there, moving out and up and down. I also noticed he was very careful about sharpening his pencils, using a knife to get a very fine point. He drew like Leonardo, the Renaissance type of shading which he learned at the Slade: a very fine line, full of meaning. He was sensitive about the shading creating the form. When he was drawing it was like meditation: the ego is nowhere around and you are the sole vehicle.

Shirin described D.'s drawing as 'a voyage towards a very definite destination':

There were never any doubts en route. I think his drawings were also like someone doing an experiment. You've got to get all the conditions absolutely right. When he was drawing he would hold his mouth in a special way as if it were full and he couldn't hold itself back from feelings welling up inside. The figure of Christ, in the Regatta picture, has the same expression – exploring and creating at the same time. I remember him saying that design was the image of the soul.

I also remember the way D. drew straight lines. He would have the canvas on the floor and lay his head down, keeping the pencil as a dot, while pushing it away from his eyeline. Using a ruler was frowned upon at that time.

This illustrates the poem by Leigh Hunt:

> *Abou Ben Adhem (may his tribe*
> *increase!)*
> *Awoke one night from a deep dream*
> *of peace,*
> *And saw, within the moonlight in his*
> *room,*
> *Making it rich, and like a lily in*
> *bloom,*
> *An angel writing in a book of gold: –*
> *Exceeding peace had made Ben Adhem*
> *bold,*
> *And to the presence in the room he*
> *said,*
> *'What writest thou?' – The vision*
> *raised its head,*
> *And with a look made of all sweet*
> *accord,*
> *Answered, 'The names of those who*
> *love the Lord.'*
> *'And is mine one?' said Abou. 'Nay,*
> *not so,'*
> *Replied the angel. Abou spoke more*
> *low,*
> *But cheerly still; and said, 'I pray thee,*
> *then,*
> *Write me as one that loves his fellow*
> *men.'*
>
> *The angel wrote, and vanished. The*
> *next night*
> *It came again with a great wakening*
> *light,*
> *And showed the names whom love of*
> *God had blest,*
> *And lo! Ben Adhem's name led all*
> *the rest.*

When he was completely engrossed in what he was doing D. could be quite severe. I just adored the ballet and I was a very good little ballet dancer until I was about twelve. I did a drawing of Pavlova's leg and foot, copied from a photograph with the utmost care and observation. I showed it proudly to D. and he simply said: 'You've done it from a photograph.' I was mortified – and since then I've never drawn from photographs again. In fact, I find it really difficult to draw from a photograph now because it's not the real thing, has no actual form, it's flat.

There was always conversation at breakfast time, and he'd often start talking about something really interesting and then in the middle he'd get up to fetch the Bible, because he just had to refer to it. I remember him telling the story of King David and Bathsheba, the wife of the Hittite: having caused the death of Bathsheba's husband, David then fathered her child. The baby became very ill, so King David fasted for days and days in order to do penance and for the preservation of his child's life. His people were very concerned about him fasting and then, when the baby finally died, went to tell him in fear and trepidation. But his reaction was simply 'Right, get me a bowl of water and a towel'. So they brought him a bowl of water and a towel and he washed his hands; he then said 'Bring me something to eat now please'. And D.'s point was, of course, that David had done everything he could while the baby was alive, so once it was dead there was no point in him hanging around and moping. There was no point in him going on fasting. D. felt that this was a lesson in doing what is necessary at the right time and then not hanging onto what is no longer there.

D. didn't suffer from self-pity. He had plenty of reason to be self-pitying, I suppose, but he also acknowledged his own responsibility for what went wrong in his life, particularly in his relationship with M. He was terribly upset when their marriage completely fell apart, and for some weeks and months he was quite distraught. He would arrive at the Rothensteins' house, looking rather bedraggled and would stay with them for several weeks at a time. They were very kind to him. Although he did talk at some length to Elizabeth, I believe, on the whole he was

Ezekiel in the Valley of Dry Bones,
watercolour on paper, 1949

quite private, certainly more private than people realised. For instance, when he was dying, his brother Percy came to see him. He was sitting in bed with his big old chest full of writings. He pointed to the chest and said to Percy, 'You can burn that'. Well, Percy didn't, and so all of this is in the archive at the Tate. I think he felt that he had revealed too much of himself; when he was alive people hadn't read what he wrote. Much of what he wrote was an in-depth explanation of his paintings, because there is a great deal of meaning in the pictures which is not obvious. Although they are public paintings, there is still some part of D. that isn't explained, some part of himself that he's kept to himself.

A lot of the letters in his archive were written to M. and quite a number to me. He made carbon copies of these. He also made many notes to himself, really just expressing his thoughts.

D. was always very absorbed in his own work and would often walk around with his head down because he was thinking about what he was doing, although he was also very aware of other people. As a young man he was quite fiery-tempered and very absorbed in all his ideas. But he was also thoughtful and considerate: he'd been brought up in a large family, sharing household duties, pushing his invalid mother around in her wheelchair and helping with cooking and cleaning – he played his part automatically. In later life he would notice if a sitter was tired or needed a rest, and was very perceptive about other people. He would notice little things and say to me afterwards 'I'm not sure if they're very happy together'. This is part of what endeared him to people: he focused on the person he was with in a quiet way, but they felt his interest. Within our family he was also quick to give help where it was needed: his eldest sister, Annie, was a gifted viola player who ended her days in a mental hospital. D. was the only member of the family who regularly visited her. D. was very sensitive and gentle towards Annie and seemed to feel her plight and would go and talk to her and comfort her. He would also visit his little cousin Amy, who was very disabled; she lived in Cliveden View, Annie's cottage that D. later moved into. Before she died, he'd go and check that she was alright. Then, when it flooded on Cookham Moor, he would get a boat out and row over to Moor Thatch to make sure that Patricia and Dorothy were alright. This was even after everything had gone completely wrong in that direction! He still found Patricia interesting – and in a strange way, after all the heat had gone out of the whole ghastly business, perhaps she was interesting.

He was also absolutely wonderful to M. Sometime around the middle of 1946, when I was in Hampstead with M. and she wasn't well, I remember that some people invited us to lunch. M. kept falling asleep and left the lunch table to sit on a chair by the fire. I felt terribly embarrassed and slightly irritated because I didn't understand, but D. wasn't bothered. He looked at M. and said 'Are you alright, Ducky?' but he wouldn't have apologised to the lady at all because he understood and accepted how M. was and he didn't feel he had to apologise to anyone. I would have felt very embarrassed in his position, and would have felt I had to say something. He had such innocence in those days; of course he did have to leave the Garden of Eden eventually and it was quite a shock to him, because it happened so suddenly.

Hampstead Scene, watercolour on paper,
1948

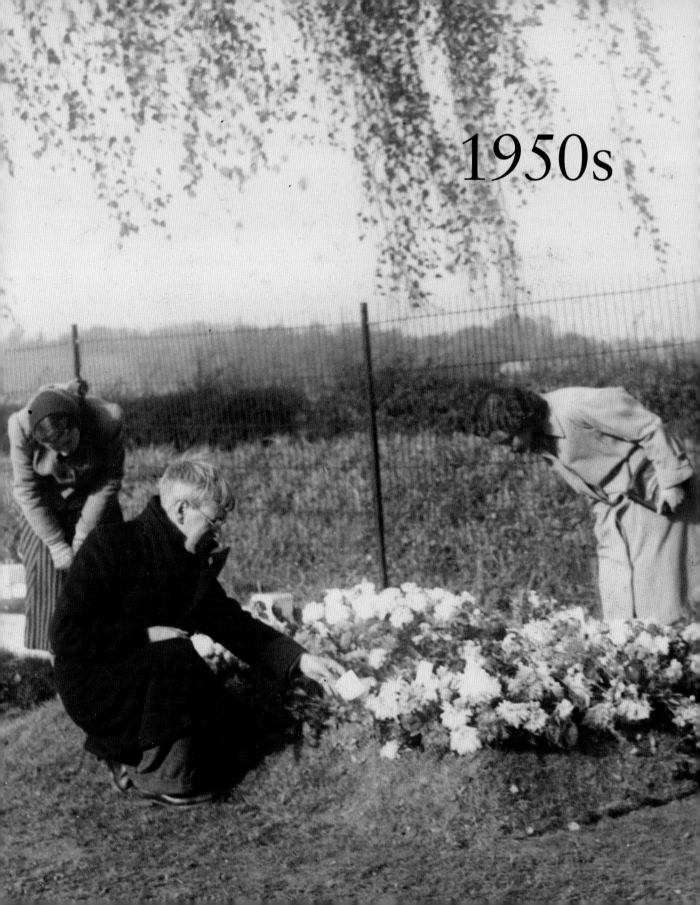

1950s

AFTER ELEVEN YEARS OF LIVING with Mrs Harter in Epsom, in 1950 I returned to Hampstead. In the space of four months a number of very important – and some devastating – things happened: Nancy married Dicky, I left Wimbledon School of Art and started at the Slade School, and my mother died.

<center>***</center>

When M. was so ill at Pond Street, Miss Arnfield was looking after her own father so D. moved up to Hampstead and slept in the house every night. He had his meals with Auntie Taffy nearby, in order to save Miss Arnfield cooking for him. During the day he painted and did any job for Miss Arnfield that needed doing, but he never went into the dining room where M. was because she would see nobody, D. included. She lay on the sofa under the window for weeks and weeks, refusing to eat anything. She would not see a doctor, until she was eventually taken to New End Hospital. It was a very worrying time. D.'s devotion was wonderful. Miss A. was always grateful for the way he was so considerate of her; she thought the world of him.

On 1 November I got home to Hampstead from the Slade, went into the kitchen and there was Nancy. 'How is Mummy?' I asked. Nancy looked very serious and said nothing. I ran out of the house and down Pond Street. I ran and ran past the shops, all the way up the long, long hill alongside the Heath, until I finally got to New End Hospital. I ran up the stone steps and when I got to the top I saw D. and the matron coming out of the ward. I knew that Mummy was dead. I let out an enormous howl, then our friend Daphne Charlton appeared. D. asked Daphne to take me back with her. She took me back to her house but I didn't want to stay, so I went home.

<center>***</center>

It never occurred to me as a child, because I saw so little of D., that he wasn't physically demonstrative. And my Uncle Dicky wasn't 'Uncly' in a demonstrative way. Whether it was the Victorian upbringing that Dicky and D. had that prevented them from being physically affectionate, I'm not sure. Yet I do remember the night M. died and I ran back into the kitchen from Daphne's house, Dicky came in and put his arm round my

Hilda at the Gate, Lindworth, bas relief, 1950

It was Shirin's idea to put this up in Cookham church in memory of M. It seemed a waste for it to stand on the chest of drawers in my bedroom.

Shirin, Stanley and Unity at Hilda's grave in Cookham cemetery, 1950

Poor M. She was such a good woman and had such a sad and difficult life.

shoulder spontaneously saying, 'Oh Unity, I'm so sorry'. Unfortunately on this occasion I was the one with a stiff upper lip, and simply said 'It's all right Dicky', trying to be brave, but almost without feeling. I later felt so sad at what I had declined to accept on this occasion, and how poor Dicky must have felt rebuffed. Yet I denied myself, as I have done so many times since that day.

A few years later Nancy remarked that she thought I felt M.'s death very much. I appreciated her perceptiveness and was grateful to her for voicing it. But I was so surprised that she had thought about me in this way that I said nothing much in response: for some reason I couldn't. I was dumb. It all stemmed, I think, from a form of repression I'd experienced over many years.

I didn't visit M. nearly enough when she was ill. I believed in her: I thought she was perfectly normal until one day Shirin told me that she

Pond Street Living Room, oil on canvas, 1950

Dicky and I bought the jug in Vicenza while on holiday in Italy; I still have it now.

Children's Party, oil on canvas, about 1954

An imagined scene.

was mentally ill. I felt I had let her down by not seeing her. When she died, Shirin and I inherited her half of 17 Pond Street, which had been left to her and Dicky by Granny Annie. So for the next eleven years I lived there with Dicky and Nancy.

Nancy was unfortunately a rather chilly substitute for M. and, since I was now twenty, I'm sure it never entered her head that I might need a mother. Had I felt more secure within myself I'm sure I would have left home at the age of twenty-one. I did ask Dicky for permission to do so, and set up home on my own, but he and Nancy were determined to keep me with them. I was told that I had a duty to the family, so, as well as the duty of doing the washing up three times a day, when not at art school or away teaching, it was my duty to mow the lawns and dig up the weeds. I painted the roof of the studio with pitch, and also the little shed roof where we kept the croquet mallets. I still have the thick denim overall to prove it. At this time it dawned on me that whenever I spoke about anything, my ideas, feelings or anything else, and then only at mealtimes, Dicky and Nancy never heard me. So I decided to stop talking, and only respond to them in answer to their questions. They never registered that this was what I was doing as I gradually learned to talk to them less and less, which confirmed to me that they – and particularly Dicky – were not interested in anything I thought or felt about things. Eventually I just stopped talking altogether, except to act as a kind of supporting role to their interests.

It was unnatural for me to talk so little and bottle up all the inner turmoils of my life: there were so many Carline family problems at this

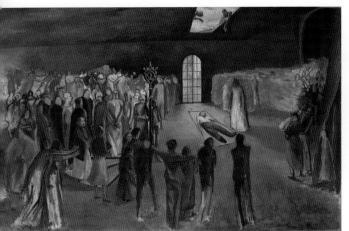

Christ healing the Paralysed Man, oil on canvas, 1952

Shirin at the Piano, lithograph, 1954

time, which I felt powerless to do anything about because I was not taken seriously. It was Shirin who pointed out, many years later, that if a child's needs and feelings are not taken seriously, or they cannot talk about important matters with their family, the only alternative may be to seek out a therapist. As an adult I was slow in overcoming the difficulties of my life that some people learn more quickly, but in the end I have learned a great deal not only about myself but also about others.

Although I was willing and helpful and tried to fit in with Dicky and Nancy, they didn't seem to know me. There was plenty of criticism, but little warmth or love or acknowledgement of the good things about me. I was so repressed that it was only when I finally left Pond Street that I realised that I had been 'used': much was expected of me in terms of responsibilities and so forth, but there was no joy. Although I could talk to Nancy, I was often used as a scapegoat or whipping boy. There are oceans of my life about which my family knew nothing. The anger I felt towards my uncle was actually for my father, but I had great difficulty accepting this and my feelings were all confused. Dicky and Nancy were unaware of how Mrs Harter had treated me as a child, her repression and dominance and the way she spoke about my mother. I don't know what they must have thought of me, because I said so little; as I had been taught to do, I would listen to them all the time but never expressed my own opinions.

I felt that Shirin never knew what Nancy was like to me because she was not concerned with my welfare either, especially where close members of the family were concerned, as she had to keep 'in' with them at all costs. I came to the conclusion that my capacity for love was my most valuable possession. Shirin had a way of being loving all the time, to the extent of not giving me a chance. There was no freedom for me, so Shirin's love wasn't altogether love at all, but something else.

It was only in the 1980s that I came to realise that my upsets with Dicky and Nancy and Shirin were all valid; that my father was not to blame for all my difficulties; and that we can all be responsible for ourselves as we grow up. In adult life we learn to become ourselves and to be responsible for our own wellbeing. But this can be very difficult if we are surrounded by powerful personalities who abuse, patronise or ignore us; don't believe us; kick us out; deceive us and others; keep things secret and hidden from us; are unkind to us; and, probably worst of all, are jealous of us.

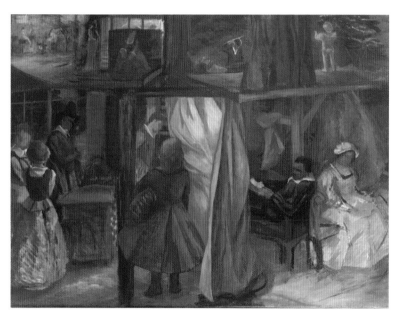

Rehearsal of The Merry Wives of Windsor, oil on canvas, 1953

The scene is backstage during rehearsals for a student production at University College London, of which the Slade School was part. Anthony Addison is conducting in the pit, top right. I am standing in the centre foreground, dressed in a coat.

Between 1950 and 1953 I studied at the Slade School of Fine Art, part of University College London. The course included more life drawing: I had learnt anatomy at Wimbledon, which helped me to understand muscles and bone structure. Drawing the figure is difficult. It takes patience and lots of practice and hard work. Every summer at the Slade we had to produce a large painting. My first was a 'behind the scenes' view of rehearsals for a college production of *The Merry Wives of Windsor*, for which I sang in the chorus.

Life Drawing, pencil on paper, 1952

Drawn while I was a student at the Slade.

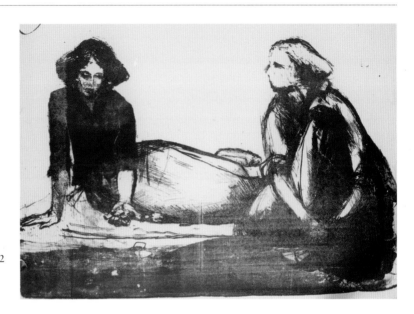

Girls playing Five Stones, lithograph, 1952

I am playing five stones with my friend Diana Cumming.

Mr Newitt, Camden Town,
oil on canvas, 1953

Mr Newitt was a pensioner whom a friend of mine used to visit. He sat with his hand to his ear, always listening out for the coal man, who never came. He could not afford coal. I used to take him wood for his fire.

One of my favourite artists is Goya. I first saw his paintings in the spring of 1951, when I spent some days gazing and thinking and absorbing them in the Prado. My main memories of Madrid are of the paintings I saw there: the Zurbaráns and Bosch's famous *Tabletop of the Seven Deadly Sins*, the El Grecos and Titian's *Venus and Adonis*. But all the Goyas, especially his extraordinary dream pictures, *Witches' Sabbath*, the children floating in the sky, and Saturn devouring his children. In spite of the appalling gory scene (and his mad expression), he looks as if you could drink tea with him on occasion. Goya's the man for me, miraculous and extraordinary. I think it was the psychological aspect of his glorious work that struck such a deep chord in me when I was young.

I returned from Spain a day late and missed an exam. My tutor, Professor Wittkower, gave me permission to write an essay on Goya instead of taking the exam. I described how wonderful this picture is and how wonderful that one was: I eulogised but could not analyse. Professor Wittkower passed my essay but commented that I had taken too much from Francis Klingender and his Communist ideas.

Similarly, Dostoevsky's novel *The Brothers Karamazov*, which I read on D.'s suggestion when I was twenty-four, made a profound impression on me. I knew in my subconscious that this was a very important experience in my life, reading that book. I wish people wouldn't talk about what goes on in our 'unconscious' minds. Even some professional psychologists say this, to my surprise. It's our *sub*conscious minds that contain unrealised feelings and valuable material, not our *un*conscious minds. After all it is our subconscious mind (or soul) that is such a rich

resource for so many of us (all of us, really). I love the story of Cupid and Psyche – the only Greek legend with a prophetic Christian flavour. At the end it says that the word 'psyche' is the Greek word meaning the soul, the soul that cannot die.

I remember asking my Uncle Dicky what was the value of art? He paused for a moment, and then said: 'It humanises us' (essential and true).

In about 1954 I dreamed that I was in prison, behind iron bars, and through these bars was a scene rather like a painting by Poussin but more real and less remote, fresher and greener. At the same time it was lonely and 'dream-like'. I was wearing my purple tweed winter coat. My uncle, Dicky Carline, and his mother (my grandmother), were hurrying along to see me. I felt very ashamed and guilty – I don't know what I had done wrong – and they were very disapproving of me. I don't remember either of us saying a word. Granny was in her usual black or navy blue and her large, high-domed black hat. She had been dead for several years when I had this dream. Dicky was in an overcoat. Looking through the bars towards a grove of trees was a large naked man in chains. He had his back to me and was sitting or squatting in a dejected way. He made a deep impression on me and I felt sorry for him. He connected with my guilt, but at the same time we were both isolated: he was a fellow prisoner. He had chains but no bars; I had bars but no chains. He was sitting on a tree stump among trees and grass, the variety that is fine, soft and springy. He was naked and I was fully dressed.

Finding life in Pond Street so draining and claustrophobic, I loved going to Cookham to stay with D. My letters back to Dick, Nancy and Shirin describe days of conversation, painting, theatre trips and socialising:

Self Portrait, oil on canvas, 1954

July 29 1954
Cliveden View
Cookham

Dear Dicky, Nancy and Shirin,

I arrived and Daddy came to meet me along the road having kept a look out from his window, most distracting it must have been for him, but nice for me. Daddy is very well and the house looks very nice and tidy. Daddy has got most of his Regatta paintings drawn out onto the canvas. It is worrying for him that he cannot do it larger. But the fact that he has got it down on canvas in the right order is something. I don't know whether I ever mentioned it to you but he first does a drawing and then does a tracing of the drawing which then has to be traced onto the canvas. It is a laborious business.

The Party, lithograph, 1954

I am standing on the right by the bookcase, talking to a friend, again sitting on the sofa, and again in the middle wearing a purple coat. Nancy, wearing a blue jacket, stands at the far end of the sofa. John Boulton Smith is on the left, saying goodbye to a woman in a green skirt.

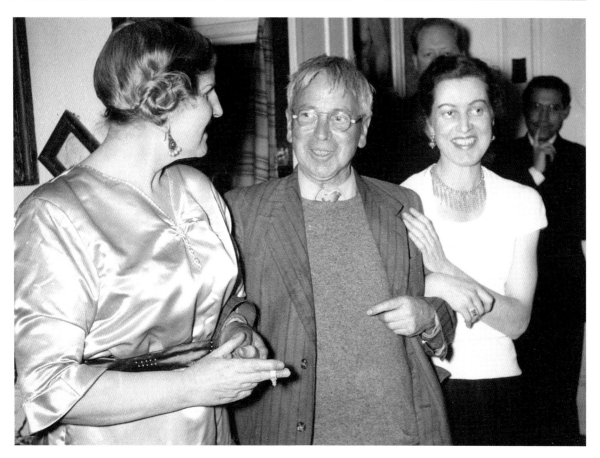

Daddy and I are going to Windsor to see 'Dial M for Murder', the play that Jas and I saw together. It seems funny to be seeing that one twice, rather than 'King Lear' or some other more important play. I think it'll be good fun nevertheless.

Daddy was pleased, Shirin, when I gave him your message about the canon and he asked what you were playing at present. I told him Scarlatti. He played a great deal to me yesterday, Bach preludes and fugues and part of the Hammerklavier. He played them in his usual slow way, but as you know he reveals so much to you about the music that way, which one would miss if played by a more brilliant person. He understands the wit of the music, doesn't he? He is the patient revealer of the music and does it so profoundly.

The weather doesn't look very promising.

Love to you all from
Unity

Mable Sharp, Stanley and Unity, about 1958

Mable Sharp was a great party-giver.

August 2, 1954
Cliveden View
Cookham

Dear Dicky, Nancy and Shirin,

Today the wind was blowing pretty hard and gave me a slight pain in my left ear. Mumps! No, I knew it was only the wind so I took a scarf in the afternoon.

You will want to know about a day for visiting Cookham. As you know, Daddy doesn't like making plans, he states the times when he was engaged, and leaves it to the other person to say what they will do and when, so I had better tell you when we are not free. Saturday evening Daddy has a cocktail party and on Sunday we are going to see some friends.

Daddy is looking very well at present and I think he is coming to London with a small wallflower painting to take to Tooths sometime this week. The landscape I'm painting at present looks much better in the dull weather: the colour is more intense and becomes weaker when the sun shines. The sun teased me the other day. I set out in bad weather and got to my spot; as I was putting up the easel the sun shone forth. I was nearly blinded by the glare of the canvas and whatever I did I couldn't see anything. So not to be beaten, I covered the canvas with a wash of terre verte. The sun was very disappointed at this and, seeing it was no use, he went in for the rest of the afternoon.

Letter, 2 August 1954

I've weighted down the easel with a bag of stones just like D. used to do.

black umbrella Daddy has an enormous which I find very useful when it rains. The country folk here are very nice & friendly & the labourers are very browny. They have no objection to one working in their fields!

One lovely evening in the early summer D. and I went for a walk across the Alfred Major Sports Ground, an open area of grass; we walked across a little path and through a hedge and then came to an enormous cabbage field. It was vast, stretching for miles in both directions, with a clear view of the slope up to the woods of Cookham Dean. I remember looking down at the reddish, Devon-coloured earth and the shiny centres of the cabbages and feeling really inspired. I told D. that I wanted to paint the cabbage field, so the next day I took my sketchbook and tried to organise the composition as I'd been taught at art school. D. said, 'Well, I don't know that that's the best way of going about it. It might be better if you just start with the first cabbage that interests you and simply move from cabbage to cabbage and see what happens.' So that's what I did, and people liked the painting very much. I'd never worked like that before: it was a very interesting experience, simply a question of relating the smallest bit to the next bit and spiralling outwards. It was almost an act of faith, but it's also very exacting: you've got to be very carefully observing and faithfully recording the shapes and forms and colours of every single detail. It's not simply a question of getting it down, muddling over it and coming back to fiddle about with the painting afterwards. I brought it home one day when it was near completion. When the farmers came to harvest the cabbages I asked them if they could start at the far end so that I could finish the painting. One of them wanted to buy my painting for his house, but he offered me a very low price so I brought it home and D. looked at it and he said, 'What have you gone and done up there?' pointing to a corner where, I explained, I felt it needed tidying up. 'Pity,' he said, 'it was Elysian Fields before.' I did sell it eventually, but before I sold it I tried to remove the surface paint with a razor, just a little bit, in the hope of revealing what had been there before. As D. said, 'You hadn't the wit to see what you'd got.'

The Cabbage Field, oil on canvas, 1954
(Private collection)

August 11, 1954
Cliveden View
Cookham

Dear Shirin

Thank you very much for your postcard. It's quite alright with us if you come on Thursday the 19th. We might be able to get in touch with the Behrends and visit them during your stay.

Daddy has been taken off this afternoon to start his portrait commission. He is going to paint the wife instead, which is far better than the old man who fidgeted. If he can get it done in six sittings it will be worth the money. Nearly every day Daddy gets a letter from either a young down and out or a student who only wants to paint 'the truth', etc., begging for help, or else a commission to do a landscape for £30, or would he see Mr so-and-so from India, etc., etc.

The weather is hardly worth mentioning, is it? Yesterday I struggled across several fields with my bags and canvas, which was

like a huge wing, and the wind blew me over sideways. I eventually reached the cabbage field. Daddy thinks it's a huge joke me painting these cabbages. He says by the time I get going on them they will be full grown daddy cabbages and then they will be gone.

Bring a pair of wellington boots with you when you come. The countryside looks wonderful and the fields of corn are a wonderful pink colour. The corn is not ripe enough yet and should have already been harvested. It is lovely at night to be able to see the moon and a wide sky without the hindrances of street lamps.

I am sorry I am undecided about going to Venice. I should very much like to go with you and Dicky but I would also like to try and get some work done during the remaining part of the summer out of doors in Hampstead. I would like to do some small paintings in Queens Crescent. I've had it in mind for a long time and it seems a pity to let it go by. It seems a pity to let Venice go by also. I asked Daddy if he would like to go and he said it was very kind of you to ask him; he appreciated it but felt that he wanted to get on with his work more. I do hope you will find someone to go with you.

Apparently Carol Weight (I'm sorry if I've spelt it wrong) has done a very good painting of 'The Betrayal' (I think). Daddy has seen it and was telling some friends of his at supper last night about it: he was most impressed. How's 'Life on the Mississippi'? Daddy was quoting something from it the other day. I get extracts so far from Fair Haven, the Golden Ass, Arabian Nights, Holy Bible and others. One learns a lot that way, especially during the washing up.

Please give my love to Nancy and children.

Looking forward to seeing you.
Love from Unity

Painting props for a play at the Downs School, 1955

My first teaching position was the The Downs School, Colwall, Herefordshire, where I arrived to teach art in 1955. The first term was good but the boys became very naughty, taking advantage of my lack of confidence. They had adored my predecessor, Mr Field, whom they

Painting Scenery at The Downs School, Colwall, oil on canvas, 1955

nicknamed 'Parsie'. I had kept their work with Mr Field up on the walls, something for which he later criticised me when he came back on a visit. I was very nervous but bravely stuck it out for a year and a term.

I remember standing on a platform on the Underground waiting for a train with D., in my early twenties, and he turned to me with a severe expression on his face. He told me that Hilda had said to him that punishment was sinister. I was puzzled, so he repeated it, and I absorbed it. He then said, 'It's not the things that other people do to us but the things that we do to other people that hurt us'. This was a real eye-opener to me: I knew that this was important, and that he was

Boys in the Classroom at The Downs School, Colwall, oil on canvas, 1955

speaking from the heart. It reminded me of his belief that 'When Hilda says something, it seems to be right'.

In 1958, looking at *Christ Preaching at Cookham Regatta*, I remarked that the children squatting on the end of the barge, facing Christ, looked like little frogs that had jumped up out of the river. D. quoted this to a journalist and was very annoyed when a headline appeared saying 'Stanley Spencer says children are like frogs'.

He did make ethical judgements, but on the whole, I think, he was very accepting of his everyday neighbours and friends. He was a true village person but without the gossip, which didn't interest him, and didn't judge people. Certainly he found some people infuriating, such as

Stanley and Unity, 1959

Mrs Harter when M. became mentally ill: he wrote to me about how she put on a particular kind of face and solemn voice: 'Oh Lord, the face and the voice you know!' He felt that Mrs Harter was judging M. for her illness and it annoyed him intensely.

He loved his encounters with people in the neighbourhood, like the village lady he greeted on the way to the cemetery who had some garden shears in her hand and said to him, 'I'm just going up to give me mother a clip round'. He had another story about a woman who went to the vicar because she wasn't at all sure she was forgiven for her sins. The vicar tried to reassure her, saying 'God has said that you're forgiven,' but she said, 'Yes, but have you seen him say it with his own mouth?' And D. said he could just see it: he put his fingers and thumb up to his mouth, opened and closed them and said: 'This is God's mouth proclaiming that you are forgiven!'

He wasn't really interested in politics: he had his principles, but would happily talk to anyone. He read the *Daily Mail* simply because he liked the 'Flook' cartoons. He found conventional behaviour a bit tedious because he felt it was a barrier against something much more real and interesting in a person. He certainly had standards and principles, yes, but not concerning appearances. I would sometimes clean his shoes or suggest that perhaps he ought to brush his hair. He would carry a ghastly cloth hat around with him to protect him against the rain. It was the most hideous thing, like a flowerpot on his head, and he looked totally ridiculous. I wonder now if it wasn't almost a kind of naughty rebelliousness in himself, as if to say

'if you think I'm plain and ugly, I'll really show you'. But in photographs of him as a young man without the glasses, he had a very refined, almost beautiful, face. Of course I think he suffered from being small and no doubt the village lads teased him a little, although he did play football on Odney Common, just kicking the ball around with other boys.

In winter D. quite often wore his pyjamas underneath his trousers to keep warm. This seemed to shock conventional people, but somebody told me many years later that working-class men did that all the time: if they'd got to get up early and go to work somewhere they'd just keep their pyjamas on and pull their trousers on top and off they'd go. He always wore a conventional suit with either a waistcoat or a v-necked jumper and a tie. The suit may have had a little bit of paint on the elbow but otherwise it wasn't too bad.

I don't think D. always saw himself in a very good light, if his paintings are anything to go by. I don't think this was a big problem for him, though. In *The Beatitudes of Love* series he sees himself as rather small and a bit desperate, overpowered by all these grand women, some of whom were very odd-looking. But he seems to be a bit unsure of where he is with them, which is probably how he did feel. Where his work was concerned I think he was absolutely convinced and secure, but in the world generally I think he was a bit nervous. He was brave, as people have to be, and would get on with the job. For example, he wasn't at all keen on aeroplanes but he bravely flew all the way to China because he felt he had an important job to do.

He seemed to be able to adapt to change; it didn't seem to bother him too much. I think his imagination was so powerful that that was much more important to him than what was actually going on around him. For example, he would be painting some part of Cookham from memory that was full of meaning for him, and then he'd go there and be surprised to find that it was quite different. His imagination was so powerful that it rose above the changes that were taking place in Cookham. He may well have noticed them, and even felt a bit sad about them, but it was never so overwhelmingly upsetting to him as it would be to many of us.

He lived in the present and could just pick up a conversation with people he hadn't seen for many years. I suppose what with the trials and tribulations and then the war, people got separated. But then after the war, in the late 1940s and 1950s, he'd meet old friends again and just carry on where they had left off. He wasn't sentimental – he could be emotional but he was never sentimental.

It was quite a change at the Royal Investiture at Buckingham Palace. Usually everyone turns up in either morning attire or their Sunday best. And, dear me, on what good behaviour!

It took an artistic chap to step out of line...

And it was none other than the king of the Bohemians himself – Stanley Spencer. He strolled into Buckingham Palace to receive his K.B.E. from the Queen Mother... carrying a battered leather shopping bag. With Sir Stanley was his daughter.

Press cutting, summer 1959

*Caryatids and Workmen, St Pancras
Church, Euston*, oil on canvas, 1956

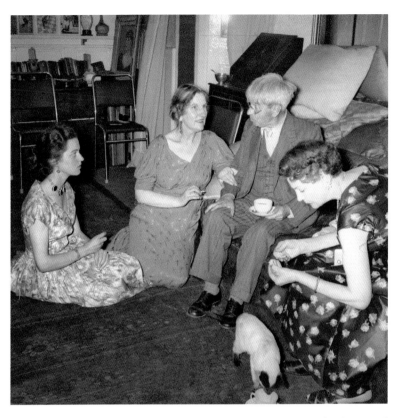

Unity, Mabel Sharp, Stanley and a friend
at one of Mabel Sharp's parties, 1959

Sometimes D. would come out with observations completely out of the blue about the situations and people that struck him. One winter's day he and I went for a walk on Hampstead Heath, starting at the bit where the Heath begins at the bottom of Pond Street. It's a wonderful walk, with tall, tall trees towering over you – they've got even taller over the years, of course. It's like being in a cathedral – in fact, I believe that Gothic cathedrals were based on trees. We walked along and on the right there was a dark, crimsony brick wall, quite high, which I suspect must have been along the bottom of someone's garden. But you don't think about what a wall is, necessarily, it just has an atmosphere. We were walking along and D. was saying something about the mysterious atmosphere of this wall. I thought, yes, I agree with him: you don't know why it's there or what it is. Then we went further up the Heath towards the Pond towards the Vale of Health and he said, 'Oh, that's the tree where Paul Lightfoot hanged himself'. This always shocks me: I don't connect D. with morbid thoughts. But there was a fellow student with him at the Slade called Lightfoot who did commit suicide. D. must suddenly have remembered this terrible thought.

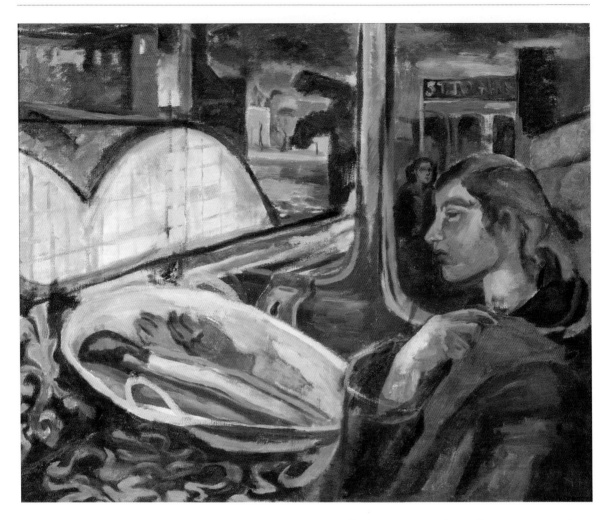

Travelling between Two Worlds, oil on canvas, 1959

Between 1956 and 1961 I had a part-time job teaching art at Bedgebury Park School, a girls' school in Kent. It was always a struggle to get the girls to apply themselves, and I worked hard at getting them 'stuck into their art'. One of the girls in my class lacked imagination and I wish I had done more to help her, while another went on to the Slade. I continued to live with Dicky and Nancy at 17 Pond Street, commuting to Kent by train.

My first experience of mental illness – depression – was in 1956. I can remember sitting like a child, at D.'s knee, in the dining room of the house in Pond Street. D. was wearing a navy overcoat and sat near Nancy, who was in M.'s chair near the window. The house and all it represented frightened me.

Unity lying on the Bed, etching, about 1969

When I first became depressed I was filled with terror, fear and anxiety. One of the things that had happened was that, since I felt myself to be powerless over my life (this was a subconscious feeling that affected me), I somehow felt that I had to put my life into my paintings. I did this to some extent because there was no one for me to confide in. *Travelling between Two Worlds* is an example of my trying to make sense of my sad and despairing life (not showing on the surface at all, of course). I created an unreal feeling in my daily life – or rather, my 'art' and my daily life, my aspiring and my despairing, got muddled up. Amazingly, through this nervous breakdown I managed to continue my part-time teaching job, travelling to Kent by train first thing on a Monday morning and returning on a Wednesday evening. At some point during my recovery I was talking to a counsellor about it and it seemed that my separation from my life rather than my involvement with my

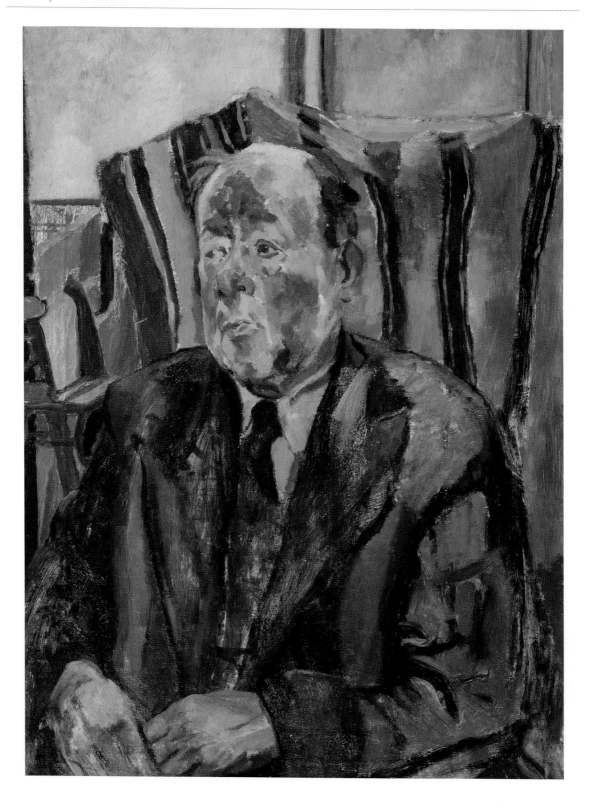

art, was the danger. At the onset of this first bout of depression I lost my sense of identity, and this was a frightening and painful situation.

I did not end up in a hospital, but for nearly a year I was very inwardly disturbed and suffering from appalling nerves and heart palpitations. My illness showed itself in an expressionless or anxious face and agitated behaviour, which I tried desperately to conceal from my uncle and aunt, since they were so lacking in sympathy for this kind of illness.

What's the good – if I'm well and happy, people leave me alone. If I'm depressed, they leave me alone. What can you do?

During the autumn of 1958 my state of mind deteriorated seriously. I still managed my part-time teaching job, but it was only Nancy's determination and lack of understanding that kept me at it. I was so frightened of her, and had to go on conforming, though by this time I felt that life was becoming more and more unreal. I had heart palpitations every time I walked up the steps of 17 Pond Street to unlock the door and enter the house – my house, Shirin and I owned a quarter each, Dicky the other half – and the palpitations only left me when I opened the front door and went out. I was terrified of going to sleep at night, for fear that I would never regain consciousness and would be lost in oblivion.

Dicky and Nancy had no idea of what was going on inside me and only saw a rather withdrawn, gloomy-looking young woman moving around the house, doing the usual chores rather more slowly and deliberately than usual. They thought some of my questions and comments rather silly; nothing showed of the appalling turmoil that was going on inside me. I found that I could not smile, however hard I tried, and that all my energy was consumed by inner conflict and anger, although at the time I could not understand the anger. I did recognise how bitter I felt and said to myself, 'You must experience this, you must not pretend you do not feel it, you must suffer it.' I think some instinct told me that if I allowed myself to suffer these feelings they would gradually ease off; it was also a relief to have some sort of 'real' feeling, however painful, as it made me feel more of a person.

I made plans to visit Seville that Christmas, with two Roman Catholic ladies. The holiday did nothing to improve my state of mind but it was good to have a break. While I was away I had a telegram

Psychiatric Patient at The Royal Free Hospital, Hampstead, oil on canvas, about 1958

Spanish Boys watching me drawing them,
lithograph, late 1950s

St Christopher carrying the Christ Child,
lithograph, about 1952

telling me that my father was seriously ill but that there was no need to return before the end of the holiday. I was appalled to find that I felt very little apart from a great sense of guilt at my lack of feeling. I made a deal with myself that if need be I would fly home to see him. I was terrified of planes; but in this case I would not let the plane frighten me. Fortunately, my father recovered without me having to fly home.

While I was in Seville I got talking to some chap in a café who was very keen on bullfights. Dicky had always told me about the extraordinary spectacle of bullfights, the mystique, the atmosphere and the idea behind it, and I thought that sounded fascinating. I thought I'm sure people will think 'Unity doesn't want to go and see a bullfight' – or at least that I shouldn't want to – but I was suffering from delayed adolescence I think, and I was absolutely determined to see one. So I went with the Spanish man and to my horror we sat very near the front row. When I got back home, somehow I felt I should admit to D. what I'd done. He was drawing on one of his big canvases on the floor in the front bedroom at Fernlea. I said to him, 'I went to a bullfight.' He looked up at me and said, very severely, 'It's just sex, it's just sex.' I felt thoroughly ashamed and awkward: I didn't deny it, but just absorbed what he said.

In my imagination, men were a group of rather marvellous beings who inhabited another planet. In my twenties I fell for a man six years younger than me. He was a bit too esthetical for me. He was passionate but otherworldly, and this frightened me. We met on a bus a few years later, by chance, and after we'd said 'Hello' he said 'I love you. I really love you.' By this time I had had a baby, but his love for me was ungrasping. We never saw each other again after that: I would love to know what happened to him.

I remember being kissed by a boyfriend on Hampstead Heath on a seat and was shaking with nerves because of the conflict between guilt and wanting to enjoy it. The next day I went to church with friends and felt very ashamed. Luckily I confided in them and felt reassured by their good humour and more balanced view. The curate had been preaching about our baser feelings, or rather against them.

I had uncomfortable and frustrating experiences with another boyfriend, Michael, some years later (my sister didn't help as she had such strict ideas about not walking arm in arm with a man unless you are engaged but she was not a prime cause of these difficulties). Anyhow, this fellow was many years older than me, and could not decide whether to marry me or not. I was pretty desperate by this time and didn't know what to do. He lived in a basement room with a cement floor and you could hear people walking along the street overhead and see their feet through the iron and glass grid. He ended up in a psychiatric wing of a London hospital, where I went to visit him. I was nervous about what I was going to find when I saw him, and went in my one and only black duffel coat. He was sitting up in bed. He had no money but was anxious for me to buy a chicken for one friend, and a small turkey for another (it was near Christmas). I was bewildered and tried to reassure him, but did not carry out his orders as most of his reality was in his own imagination.

When I was twenty-nine my doctor asked me if I liked men. I paused briefly and said rather thoughtfully, and with a question in my voice, 'I find them fascinating.' I could not bring myself to say that I liked men, because deep down I must have felt, for the first time consciously, that I didn't.

A day out in London, early 1950s

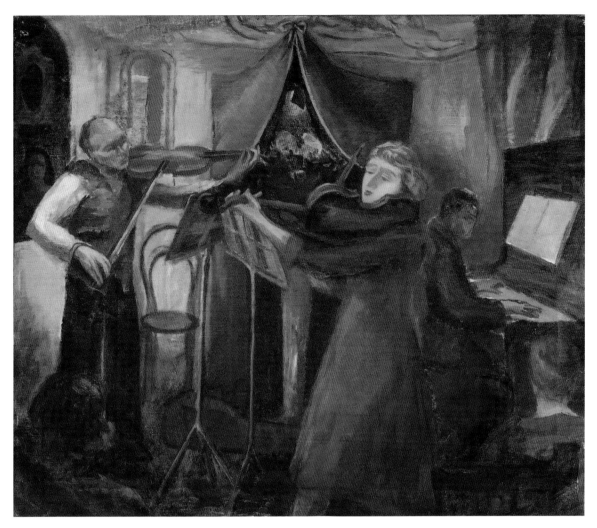

Ernest Jones's Party, Hampstead, oil on canvas, 1959

My father needed to be alone a great deal, not because he had a 'monkish' temperament but simply that he had to go into himself and rummage around and walk about inside himself; this was his source of strength and conviction. He often used to remark to people that he needed to 'surface a little', like a fish coming up for air. The interesting thing to me is that he needed times of what he called 'introspection': it was as though he were plumbing his own depths. Yet anybody – no matter who – who chanced to meet him at any time, found him absolutely 'alive' and on the spot. He could be involved in a situation in a second, without thinking twice. He also loved to be deep in conversation – quite often at a party he would be huddled in a corner with some elderly lady, completely engrossed, while the charming young society hostess would be both amused and slightly put out because her star turn was not very much to the fore.

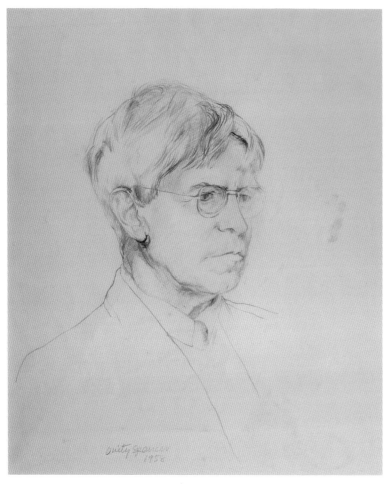

Portrait of Stanley, pencil on paper, 1957

He liked children and was quiet and gentle with them. He got down on the floor with them and entered into their world. It is odd that his genius took him away from us. If he had not been, he would have stayed with us. But genius has such a powerful pull.

Although he loved visitors, and often felt terribly lonely, D. also felt broken up if someone called just as he was 'rounding the bend' in a painting. Considering the amount of interruptions of so many kinds that he had in his life, his output was colossal, especially as he had no apprentices like some of the Old Masters. I once tentatively offered to help him with the donkeywork, painting some of the pebbles in his picture of *Christ Delivered to the People*. He was very sweet and considered for a moment, and then with a little heave said, 'I think I'd better do them myself.' I helped him a lot by going through his hundreds of drawings. I would get very absorbed or carried away by this one or that and he would expand on it, because he had got the response he

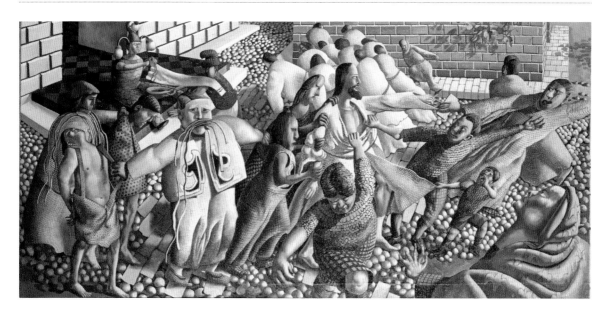

wanted from someone else. Nothing mattered to him more than that a person should really understand his paintings; in fact, he would almost judge a person by whether they liked his work or not. Perhaps this is dangerous to say, but he longed for people to look at his paintings even more than listen to him. People became very fascinated by him, and young people and students in particular would hang on to every word he said. I think this was because he made each individual feel that they had tremendous powers within themselves, and that they could also be geniuses, each in their own way. I miss him tremendously from that point of view, his wonderful appreciation of each person's individual character.

He also found apparently small things very moving and thrilling – the way Mrs Kate Morrell stroked her son's hair off his forehead from behind his chair, when he was hot and bothered about something; Nancy's specs and the way she looked through them, which reminded him of his mother. If he was drawing a particularly charming young sitter he could be almost carried away with a blissful feeling. I used to have rather the same feeling when I was teaching at the Downs School. I used to make drawings of the little boys in my class while they were working and I felt seduced by their eagerness and freshness and the fact that they were all potentially men: they were charming, but the fact that I didn't matter a scrap made them all the more fascinating. D. also had a very gallant attitude towards women: he loved them and respected them. In the last mellow ten years of his life he had no wife or woman to comfort him and I remember him saying to me that he lived like a celibate. This can't have been easy, but he had a remarkable way of

Stanley Spencer, *Christ delivered to the People*, oil on canvas, 1950 (Scottish National Gallery of Modern Art, Edinburgh)

Get-well-soon card sent to Stanley during his final illness by his neighbour, Minnie Smith

The message continues inside: '... and will soon be out again'.

solving his own problems. For example, when he was in hospital having a very serious operation he had to undergo all manner of disagreeable procedures, to say nothing of daily injections. If he had allowed himself to think about all these things at once, he could scarcely have coped. But instead he told me that he looked so far and no further: he didn't think, 'Oh dear, I have forty injections ahead of me', but rather, 'Today I have three injections.'

D. and I never argued and always got on so well, without any undercurrents or hurt feelings or misunderstandings. Once, when he was lying in bed a few weeks before he died, I was sitting in the room with him and he said something a little sharply to me – understandable in a very ill man. I replied in a rather hard way. It was unkind, but I was trying to detach myself and not love him quite so deeply. I regretted my sharp remark but it was soon forgotten – at least I hope so. D. certainly gave that impression, although no one could tell what he was thinking, not because he was secretive but because he had lost all his energy – and he was also always considerate of our feelings.

When I visited him in hospital I could hardly speak to him. I was a little fazed since he seemed a different person, a rather wonderful being. I usually kissed D.'s hand when I came in to see him and he would give me a sweet, fatherly smile and then continue his alert conversation with Percy or whoever happened to be visiting. In hospital it was an awful shock to see him so gaunt. I remember just looking and looking at him as he ate his pudding and wondering if I would ever see him again. He was sweet and he asked the charming nurse for a spoon for me, indicating with his finger in such a characteristic way the bit of pudding that I could have. To me it was like a little sacred ceremony eating this pink pudding together, like drinking from the same glass, or Holy Communion. There was never a flicker of sentimentality about D. all this time, not one.

I wrote my last letter to D. just two weeks before he died:

Nov 30 1959
Bedgebury Park
Kent

Dear Daddy,

It was lovely seeing you last Saturday and nice seeing Uncle Percy too.

I have just been glancing through some essays that the children have written for me. They are so funny, especially the ones where you know that the poor child has hardly understood a word of what he has written, e.g., in referring to Botticelli one child writes, 'He was one of the most original of painters, a creative genius, fantastic restless and vehement, an artist who in his passion for expressive line often overshot the mark… the very mixed pleasure caused by his works is a kind of nervous vibration,' etc. etc. It made me laugh so. Anyhow it makes them look at the paintings for a few minutes.

I wrote to the French boy who visited, and sent six of your reproductions. I told him a few things about the Resurrection to help him know what to look for. You may say that there was no need but I think there was as it was a small reproduction. I pointed out the Africans resurrecting and Mummy lying in the nest of ivy and also standing by the river on the top left corner…

Yesterday evening after supper we went to join a little Advent ceremony, which was very nice. But according to one boy, Johnny, it was not in the strict tradition because they lit four candles instead of one. I can't see the point of changing a tradition just for the sake of doing so. Anyhow, it was sincerely done and we sang an advent hymn.

It did help to restore the balance, because this morning I saw on the side of a bus, 'I'm dreaming of a white "label" Christmas'. Isn't it dreadful! How can anyone enjoy Christmas when it is turned into an advertisement?

Well Daddy, I hope you can read all this writing and I hope you're feeling more comfortable and that you manage to sleep at night. I think of you a great deal.

Lots and lots of love
From Unity xx

On 14 December 1959, the day before D. died, he said: 'If I could have my life over again I would learn from the Africans. We know a little about art, but not very much.' Although he was so weak and frail and spoke often in a whisper, he was so tremendously on the spot. It was quite extraordinary how he changed. One minute he seemed out of this world, with a peaceful smile on his face, writing with his hand in the air (if he had not been so dear to us it would have seemed even more strange and mysterious), and the next minute doing everything slowly and quietly but with a practical mind attending to practical matters such as where to place the chair for comfort for one of his visitors. He placed Shirin in her chair and me at the foot of the bed. This seemed to me the most suitable place for me, at the foot of my father's bed. His last remark to me as I left the room – and I was the last to leave it – was to ask me to close the window as it caused a draught on the red cyclamen that was standing on the table. Under this fearful circumstance, where our hearts were breaking and numbed, here was D., always master of the situation in a quiet and simple and direct way. A few minutes earlier he had put his arms around us and kissed us so lovingly. Because he was never very demonstrative to us in his life, we felt this special act of love for us very deeply; without admitting it to ourselves, we were nevertheless warned that we were saying goodbye to him.

My father seemed to me such an incredible person that to state all the wonderful and beautiful things about him would only belittle them. M. always loved everything about him dearly and passionately. To her he was pure and true, without an atom of falseness. She knew that he possessed something very rare and wonderful, what one friend described as 'white', for want of a better word: a purity and integrity of soul, a courage in revealing himself, and a wish to be in harmony with everything and everyone. He wanted such perfection from this relationship that any slightly jarring note or disagreement upset him. If he was inspired to express an idea or opinion about something and received an opposite opinion, it was like having a fist thrown in his face; he could never understand why people made a point of disagreeing.

Shirin and I received hundreds of letters of condolence from all over the world following D.'s death.

HIGH BERRY.,
HAMPSTEAD,
SAINT MARY,
JAMAICA. W. 1.

11th, February 1960.

My Dear Unity...this is a letter to you both but alas! I cannot
spell your sister's name. Forgive me for not writing to you sooner but,
I could not bring myself to write about so distressing a matter. May be,
you both know how greatly we loved Stanley and, to realize that we will
never see him again is to us a lasting grief. You had a wonderful
parent and I am glad that the world appreciated him. He will go on as
long as time as we know it, lasts. How utterly sad to think that one
so gifted and so lovable should die so young.

Stanley gave so much to so many and in consequence he derived
much from life. His fund of knowledge of life appeared to spill into
every aspect of human thought. Dickory and I have listened entranced to
his wise councel and, during the period that he stayed with us at
Chauntry Court it was a joy to be awakened by the soft, so soft, playing
of Stanley on the piano..you know that he was always an early riser.
Again the long times of just sitting when he was painting our
portraits was enlivened by his skilful conversations. Do you know that
he would quote word for word entire passages from the Bible? Painting
was his life and both Dickory and I are happy and honoured to have known
him for so many years. Much he finished but, alas! so much he has left
unfinished. The world and posterity will remember him by his paintings
but we, his intimate friends will remember him because of that inner
spirit and charm, that essence which was Stanley, as well as by the visual
perfection of his paintings which will continue all our lives to give us
joy and a sense of wonder..and this will be in our home always.

Often he spoke to us about his daughters..he was so proud of you
both..proud of you both as individuals but also very proud of your
achievements.

Bless you both and our love and sorrow that so great a person
should have died.

yours Ever

Edmund Frank

*P.S. His last gift to us - Two self
portraits, drawings which he drew
at a young age are a joy and
fine examples of his draughtsmanship,*

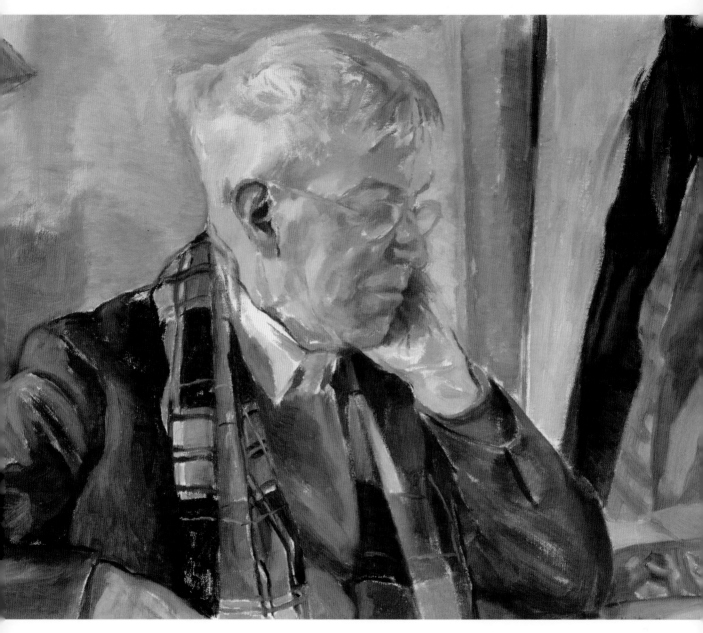

Portrait of Stanley Spencer, oil on canvas, about 1957

D. ased me if I would like to do a Kopf of him, saying that he would have to read a book to keep himself occupied. Christ preaching at Cookham Regatta *is part-unrolled in the background.*

He had an extraordinary stillness, especially, I noticed, when he was standing on the bridge on Cookham Moor, looking at the swans and the still surface of the water. He loved that bridge and as he walked along he always had a very steady, purposeful step, at the same time pondering.

I realise now how truly gentle and understanding he was and wish I could have done more for him. When I was with him I was always deeply aware of his gentleness and understanding, his generous appreciation and genuine pride in me. He also had great courage, bearing suffering of any kind inside himself. Shirin has the same courage.

The evening D. died I was staying at the vicarage. I had a sudden urge to walk round Cookham village on my own. I did so, feeling the place and communing with it. This was round about 10 o'clock at night. It was that part of the village I was aware of most, full of my infant memories with my father. When I returned to the vicarage, Revd Michael Westrop came in shortly after to tell us that D. had died. I knew then that my little walk in the village was in communion with my father.

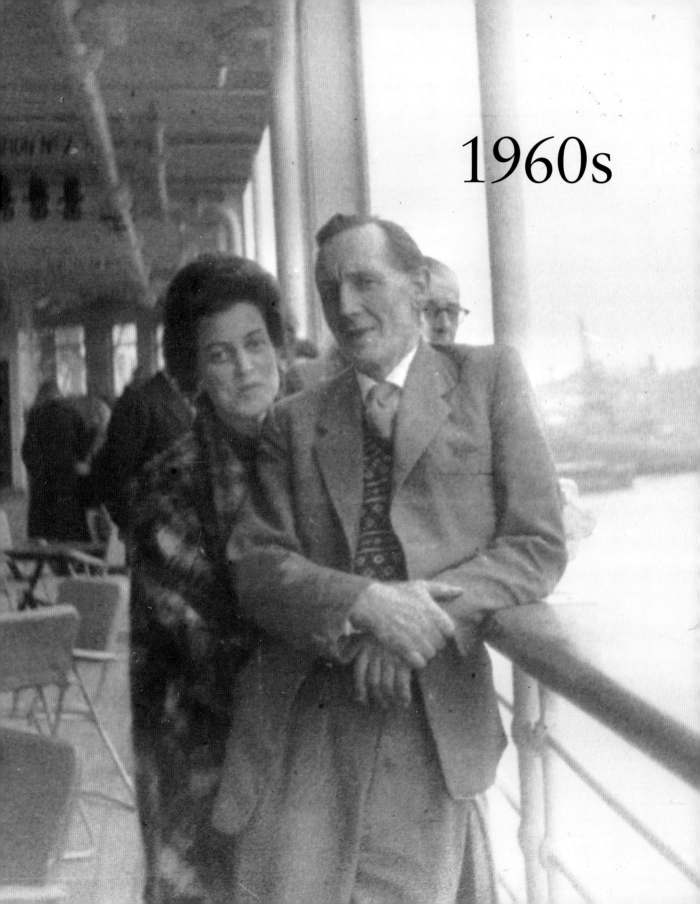

1960s

I
N LATE 1960 I JOINED THE IVS – the International Voluntary Service – because I was struggling with the claustrophobic atmosphere of my home life in Hampstead, where social problems were only ever related to artists. I wanted to discover how other people lived, and do something active about it. I spent two summers working as a volunteer in Germany, and in 1963 took part in an Aldermaston peace march with my baby son, John, in a pushchair. I marched from Reading to Maidenhead in the rain, with people standing at the side of the road criticising me for doing so – but John was perfectly happy.

The IVS work camps abroad were really enjoyable and interesting experiences. I also spent several weekends volunteering in London, redecorating old people's homes. I was never too happy about the soundness of our work: if I had my way, we would have been more thorough. The other volunteers were an odd mixture, some of them driven by their guilt complexes. One day in early 1961 I was making sandwiches for homeless people in a hostel in London, when I heard a voice behind me: "'Ello Love, I've seen you before.' I turned round, to come face to face with Leslie Lambert, a fellow volunteer, who was to blight the next decade of my life. At fifty he was almost twenty years older than me, but I was attracted by his friendliness and, I suppose, by his interest in me. He seemed to me an honest working-class man, warm-hearted and idealistic – a Communist Marxist Leninist and a member of the Salvation Army – with a social conscience and a determination to fight 'the system'. It wasn't long before I realised that he was moody and unstable, but I still felt that he would look after me, which I felt very much in need of at the time and because of my past experience with men I had come to the conclusion that 'beggars can't be choosers'. On 3 March 1961 I wrote in my diary:

> Dear Les. Bless his kind heart, I love him. A somewhat bewildering person, with simplicity at the base of him. As a friend says, the goodness in him is encrusted and obscured by knotty bits and pieces. When I look at the photo of him as a young man with his father it makes me ache to see him as he was then…

From very early in our relationship Leslie wrote many letters to me. His early letters are full of his theories about life, his thoughts and aspirations, soul-searching and self-reproach – and his feelings for me, which ranged from declarations of love to irritation and, eventually, to deep anger.

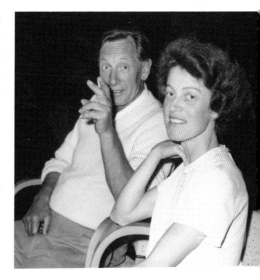

Leslie and Unity, about 1961

Unity with Leslie, about 1961

Letter from Leslie to Unity

My dearest Unity

A letter is poor consolation A very inadequate substitute written in one mood read in another unless it is so strong that it carries its own mood and invokes Anew it must fall flat.

Unity my sweet? It is such a long way from understanding to acting what is called reasonable. For me there seems no way from the one to the other.

I know what you want and what you want to give, it is clear to me and fair, it is the love and companionship which makes and gives happiness.

The man who did not go through the forest, because it was out of his way, did not find the crock of gold …

… since I last saw you I have worked and settled many problems, the chief of which is humility, and clarity, hence no phone, no letter … I shall refrain from all temptation.

Cheers my sweet, love and Xs,

Leslie John

Leslie may have been unstable but would never admit to any mental problems and was able to con people into believing what he said.

Dear Unity

Please try to understand, I have no excuses, I was too confused to appreciate your feelings…. I thank you for your loving sympathy kindness and understanding please think of all mistakes and the advantages I took as the emergence of a bird from the cage, U have made me very content and happy no more confused prostrations terribly worried as how to best strive to act in adult quiet way, to help not hurt. I sincerely care for you, my feelings for you of complete unselfish desire to have you as a friend in understanding. Who will find in me every virtue I have lost.

You are wonderful … I now know where I am going, and have to control myself, thanks darling you are indeed a sweetheart, darling, and a great character, please be patient I hope to repay the debt I owe you.

Loving kisses, passion and joy be ever yours,

Leslie John x

Les constantly nagged me into getting pregnant. After a year of knowing him, I finally decided to allow pregnancy to happen. I was a virgin of thirty-one when I met him and thirty-two when I became pregnant. Our son, John, was born when I was thirty-three years old. Les was shrewd enough to know that I wanted the child, and I thought we would get married. I was living in an attic bedsit when we met, and he 'dossed' down with me. Although my landlady found the situation awkward, as none of this was my 'scene', she was very tolerant.

By this time I had already had a nervous breakdown – or my first bout of real depression – which frightened me, but with therapy I had come through it. None of my therapists or social workers expected me to find myself shacking up with someone like Les, so my new situation was a surprise to us all.

The effort to control my anxiety and be the person Les wanted me to be became all-consuming and exhausting, until I began to feel that I was losing the ability to express my feelings at all. On 20 March 1962 I wrote in my diary: 'I used to write with so much passion. Now I don't. Perhaps my equilibrium is right at the moment. Yet passion is such a vital part of life and this is something my father possessed.'

In the same diary entry I wrote about my love of Beethoven – throughout my life I have found great consolation in music, as D. had. My diary entry for 20 March 1962 continues:

Beethoven was a saint when he wrote the Pastoral Symphony (especially conducted by Bruno Walter, who brings out so beautifully all the undertones and phrases. One is aware of the melody and the wonderful construction underneath, instead of, as so often happens, a rollicking tune on top of a confused mass underneath). This performance is delicate, broad and expansive, full of joy and expectancy. The timing and precision are wonderful and accentuate the eternal beauty of this symphony. It is often more difficult to express happiness and joy than tragedy, etc. Daddy had a wonderful capacity for joy and was able to express it in his paintings to perfection, and in a way I have never seen it expressed before. I believe music and movement were as much a part of his pictures as form, detail and composition in the physical sense, all based round his basic idea.

My life with Les continued to be difficult and my diary entries for this period are full of anxiety and soul-searching as I tried to analyse my thoughts about him and about our relationship – and how best to react to his demands:

July 8th 1962
I want a man to have some purpose in life, something that keeps him perpetually interested, because if he has this, his wife will always have an underlying feeling of security and confidence. But for a man to say to you (as I have had said to me) that he wants to make you his life and study you, is most alarming, even though it may be flattering to one's ego and in some ways reassuring, because you think or hope it means that he will always try to understand you. And I rather stupidly always hope to find a kindred spirit. But when someone says they will try to study you and make you their life, you become suspicious, wondering why they felt the need to say it. Surely this is something that should come anyhow, with love, and need not be spoken about all the time? But I think my dear Leslie can't help talking. I am incapable of uttering all my inner thoughts, not because I want to keep them to myself, but because I would get so worn out continually speaking my thoughts out loud.

Les tended to dominate conversations, depending on what he wanted, unless he needed to win the person over; then he would use charm. However, he did do kindnesses for people, such as driving an old lady somewhere.

One day in July 1962 we were discussing D.'s use of colour and whether or not D. was a colourist. I immediately thought of the general attitude to colour at the time and the criticism that D. 'tinted' his pictures. The traditional norm seemed to be the French Impressionists' use of colour. But D. did not follow any school, he just mixed colours as he saw fit. When John Boulton Smith discussed D. with Les, he said he did not like the colours of D.'s latest paintings because they reminded him of boiled sweets. I understood what he meant, but to my mind D.'s colour is so original and evokes such a very special atmosphere peculiar to him (and at the same time to me), expressive of his home and environment. I reminded Les that D. got all his inspiration from 'home', and for him that was Cookham. Les said that it was also the Cookham

light that inspired D., which is perfectly true: he often remarked on the light there. I would say that Cookham's light meant as much to him as the place itself.

The reason why D. wasn't a colourist in the sense that the Impressionists or Poussin were colourists is because he was primarily concerned and passionate about form, which can be revealed to its fullest capacity by means of light. Some artists would use colour to reveal form, but they tended to use the light yellows, etc., for the light parts and cold greens and blues for the dark parts. I remember Jas Wood pointing out to me that strong sunlight takes the colour out of objects. I was sitting by my window looking at Les on the sofa: the light shining on his forehead and arm and cardigan made the colours very anaemic and bright, the part of his face in shadow was very dark but rich in colour. I was curious to know what Jas thought of the colour of D.'s

Press cutting, 15 February 1962

Oh dear.

Paul Tanfield

LOOK OUT for shocks from the NEW Spencer

I HAVE exciting news this morning for the art world, now settling back cosily and smugly to life without the shocks of Sir Stanley Spencer. We have not finished with the Spencers yet.

His 31-year-old daughter **Unity** is painting too—and in the very sphere in which her brilliant father caused so much controversy. Courageously, she is putting religious subjects into modern settings.

Small, shy Miss Spencer stood under one of her pictures at home in Hampstead last night and said: "I wouldn't have dared to paint it while my father was alive.

"It's called *The Last Trumpet.* Those are angels up there and these are my friends sitting on the bank at Cookham.

"From the middle of the river a puntload of Sunday afternoon

trippers were being spirited upwards.

I was reminded of the day in May 1959, a few months before Spencer died when the small silver-haired painter led me up the stairs of his house in Cookham High-street to show me his last great work which he left unfinished

"I call it *Christ at Cookham Regatta,*" he said.

EMBRACE

Since her father's death at 68 Miss Spencer has felt a new confidence in her painting. Some of her work so far only exhibited in Hampstead will be shown this weekend at the Stanley Spencer Memorial Gallery in Cookham, together with some pictures by Sir

UNITY SPENCER
Never dared to show father

Stanley's friend and patron, **Viscount Astor.**

"One of the pictures I'm exhibiting shows rows of cabbages at Cookham," she told me. "I'm not showing *The Last Trumpet* though."

I picked up a picture of a young couple embracing—"No, nor that," she said.

Miss Spencer who scorns make-up and wears *sensible* shoes, was a little embarrassed.

She hesitated. "These are

Study for *The Baptism*, watercolour on paper, about 1960

Port Glasgow series. I had discussed them with Nancy, who gave me courage to admire their colour, which to her was rare and beautiful. I was so pleased, and learnt so much from Nancy's fine appreciation.

To me there is something almost jewel-like and soft about D.'s colours, suggesting the quiet jewels that are nearer to pebbles on the beach, and moonstones and pearls. But I always find his colour original and evocative, whereas most modern colourists bore me, because I've seen all their colours before. In July 1962 I took Les and a friend to an exhibition in Hampstead and wrote in my diary the following day of my disgust at the imitation Cézannes and Picassos hanging there, and the ghastly, infantile efforts they had stuck into expensive-looking frames and then had the audacity to charge 20 guineas for them. I was appalled:

> You could see the so called 'artists' standing at the back, a superficial, hypocritical lot of materialistic sods!!!! They are doing so much damage to art because of their selfish, petty, puffed-up attitude. Occasionally you find a genuine picture among them, but no doubt the public pass those ones by and flock to gaze at ghastly still lifes of shining oranges and apples painted against a black background to 'show off' the artist's prowess (as he thinks) in painting all the

shining lights on the fruit. I felt like getting Courbet's *Still Life with Apples and a Pomegranate* from the National Gallery and putting it beside them to teach both the painters and the poor onlookers a thing or two. I hope to God they don't sell.

In the same year I was commissioned to paint a portrait of Eric Torrence. I did two little sketches to help me to plan out the painting without making unnecessary beginnings and mistakes, and as a guide to the right proportioned canvas. Luckily Eric had a clear idea of the position he wanted to be in and the chair, and light. I liked the mixture of day and night light on him, as it was a softer, more gentle effect, which suited the sitter and also gave more feeling of depth. It was Eric himself who raised the matter of depth in a picture, which led to a discussion: I was interested that he should consider this important (which it is). I said that the sketches would help me to achieve this, as I did not want to fall into the same pitfall as I had when painting old Mr Gilmore, a patient in the OT Department of Hampstead General Hospital. I painted Mr Gilmore's face with great intensity and feeling, but weakened over the feeling of depth, even though I painted the background, as I thought, faithfully. Apparently John Boulton Smith told Les that this particular painting lacked depth, although it was very good in other respects. This criticism made indirectly to me taught me something where portraits are concerned: it is easy for me to become preoccupied with interpreting and portraying the sitter, but the abstract three-dimensional aspect gets left out.

I also made a note of the rest of the conversation during Eric's sitting in my diary: 'Eric spoke most interestingly today about creativeness, homosexuals, Jews and religion. He is a thoughtful person, not given to making hasty judgements.'

By February 1963 I was pregnant and finding life with Les utterly exhausting. I continued to use my diary to express my unhappiness and try to find some answers. In my entry for 3 February I wrote:

I suppose I expect far too much out of life and out of people. In actual fact I don't but I expect Les to understand me if, as he says, he loves me. He does love me and he is wonderful to me and would do anything under the sun for me, but our arguments or so-called discussions, as far as I am concerned are not only exhausting but utterly futile. I suppose I cling to Les because he gives me a sense of security because he is loyal and I feel he would never leave me, but what a cowardly attitude I have. I know I have a horror of marrying a man and then it all breaking up (because of poor darling Mummy and Daddy I suppose) but what's the use of marrying a man because he is good to you if you suddenly feel poles apart from him on certain levels. I think Leslie is a very understanding person, but there are times when we are at complete and utter loggerheads. I feel so heavily weighed down at this precise moment that I couldn't care less about anyone. It won't last, but the cause for this momentary depression is so unnecessary and need never

Study of Leslie, Cookham, pen on paper, about 1964

ditto.

have happened. I want harmony and understanding and for an appreciation of differences, not for differences to be sneered at. At the moment he is preparing a meal possibly for this evening and I am sitting here feeling bloody blue, but he has no right to talk for an hour and only allow me five minutes to put over my point before he starts on the next volley. Why does one have to 'get one's way' by subtle means? Many women do. I suppose it's their only hope but God how I hate it. I don't really know what I feel about Les and this is the hopelessness. I've tried and I don't know what to do, I feel as tho' I were cheating. Probably this is all a great mountain out of a molehill and I would be utterly lost without him but why am I afflicted with some absurd ideal which doesn't exist?

Les often looked very sweet and even beautiful when he was sleeping, and reminded me of a hedgehog, an animal I am very fond of. He had a lovely and attractive smile. I was aware that it must have seemed fantastic to my various old Pond Street friends that I should have anything to do with a man like Les, but then I felt that they hardly knew me except at a very superficial, sociable level, since I had never had a wish to confide in them. And they knew nothing of Les other than what they could see on the surface.

In February 1963 he concluded that his nervous energy was completely exhausted – about a fortnight after it had become blatantly obvious to everyone else. Although it wasn't an easy thing to do, I wondered whether I should take a firmer hand with him.

During the time when I was pregnant and renting an attic bedsit in one of Olga Guedatarian's Hampstead houses, I had a vivid dream. A woman in black, looking rather like a witch, was punting a boat through torrents and floods of water. She was not malevolent. I was caught up in this somehow, but can remember little except that the flood seemed endless. There were trees and banks by the river. She steered the boat very cleverly.

At 6.15am on 13 May 1963 my son, John, was born. Early that first morning I remember holding him and saying 'Hello Darling'. I had only just come round from the anaesthetic, but it was a wonderful experience, to know this little mite at last, even though I was so dopey and could only see his sleeping face dimly. He was so sound asleep. A marvellous, profound sleep, full of wisdom, and complete innocence.

The day after John was born, Minnehaha wrote me a letter:

May 14, 1963
Epsom

Unity darling,

I am perhaps rather late in the uptake, but when you were with me I had no idea! It was of course a bit of a shock to me as things are. But this is so unimportant really. I mean what I may think or feel is beside the point! What I feel really matters is that you and your son are well and happy and will always be blessed! I long to see you with him. I am so pleased to think that Shirin is with you at the moment in Cookham. Being there does mean that she will not be against you any more, and I am sure she will gradually understand your point of view in all these troubles you have gone through. Only she must not wear you out, she is somewhat authoritative!

I am thinking of you so much all the time and of the baby son. Also Les. I know he will always look after you both, but how glad I will be when you are married, for the sake of the child! I am trying to picture you with a baby in your arms: I wonder if you had ever handled one? I was an aunt when I was 10 so had plenty of practice before I married! Will you call the baby Stanley?

Gwen has just come in and sends her love. I must stop.

Ever so much love
Minnehaha

My mother had a very special smell, which I loved: sometimes she smelt cold and fresh from outside; late at night she occasionally smelled of cigarettes (not her own, but other people's). This made her slightly more exciting, hinting at where she had been and who she was with. When John was tiny, Shirin remarked that she loved his smell, and I must say I did too. I often kissed him because of his lovely smell.

From a letter to Mary McColm, a Quaker friend:

> I feel I must put in a good word for psychiatry and therapy. They do their best under difficult circumstances. I am still an insecure woman, very insecure at times. So is Shirin but our temperaments are so different that we cope with our insecurities in different ways … you rebel in your youth and/or are awful to your parents, though probably not as awful as you make out. At least there was sufficient security in your home life for it to be safe for you to rebel. But unless we rebel we do not become fully independent. I did not rebel in my teens, unfortunately, but did so at the age of 29 to 31 … rebelling at 29 was a very distressing experience … because it was not really acceptable at that age.

Having been unable to rebel in my teens and early twenties, it wasn't until I was in my late twenties that I began to experience a kind of adolescence. Certainly in my teens and twenties I had to be independent, living away from home for much of the time, but I was too insecure to attempt any sort of rebellion – and any such thoughts were soon quashed by my Uncle Dicky. I began to re-question things again in my early thirties, but by this time I had a small baby to love and care for. I was immensely grateful for him but to be an adolescent young woman, and a mother, desperately trying to keep up the appearance of being an adult and trying to do what was expected of a woman in her thirties, was very distressing. I was searching and searching for enlightenment and hope while living with a man who could not relate to people and who was permanently adolescent at the age of fifty-odd.

Les's adolescent behaviour took a different form from mine. He thought he knew it all, and told everyone so. He needed to dominate, and did so. It was impossible to have a normal, rational conversation with him about anything. He was totally at loggerheads with himself and with me: however hard I tried to help or to be what he wanted me to be, or to do, it was wrong. I would clean a room thoroughly and he would come along and complain that it was badly done and do it all over again. Or he would show me how to do something that I already knew how to do (and I could usually do much better than him anyway). But these things were exasperating and bewildering. There were other things about Les which caused me, by nature already nervous, to feel so frightened and worried – and of course it was important not to show one's fear, as this was part of his intention.

I came out of hospital with John when he was ten days old. Our little family – Les, John and I – went straight back to Cookham, to Fernlea, the house where D. had grown up. We had moved there shortly before John was born. Here Les enjoyed working in the garden: he appeared rather ruthless and brutal in the way he went about it, but the plants thrived and the grass grew. He loved flowers and planted them quietly but carefully. He also had an instinct about cars, although not a trained mechanic, and could put them right. He was a very good painter and

Leslie and Unity leaving hospital with John, 23 May 1963

Diary entry, 13 May: My baby was born this morning. John Spencer Lambert, 6.15am.

Diary entry, 23 May: The baby and I came out of hospital this afternoon. Francis Davies to supper.

SIR STANLEY

The love of an artist's daughter

❝WE DON'T AGREE THAT MARRIAGE IS THE ONLY ANSWER❞

Baby for Miss Unity

By BRIAN PARK

Unity Spencer—her baby is 6½ lb.

FIFTY - YEAR - OLD ex-trade union official Leslie Lambert set to work yesterday with a bucket of whitewash to smarten up the cottage where the artist Sir Stanley Spencer—"the rebellious genius"—once lived.

He said: "I'm getting the place ready to welcome home the artist's daughter and our newly born son." He had just written the announcement: "On May 13 to Unity Spencer, a son, Royal Free Hospital—John Spencer Lambert."

In splashed overalls, tall Mr. Lambert stirred the whitewash and said:—

"We are all absolutely thrilled—and that goes for the dozens of friends Sir Stanley had round here during his lifetime.

"The baby is a wonderful little chap, 6½lb. We are calling him after me because, as artists, Unity and I don't agree that marriage is the only answer for couples in love.

"Anyway, Unity wants to keep her father's famous name to help efforts she is making to preserve his most famous paintings and writings for the nation."

Sir Stanley's old home, Fernley, is in the centre of the picturesque main street of the Berkshire village of Cookham. He spent his life in the village, producing masterpieces and causing upsets among fellow members of the Royal Academy.

Trust

The cottage was left in trust to his daughters, Unity, who is 34, and Shirin, 38, on his death in 1959.

A month ago Unity and Mr. Lambert moved from Hampstead to live in the six-room cottage.

Mr. Lambert said : "Unity and I met three years ago at an International Voluntary Service camp and have been together ever since.

"I decided to give up my job as an organiser for the Transport and General Workers' Union and help her with her mission to preserve her father's masterpieces in England. It is a full-time job."

He waved an arm round the room : "This place is full of memories of Sir Stanley — the cups and saucers he used, his favourite ornaments, even six of his original line and wash drawings. No, that banjo on the wall was not Sir Stanley's. It is mine.

"Round the corner from Fernley lives Lady Patricia Spencer, Sir Stanley's widow and second wife.

No contact

Mr. Lambert said : "Unity and I have no contact whatever with Lady Pat. Unity and I might get married sometime but first she wants to complete her task of preserving her father's work.

"Of course, I will have to get a divorce myself first. I have a wife from whom I have been separated for many years.

"Unity's sister Shirin, who teaches music, is coming here to live with us after Unity comes home with the babe next week. I am sure we will all be very happy together.

"Unity is an artist in her own right. She has just sold a £200 painting of St. John the Baptist and she has a commission to paint a former mayor of Paddington."

Later at the Royal Free Hospital in London he joined Shirin at Unity's bedside. He said : "She is longing to get home with young John to her father's old cottage. We have so many plans for the future."

200 walk out

❝I NEED TWO WIVES, SAID SIR STANLEY❞

UNITY'S father led a somewhat unorthodox life himself.

Much of it is told in letters and writings he left.

And in the biography by Maurice Collis, published a year ago, it is revealed that until he was 29 he had never kissed a girl.

Then, at 32 he married Hilda Carline, mother of his two daughters.

Four years later he fell in love with painter Patricia Preece.

Letters he left showed that he was beginning to be obsessed by the idea that sex was all-important.

DIVORCE

At 45 he was divorced at his own wish. Then he suggested to his first wife—before his marriage to Miss Preece — that both women should have rooms in his house.

"I say I need two wives," he said.

Before he was married to his second wife a week he was also back with his first and the second marriage broke up.

He wrote his first wife endless love letters. He kept writing them in passionate terms even after her death.

He rowed with the Royal Academy, made it up and was knighted in 1950.

His two most talked-of paintings were "The Resurrection," showing the dead rising from Cookham graveyard and "Christ Preaching at Cookham Regatta."

He was still working on the picture showing Christ in a black straw boater when he died.

Liner races to aid hurt seaman

The 13,816-ton liner Pretoria landed at Southampton yesterday an injured French woman who had been hoisted aboard from a trawler in the

Wife's man No. 1 sues

BEAUTY QUEEN Mrs. Elizabeth Schaefer, aged 28, who returned to Britain from America to find that she has TWO husbands, is being sued for divorce—by husband No. 1.

He is weight - lifter Mr. Norman Hibbert, whom she met on holiday at Nuneaton, Surrey, and married nearly nine years ago.

He is alleging misconduct, and the man he is citing is husband No 2—ex-Mr. Universe Raymond Schaefer, whom Mrs. Schaefer wed in 1957 after an American divorce from her first husband which is not recognised under English law.

The man of peace and war

LORD BEAVERBROOK

DAY IS MAY 25

LORD BEAVERBROOK'S birthday, May 25, is to be celebrated as Lord Beaverbrook Day in New Brunswick for the second year in succession.

The provincial legislature has decided that it will again be a school holiday, and a proclamation officially designating the day appears in the current issue of the Royal Gazette.

The Gazette pays tribute to Lord Beaverbrook for his "innumerable contributions to the educational and cultural advancement of our province," and refers to the world - wide respect and admiration for his accomplishments in war and peace.

Lord Beaverbrook will be 84 on May 25.

Farm research

Britain's first university department for the study and teaching of agricultural marketing is to set up at King's College, Newcastle-upon-Tyne with Government aid, Mr. Christopher Soames, Minister of Agriculture, announced yesterday.

THE SKIPPER WHO LOST HIS SHIP

A SKIPPER who earned more than £100 a week yesterday faced a new life as a £12-a-week deck hand.

He is Bill Stores Gregson, who rose from a 14-year-old deckhand to become Fleetwood's youngest trawler skipper at 22.

He heard a Ministry of Transport inquiry at the Lancashire port describe the explosive failure which led to the loss of his ship. It lost him his command for three years and he was also fined £200.

The inquiry into the loss last November of the trawler Ella Hewett found that Gregson, now 33, had committed a "grave error" in allowing his ship to be placed in the hands of his mate.

The trawler sank after straddling the wreck of the sunken cruiser H.M.S. Drake off Rathlin Island in the Irish Sea.

omething's aking Britain brighter !

YOU CAN'T RE-SHOOT MOMENTS LIKE

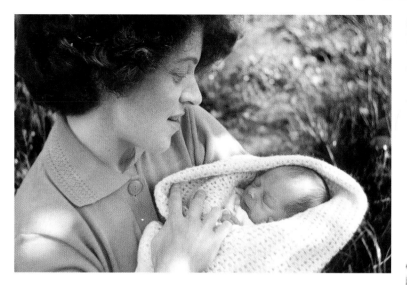

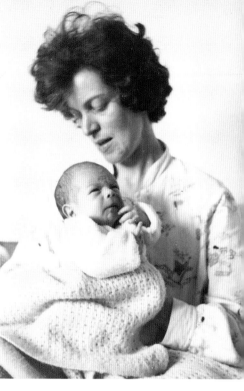

Unity with John in the garden at Fernlea

Diary entry, 26 May: Lovely peaceful day. John slept in the garden.

Unity with John, 1963

decorator (but definitely not an electrician, builder or tiler). As someone shrewdly pointed out, he had to be everything or nothing.

My life in Cookham was pretty grim. I was after all a single mother, so my social life was practically non-existent. Les was a terrifying person to have a relationship with, and caring for and protecting my child made me particularly vulnerable. He used mental cruelty to his advantage, though in the end I proved stronger than he thought.

What others think of me now doesn't matter. My parents in Heaven know who I really am. I have a very clear memory of the family, going way back to when I was a little girl of three or four years: Granny, Miss Arnfield, Dicky and of course M. Shirin was always possessive of the Carline family and tried to manipulate me where their property was concerned. She thought that Cookham was right for me. How could she?

Shortly after Les and I moved in to Fernlea I had a letter from Shirin saying that she had been advised to impose a lease for Fernlea upon me while she travelled in Africa. This caused me huge anxiety and distress: if she got married and stayed in Africa, would I have to write to her there and ask whether my lease could be renewed, depending on and in accordance with her wishes? I would, of course be looking after her home (shared with me) and carrying out her repairs. Until that point I had always considered what would be best for her and thought that Fernlea would be a home for her to come to whenever she liked. If we found in the course of time that we could not make a go of it together,

Daily Express, 17 May 1963

then one of us could buy the other out. We discussed the plan at length, and I felt completely dominated as Shirin told me things, 'as an elder sister', which were 'for my own good'. I felt that we had gone right back to our childhood, with me completely controlled by my sister.

May, our cleaning lady, answered the door to me and I spoke to her in the hall. I heard movements in the kitchen, which presumably must have been Nancy, but she didn't come out to say hello to me, no doubt from a guilty conscience. Dicky was much the same: as I walked up the stairs to Shirin's room I could see his back view through a half-open door and said in an audible voice 'Hello, Dicky.' But he made no reply; so I went into Shirin's room to see how she was.

All through the previous autumn I had called regularly at the house in Pond Street once or twice a week, with Jean Gilin, a Hampstead friend, to read through my father's manuscript. Not once were Dicky or Nancy anywhere to be seen: they were too cowardly to face me. Shirin had not told me a thing about the manuscript my father had written at great length for his autobiography: she had been reading it to him before he died. It seemed rather curious that my sister refused to tell me anything about my father's writings. I was well past the age of twenty-one twelve years ago. Shirin had probably forgotten, if in fact she ever knew, that she and Dicky were co-trustees of the properties of which my share was equal to hers. She utterly refused to discuss any of these important matters with me.

My son did not just 'happen'. He was far from being a mistake. He was intended. I actually knew the minute I conceived him. I was not married and my situation was very difficult. In 1962 it was still a disgrace to be a single mother. I suffered from severe anxiety, confusion and a frightening experience of slipping away from reality. I saw a good psychiatrist and gradually began to feel less frightened of men. I was frightened of them because I didn't understand them. I didn't know what men were like, having been brought up in a world of powerful women. I didn't understand men's thoughts about life, nor did I know

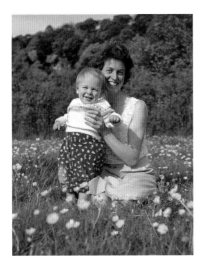 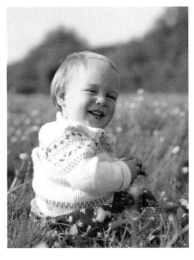

John and Unity in Cookham, spring 1964

and others were rarely seen because we were too far apart – or for other reasons. These were, of course, small problems, and if my life at the time were a more contented one, no doubt they would soon disappear. Having tried so hard to put my life 'right' following D.'s death in 1959, and having, I felt, misused this opportunity, by October 1964 I was beginning to find it desperately painful to live with my mistake. I acknowledged that my situation could be very much worse, but inside I felt so lonely and had lost my sense of purpose in my attempt to keep going. On 16 October I wrote: 'If God exists, my Faith is being really tested now.'

To make matters worse, I found that I couldn't seem to put my thoughts and feelings into painting: I wasn't able to crystallise anything by means of art. In desperation, I began to feel that there were oceans of me that could never be expressed.

By 30 December 1964 I was questioning whether I had made use of Leslie to have a child. But he kept on telling me that this was what I wanted, which was true. John was now eighteen months old and I was hoping to have another child. Once again, I turned to my diary as I tried to resolve my feelings:

> Les says I must not marry him till I want to for his sake. He also says that it is getting too late to have another child, so my summing up of this whole affair is that Leslie got me pregnant in order to ensure his own security with me for life, whether married or unmarried. I had an instinctive feeling that he never meant to leave me, even tho' he was so boastful about it. He still goes on about the 'wiles' of women. He must be thinking of other women, not me as I've never led any man up the garden path, quite the reverse.

Unity and Sir Frederick Lawrence, 1963

*Sir Frederick confessed that he had at first
thought the portrait made him look angry.
I told him that I was not a bit angry while
doing the painting: 'I enjoyed doing it.
Only an angry artist would paint an angry
expression.' Sir Frederick said, 'That is
the kind of reply one would expect from a
young lady of her talent.*

Where Does the Duty Lie? Fernlea, oil on
canvas, 1964

*I was torn between playing with John and
doing the washing up. The truth is that
washing up was easier.*

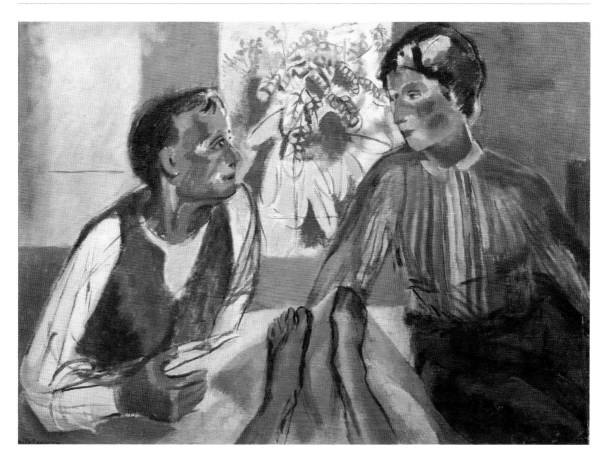

View from the Pillow, oil on canvas, 1965

I was ill with the Cookham bug. Leslie was desperately worried, so he ran out into the street and met one of our neighbours. She came up and they sat on either side of my bed. One of my legs looks alive and the other one looks dead.

During the spring and summer of 1965 I had a thousand ideas for pictures but got very tired and could only paint at a certain speed. John, now two, was becoming very demanding, constantly asking 'where has daddy gone?' and crying. I felt that I could give John what he needed, but Leslie's needs were too great for me to fulfil.

I have all my life exercised some discipline over myself where painting is concerned. It is also necessary for an artist to browse a little, to meditate a little; I have always been brimful of ideas but never seem to have the time to carry them all out. This was especially true in these early years of John's life. On one occasion Leslie said he realised he should treat me differently and asked me in what way he could help, but then completely forgot my reply. He would always find some inadequacy or fault in me and then magnify it. If I was actually painting, this made things impossible for me: an artist is not a machine. He would also talk about me in general terms – 'A woman does this, that and the other' – and always talked in generalities

about marriage, for instance, prefacing his remarks to me with 'what you have got to understand Darling, is …': but I understood all right.

Leslie was a good organiser, wanting to direct me and everybody else. I felt unable to stand up to him without feeling angry and hurt. Although I tried to arrange my time to fit in some painting, with an unpredictable and very energetic two-year-old child, this was not always possible. For a time I had a marvellous Spanish au pair girl, but of course she needed free time. I found Cookham draining.

By this time the deepest emotion Leslie stirred in me was anger. The doctor told me not to chastise myself, but all the things he pointed out to me made me feel inadequate. I enjoyed going out to visit people without Leslie so that the conversation could flow. If he was there Leslie would speak for me: for example, he would ask Dr Hopkins to explain the effects of drugs on my brain and mentioned our hopeless sexual relationship.

One day Dr Hopkins asked me about Cookham Day nursery: we hadn't paid the bill because Leslie had wiped the floor with me for paying the electricity bill. He would plan things out as though I didn't exist, such as driving the car with John at the wheel, handing John to me when he saw a policeman. Leslie and I could never have lived together if we had no money: Les would shout me down whenever I spoke the truth, he shouted down other people who spoke the truth, and he shouted his point of view to convince himself that most people took what he said with a pinch of salt. He would tell me I was wonderful one minute and launch a vicious attack the next.

Les was always reluctant to go abroad for a holiday, preferring simply to go to Labour Party conferences – having said to me 'I'll take you anywhere you want to go'. He decided that we had become estranged and that I was blissfully unaware. One night in September 1965 I had dream in which my bitter animosity – my animus – left me for Australia. This preyed on my mind for a week, after which I phoned some friends and arranged to stay with them for a week. On my return home I felt altogether different and clear in my mind. But Les, in his usual, tactless way, immediately plunged into planning an exhibition of my parents' paintings. I was angry and upset. I'd only just arrived home and couldn't adjust to Les's abnormality quickly enough, so I went into the kitchen to wash up. Les came in and apologised, and we made it up. After that we got on better than ever before: he seemed more

sensible and reasonable and adult and I began to feel healthy for the first time in many months. I stopped taking tranquillisers, feeling that they were now unnecessary. I had a new energy and began painting again: I painted a landscape and some drawings of John. At last everyone told me how well I looked.

Les was never able to overwhelm me or thrill me physically. His technique, such as it was, was completely inadequate, although I tried very hard to cooperate. He was always very ready to criticise others in justifying himself and his efforts: he seemed to have no respect for other people, apart from the few he admired, and returned my careful tact with selfishness and tactlessness. He badly wanted another child, for John's sake, but I didn't dare, which was perhaps very selfish of me.

It seems that one is caught unawares by the thing one craves but cannot have, as happened to me twice during this period. A friend, Harry, came to see me and we talked openly all afternoon about these problems. I was blissfully unaware of any inducement in my direction until an indication was made and then I became all churned up. I then rejected him, kindly and against my feelings, and discussed it a day or two later with Les.

By February 1965 John's vocabulary was growing, and I loved recording his development in my diary:

> He says a lot of things now. 'Get down' being one of the most positive, applied either to himself or me or Les. He sometimes gets confused and calls everyone 'Mummy'. He was calling Leslie 'Mummy' most of yesterday, while I was in bed. But when Les is at work and he hears the bell or a gate shut, he immediately calls out excitedly 'Daddy! Where's it gone?' 'Gone' being pronounced like the French word for 'glove'. Sometimes the 'gone' is prolonged with a sad enquiring shake of the head, so that the vowel wavers a little. Also 'Whatsiss? Mummé!' and points at the electric light bulb or a crumb or something else. 'Gaggi' really means dog, and possibly

Page from 1965 diary

Dec. 12th The other day John had the white & Brown loaves on the kitchen table & was calling the white one "Teddy" & the brown one "Doogle". They where already cut & looked like this .

Teddy → [sketch] & "Doogle" [sketch] I was amused & rather amazed at his imagination because Teddy looks like

this - [sketch of teddy bear] & Doogle looks like this - [sketch]

Dec 14th 1965. I believe this is the anniversary of Daddy's death. Seek ye first the Kingdom of Heaven & all other things shall be added unto you.
Joan Beay was being interviewed on the Woman Hour this afternoon & sang a couple of songs. A sentence from one of them -

any other animal, also the TV. 'Ooff Mummé' means a car. He used to say 'Tar', very short, quietly to himself when I gave him anything, but now he sometimes says 'kyou' which is the end half of thank you. 'A-pul?' He says very cheerfully for apple, and also for potatoes and onions. He is nearly a year and three quarters! How time does fly.

About this time I finished a portrait of Laurell Westrop, the young daughter of the vicar of Cookham, and re-started a portrait of Dr Joshua Bierer. I was pleased to have made a good start with the Bierer portrait, which was a more sensual beginning than some of my paintings. The sitter must have been painted several times, for certain: perhaps he learned about himself through these different interpretations, bearing in mind that there is a lot of 'us' – artists – in the portraits we paint of others.

My father was a prolific writer and correspondent, and at his death the papers in his possession were left in the care of three executors. It wasn't until six years after his death that I felt strong enough to read them, so I wrote to one of the executors, Mr Shiel:

Feb 16th 1965

Dear Mr Shiel

I am writing to you on a subject to which I have given a great deal of thought, namely my Father's writings.

 As some five years have elapsed since his death, I feel in a position to be able to read them without being unduly disturbed. I have some idea of the variety and content of his writings, as he used to read extracts when I visited him during the last ten years of his life. As you know, there are among his papers letters addressed to me; some of these letters I already possess as he wrote them in duplicate. There may be others also addressed to me which he did not post, but this I am in no position to tell at present. I would be very grateful if you would let me know when it would be possible for me to go through his, my Father's, papers, as I feel it an important duty to his memory, that I should do so.

Yours sincerely
Unity Spencer

31, Bruton Street,
London, W.1.

28 March 1966

Dear Unity,

We, the undersigned Executors of the late
Sir Stanley Spencer, are of the firm and unalterable
conviction that it would not have been the Testator's
wish that <u>any part</u> of his private papers and correspond-
ence should be made accessible to members of his
immediate family. He left these to us to deal with as
we thought best. If there were among the papers any
letters written to you, as you suggest, (and we have
not searched the very voluminous correspondence), we can
only conclude that he did not send them for his own
private reasons. We are determined to carry out what
we believe would have been the Testator's wishes to the
best of our ability.

If sold, it will be a condition of the sale
that no part of the papers or correspondence can ever be
published without our prior consent.

Yours faithfully,

Miss Unity Spencer,
Fernley,
High Street,
Cookham,
Berks.

Letter to Unity from her father's executors

The trustees replied to say that they believed that D. would not have wanted his family to see his papers, so access was refused. On 29 March I received their letter of refusal. It was signed by Mr Shiel first, Jack Martineau second and Mr Tooth third. This seemed significant to me, since Mr Shiel usually referred to Mr Tooth as 'senior' executor. My diary reveals my sense of shock and disappointment at their decision:

> I feel that they are the people who have received the shocks from seeing D.'s papers. Quite possibly there are references to Tooth which Tooth would quite naturally not like, or want known. Also they show themselves up apparently unknowingly, by saying that they themselves have not quite gone through all the vast amount of papers. Surely after six years this is rather negligent of them? Surely they are in no position to withhold papers which they have not read?

Around this time I dreamed that I was in a high-walled garden, rather like the vegetable garden at Pond Street but with long ropes of dark green foliage, a rather vivid, viridian green. I had a terrible feeling of being lost, alone and deserted, and I think I may have cried. I think Leslie featured in my dream: possibly I felt deserted even by him. It was that feeling of panic that children have when they leave their mothers for a few moments when shopping. There was all this dark green foliage hanging over the wall, very thick but very orderly as though cultivated to do so.

By the summer of 1965 we had been living in Fernlea for two years and I was beginning to enjoy the beauty and peace of the place (apart from the hideous traffic in the High Street). I knew many nice and interesting people in this area, which made a great difference. On 12 June the Friends of the Stanley Spencer Gallery organised a coach to Burghclere. I didn't particularly want to go, having been to Burghclere the previous year and not wishing to join a coachload of elderly Cookhamites, but in fact I enjoyed it. I went partly for the sake of Lesley Ashton, a Cookham friend. It's extraordinary how I'm always affected by the chapel, but

Unity and John outside Fernlea, 1964

At the Stanley Spencer Gallery, Cookham, 1964

Stanley, me and John and Hilda in the background, putting flowers in the compost!

I'm always thrilled by the first sight of the crosses on coming through the door, how alive and luminous they are, and then I'm awestruck and gripped in lively and intense contemplation. There is always something new that I haven't seen before.

I had been to the chapel six or seven times since I saw it being painted when I was six months old. I came out of the chapel to have a look at our cottage, on the opposite side of the railway to the chapel. An old man holding a pair of grass shears appeared and asked me what I wanted, so I explained. He pointed to a house that looked to me enormous. I asked him if he was sure, and he was certain. It turned out that he knew D. very well at that time: his name was Parsons and he had been gardener to the Behrends at Grey House, and asked me – very amused – if I was the little baby! He and his wife often stayed with the Behrends in Wales. He asked if I knew their housemaid, who had lived in one of the almshouses for many years, and if I remembered the cottages near the station, which D. had painted. Apparently they had been modernised and their charming front gardens tidied up, and they were now quite different. I meant to tell Geoffrey Robinson from the Gallery, who prior to the outing asked if there were any particular views we could see that had been painted by D.

Geoffrey Robinson and his wife showed me and Lesley Ashton the garden at the back of the chapel. It was lovely: his irises, sweet peas, potatoes, pinks, etc., were beautifully kept in rows on one allotment, the rest of the garden homely, fresh and green, a few fruit trees and a pretty view beyond.

It all felt so peaceful, real country. I always do feel 'at home' at Burghclere.

I also met a couple of elderly ladies (sisters) whose mother had been taught by Uncle Will. They told me that he had been a marvellous teacher and their mother was a brilliant musician because of him. It was sweet of them to speak with such praise of Uncle Will, who I believe was a very fine teacher as well as a beautiful pianist. He was incredibly gentle, but he also had you spellbound: I found him quite remarkable. These two sisters were delightful, one in navy blue, one in grey, both wearing hats, and with charming old-fashioned country women's manners. When will I be called 'Miss Unity' again?! The younger of the two was very earnest and finished her sentences with a sudden smile and a batter of eyelashes, which on a less sincere person could have been affectation. I could imagine D. having marvellous cosy afternoon tea parties with them in their cottage. The elder sister said a great many appreciative things about D. and his paintings, and the younger asked me, very earnestly, to sign her book (by George Behrend on the Burghclere chapel). She would then lend it to the vicar's wife who was bringing the WI to the chapel on Tuesday, and they would then feel that I was with them. Why they should wish me to be with them I don't know, but evidently I had to 'stand in' for D. I'm always glad to do so, although sometimes the aura is too much for me. I made a point of writing 'younger daughter' in the book, since with Shirin being abroad, they might get the wrong impression.

As I was returning to the coach after tea at the 'Tudor Rose' I said to myself: I must write to D. when I get home and tell him about today, and then – I quickly realised that I couldn't. This was at least the second time since D. died that I had thought of writing to him.

Leslie was very careless about electricity. Over and over again I wanted to get an electrician to look at our immersion heater, but Leslie insisted on doing it himself and I felt powerless to do anything. I recalled the incident in my diary entry for 16 June 1965:

> Eventually a friend of his from work came and looked at it and was horrified – and surprised that we were still alive. He put it right, thank goodness. This incident told me a lot about Leslie. He is terribly sensitive about his own feelings, but excruciatingly insensitive to

other people's feelings. He deflates me, and takes away my confidence and confuses my thinking, so that I have a constant battle to know what I do in fact think. Leslie is so emphatic on everything and if I'm not he gives the impression that it's a weakness in me. When Leslie hurts me, I often take it out on John, who is innocent, because Leslie cannot take my reaction to heart. I'm worn out with 'trying' or 'trying to understand'. I don't want to be bothered with Leslie: he's too difficult and complicated. He tells me various conclusions he's come to, which very conclusions I had come to before I ever knew him, and which I have known all the time I've known him. I hate him for trying to analyse me. He is the biggest nincompoop that ever existed. He's like a bull in a china shop – he couldn't care less about other peoples' feelings and he's so intent on expressing his views, that other people's don't get much of a look in.

I would use my diaries to express my desperation and my determination to protect John from Les's unpredictability and violent behaviour. One entry is a tirade listing Les's many faults and reveals the anguish I felt as I tried to find a way of coping with everyday life:

– Front doors, gates left open, dangerous doors left open.
– Carelessly washing clothes.
– Rough handling of objects, plugs, etc.
– Cigarette ash everywhere, and a burning cigarette left on top of cupboard.
– Burnt holes in carpet and clothing.
– Lids left off jam, bottles etc., with flies about.
– Loud voice, a bit rasping.
– Shouting in the street and in shops.
– He puts on a different 'air' or 'manners' according to whom he is speaking with.
– Therefore, which is the true Leslie?
– And why is he unable to be his real self with everyone (within reason)?
– Drops money on the floor.
– He is rude in a negative way.
– Does not reply to questions.
– Does not say that he must have time to think.

– Wanders off when we are out, ignoring me, possibly to enquire
about something, but never says the natural polite thing e.g.
'I'll just ask this man', etc.

– He commands you to do this, that and the other.

– I have stopped trying to tell him what I really think and feel …
One can take so much hurt, but no more.

– He is confused.

– Afraid of loneliness.

– He is not self-sufficient, tho' he keeps on saying he is.

– He contradicts himself over and over again without knowing it.

– He is only concerned with putting over his own ideas, convictions,
etc.

– Leslie is oblivious of the need for 'give and take' in a discussion.
Therefore it is always impossible to have a discussion with
Leslie.

– Leslie thinks he can save the world.

– Leslie also thinks he can save people.

– All this is out of the question until he has first put himself right.

– At his age, this seems impossible, and I have given up trying to
help him … The strain is too much.

– If I can't love him, I might as well hate him.

– What about John?

– This is my perpetual problem.

– I am not going to pull myself to pieces all the time in order to
try and kid myself that Leslie is really as confident and as
integrated as he would like to make out. Trying to live with
Leslie drains me of the energies which should be put towards
John, painting and living in general…

– Leslie contradicts me like a child automatically does. I make an
innocent remark which Leslie automatically contradicts. I love
to talk to people and exchange ideas. I daren't with Les because
of insensitivity, blankness and contradictions from him.

– With a man like Leslie it is difficult to sort out truth from fiction.

– People in the shops thought that Leslie was drunk at first, when he
asked girls to kiss him … but they later came to the conclusion
he was a bit odd.

– He's much better now.

– Have I got to be Leslie's teacher and psychiatrist all my life? And

at the same time go to my own doctor and be joked about, although it's the only help I have with this problem…
– When will I have any peace of mind?
– The roof? When will it be mended?
– The Quaker meetings are a help…
– Poor wee John. He loves his father. He is so trusting. Have I the strength to force myself to love Leslie for John's sake? I love John with all my heart. I speak with my whole heart to him. I do not speak with my whole heart to Leslie any more. It has been dreadfully bruised trying to open Leslie and help him, and all of us, out of necessity. To my mind the best love goes where it is needed, NOT where we feel self-satisfaction.

As life with Leslie became more and more difficult, my overwhelming love for my son gave my life a purpose and a new focus:

Leslie's so rough and ungentle. When he was ill, I would listen to what he had to say, do what he asked me. I did not run away before he had finished a sentence, leaving him stranded and helpless. He does this to me. I am tired of seeing Leslie's point of view at the expense of my own.

Leslie also said on Sunday evening before bed that for the first time in my life I now had security. I wondered what he meant?

When John lies in his bed asleep with his arms above his head and I come to cover him and remove his bottle it is the most beautiful sight I know. I've tried drawing him. He is so beautiful I'm afraid to try; I know I cannot perfect his beauty in the drawing. This must sound a terrible over-fond parent attitude but it is honest feeling. He moves a little, perhaps rubs his eye or turns. All this is common to all small children, but there is no one in the whole world like one's own child. Isn't this wonderful?!

I also found comfort in music, painting and in a groping for some kind of spiritual support:

… I hope I will always be able to dance even when I am old – I want to dance sing, play the viola, paint, as well as look after John, the house and all the responsibilities besides…

I believe this is the anniversary of D.'s death. Seek ye first the kingdom of heaven and all other things shall be added unto you. I wish I could find the Kingdom of Heaven within myself. It seems impossible. I can only pray that God will continue to help me, create a right attitude in me.

During 1966 I found Leslie's irrational behaviour increasingly difficult to live with:

Before lunch Leslie turns on the TV to watch the tennis. When lunch is ready Johnny offers to tell Leslie that lunch is ready and does so. Leslie takes no notice, and John gets fretful and whimpers. Eventually Leslie comes but leaves the TV on throughout lunch. Leslie gets up when he is finished and puts on wireless so now we have two lots of voices talking but about different things. Then Leslie disappears. I find him watching TV in the sitting room, Radio still on in the dining room where I am. I then turn off the radio, Leslie comes through a few minutes later and turns the radio on and takes it into the garden. John follows him, and Leslie tells him to get an ice cream from the fridge. I go and turn off the TV which Leslie has left on in the sitting room. John has been clinging to Leslie all day. He is afraid of losing him.

Several times Leslie has said in front of Johnny that he is going to leave me so naturally John is afraid he is going to go. So John clings to Leslie and won't let him out of his sight.

When friends went off in the car they joked about taking John with them, then Les … pretended he was going … John panicked and cried and they still went on joking. I said it was very unkind and Leslie stared at me. There was nothing I could do as John was clinging to Leslie. Sometimes the radio is on very loud inside and out … visitors sometimes turn it off; I would be ticked off for doing so.

… When I get Johnny into bed my instinct is to escape with nothing. I don't see it as an opportunity to do something interesting, I think my present problems are still strongly linked to my resentments of the past. There is no strong incentive in my life. Only a sense of guilt surrounding John. Not pleasure, I don't really enjoy John's company and yet I love him. I suppose I am very lonely really. I am lonely for congenial people who don't exist except in my mind.

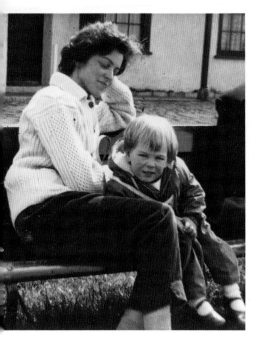

Unity and John, 1966

I decided to take John away for a few days, and wrote to Les from a hotel in Dorset:

Dear Leslie

I'm writing this in bed, John is asleep. I have put my dressing gown around his cot to shield him from the light. I was trying to work out how you found the phone number where I am staying as I didn't leave you the address. Very clever of you.

… John called out 'Les!' as he came down the hotel stairs this evening. If he feels a little frustrated with me he whines for 'daddy'. If you were here, his world would be perfect. I must say Les this really is an ideal place for children. You might find it too quiet, I don't know. Johnny was running delightedly in and out of the little pools of water in the sand caused by the ebbing tide this morning, and calling out in excitement, 'Water! Water!' I took him on the seesaw and swing in the garden. We were up at seven this morning and out for a walk where John chiefly inspected the cars … John says 'hullow' to everyone and gets a friendly reply. The staff here are very nice, the air so fresh … John's energy seems endless. I am thankful to be in bed.

Lots of love dear Les
From Unity and John xxx

Dr Hopkins was our family GP in Hampstead, who became a great support to me through years of depression and legal struggles with Les, and who vouched for me when John was made a Ward of Court.

Dear Dr Hopkins

I am sorry I had to put off my appointment with you. I had too much on my plate and could not get a babysitter. I picked up some papers off the floor and found a summons for Mr Lambert, Leslie, to appear in Maidenhead Court next Thursday for failing to produce driving licence and insurance. Leslie has not mentioned

anything about this to me. According to the policeman concerned Leslie said he would produce driving licence and documents within five days, which apparently he did not do. When the policeman called at the house (I was not in) to tell him he would be reported, Leslie is quoted as having said 'You do that. I like going to court and I will not produce them'.

You once told me that a healthy contempt of the law was a good thing. Perhaps you are right, but since I've known Leslie I've been interviewed hundreds of times by policemen and practically offer them wine now, and I couldn't care less. He seems to be constantly in trouble on account of his van and you may remember the bailiff came to see me one day. I also had to go to court when John was tiny to plead guilty for something I have not done. Leslie couldn't care less that for me it was a very hurtful experience. Everything is done and written in my name. Half the time I don't know what Leslie is up to. How can I? Leslie complained to the police about cars parking both sides of the road in the High Street. Does this sound like a healthy disrespect for the law, or just a big chip on the shoulder and the need to be 'agin' everything? He goes around Cookham looking like a tramp as often as not with his fly buttons undone. About a year ago in Maidenhead a policeman had to ask him to do them up.

He is the most money-conscious man I know. He goes up to a friend of ours in the street and calls her 'the wealthy Astons'. She told me this and was obviously hurt by this remark. She is a gentle and good person. He also told some other friends of mine that I ought to be a wealthy woman and when I first knew him he talked about the rich Miss Spencers. When I demurred, he said 'I mean rich in attributes'; that was a clever way out. He has an answer to everything. Mr Wickenden (solicitor) has asked me for a further £100. Leslie said I must not send it, and when I'm about to send a letter Les told me not to until he had spoken with Mr Wickenden. Les didn't call. I try to ignore Les but then he becomes unpleasant. When we did meet Mr Wickenden the young clerk very quietly told Les that he was trying to make things go his way. Or words to that effect.

I had to tell Les that I have been drawn into conversation with one of my father's executors and that I had again expressed great concern about my father's writings. I was afraid to mention it for

fear Leslie would tell me I'd been a fool, however he didn't: he made various suggestions, not in a reasonable manner but in his usual soapbox manner. There is no room for my questions or if there, is I am told I don't understand. Can you wonder that I get confused and don't know how to proceed?

Leslie has no bank account, his mother always looked after his money; he always says money doesn't count but he likes what money can buy. At long last he is beginning to realise how much money I pay out every month. He points it out to me!!

A pianist friend of ours called last Sunday, and was able to point out to Leslie that he was deceiving himself that he was religious and that he was illogical and that he was a crazy mixed-up kid. This young man has a very gentle manner; Leslie didn't agree but he couldn't fail to listen. If it had been me I would've had my nose punched (figuratively speaking).

Leslie hides behind my problems to cover up his own and I feel that if Leslie was not fighting these legal battles, which are really mine, in respect of my mother's will on the one hand and my father's on the other, he would find something else to fight. The trouble is I suffer through all this. Les started to wake up past misdemeanours of mine and my sister's. Les used to make me repeat after him word for word what I must say to this or that person. I used to feel an idiot, and tried to put it into my own words. He made me write a letter to my own sister, dictated entirely by him. She saw through it and was disgusted with him for browbeating me. In fact one of his reasons for not leaving me was that I would have to handle the legal problems alone. He tried to fight me this way. I suppose you think that 'the love of a good woman can heal him!!!' I just avoid anything that is at all contentious. A lot of the time he complains that I never tell him anything.

At present he is converting the kitchen. To begin with he shouted me down when we were discussing it with the bricklayer and told the bricklayer I knew nothing. Since it is my kitchen, I ought to know something. After one or two attempts to express my wishes I felt I'd better keep out of it, but the bricklayer came and had a word with me on my own later. Leslie started pelting me with questions about everything all at once to do with the kitchen. He wanted to pull down walls here there and everywhere because

I seemed not very 'with it', as you might say, and he accused me of lacking enthusiasm. He keeps on and on about how he could do the job himself and I agree with him. He adds that he would be slower than professionals, and then says he hasn't got the time.

His reactions to anything are quite unpredictable. He can't express himself as he pleases. He uses as many 'Christs' and 'bloodies' as he likes, but I must never express any feelings other than unfailing happiness and perpetual loving kindness towards him. I must never get exasperated over things. I suppose he thinks I must control myself and behave like a lady. The voice must always be tender and sweet. Any not‑ sharpness, hardness or even aggressiveness he immed‑ s on. If only he could hear his own voice. Som‑ really sorry for him, not in a patronis‑ ‑d. The other day I was furious ‑d for once he seemed inca‑ wering back. I felt better‑ result of this and perhaps‑ ome weakness.

By the autumn of 1‑ ‑e in the same house. I threw h‑ ‑nd he continued to hound me ‑ He was the cause of endless a‑ ‑e, bringing up and protecting ‑ Leslie's cruel games. I didn't what Les was really like: I was a‑ get back to John. I was trying un‑ to keep things calm (laughable) at ‑ anything negative to John about his me, John and his friend Philip Hans, Moor on the way to nursery school. Les s‑ black overcoat, shoulders hunched and wa‑ the children, saying 'Remember, John, you ha‑ Philip burst into tears while John simply looke‑ We continued on our walk to nursery, the childr‑ shaking like a leaf.

Les often spied on me. At night he would sometimes come up the side passage of my house when I was in bed, ring the doorbell and drop an unpleasant letter through the letterbox, sometimes enclosing a £5 note, and stomp back, slamming the front gate behind him.

As time went on he became increasingly angry and irrational, haunting our lives, humiliating me in front of friends and neighbours as he tried to break me down. He was now living in a camper van, and would turn up in Cookham to take John out for periods of time, usually pre-arranged by letter since it was quite impossible to talk to him on the phone: he would constantly interrupt and shout me and Shirin down. In his desperation to persuade me to take him back he tried to make Shirin into an ally, taking her off in his camper van for eight solid hours at a time, with nothing to eat. He also repeatedly visited a number of my Quaker friends in a vain attempt to make them persuade me to take him back.

He told everyone that I was incapable of looking after John or myself on my own, and that I needed him to look after me. I think he was more than a little put out to find that I managed quite well without him. One day, after he took Shirin out all day, she asked him to drop her near Cookham but he insisted on bringing her all the way home. He stopped the camper van outside the gate and as she got to the front door he ran past her, hoping to push his way into the house. Shirin warned me by calling out, 'It's me and Leslie!' so I refused to open the door. Leslie then called loudly through the door for John, who was up in bed. He woke up to hear 'It's Daddy, darling!' Johnny was obviously excited, so after a while I asked Shirin to tell Les that if he promised to go away afterwards he could come in and say goodnight to John. I left the door open and went into another room to avoid seeing Les: the very sight of me made him angry. Les spent a few minutes with John, telling him that I was stopping them seeing each other, and then rushed downstairs and barged in on me to start some futile tirade about making a go of it together. We were both too worked up for a sensible discussion, so I asked him to go as he promised. He said 'I never promise' and sat down. It was only when I threatened to take Johnny and go myself that he finally left. Leslie later phoned Shirin and me and persuaded us that we must find him somewhere to live. We did our best and finally, with the help of the vicar, we got him a place but he refused it.

On another occasion Les temporarily returned because he was 'ill' and created quite a scene. Shirin was in her dressing gown peeling

potatoes on her lap in the dining room and I was in the room with her. Leslie came in wearing his overcoat and started one of his tirades at me. Eventually he reached such a pitch that I had hysterics. Shirin then flew at Leslie, who turned to taunting her, knocking the knife out of her hand and the bowl of potato peelings across the floor. Like a coward, I rushed out of the house for the vicar, who, having got the gist of what was happening from me, came round to Fernlea and managed to calm Leslie down. Finally the doctor came and gave Leslie some medicine. With more help from the vicar, I managed to get Leslie upstairs to the bedroom, where he lay on the floor by the fire. He refused to eat what Shirin had cooked for him until I brought it to him and gave it to him.

I couldn't bring myself to let Johnny see Leslie when he was in this state, particularly as his father used him to upset me, which he found terribly distressing. Les seemed to have no regard for Johnny's feelings. I was extremely careful not to say anything hurtful about Leslie to John, but unfortunately Leslie showed no such restraint. Yet he did tell his friends that he believed that it would split Johnny in two if he was taken away from me – but the damage had already been done. So his attitude and behaviour were completely confused: he caused a disturbance to John on a number of occasions, some of which must have been real shocks for John and at times he showed visible signs of fear. And Johnny obviously had mixed feelings about Leslie.

One weekend Johnny and I agreed that Leslie should collect him at 10 o'clock on the Saturday morning and return him to school on Monday morning, taking him to his friend Andrew's party on Saturday afternoon. When I arrived to collect John from school on the Friday, Les was watching us from his camper van at a vantage point opposite the War Memorial at the end of School Lane. I pretended I hadn't noticed as I walked towards the school; he starting shouting euphorically up the road at me out of his window. I calmly pointed out that he was holding up the traffic so he moved on and pulled up bang in front of the school gate, walked straight into John's classroom and then stormed out again, hurling abuse at me. I managed to stay utterly calm and answered his remarks in such a way as to leave him in mid air, so he got back in the van and drove away screaming 'scum collects scum!' out of the window.

After I had put Johnny to bed that evening, my friend Jane Lonman called and said she would babysit for a little while if I would like to go over to the Royal Exchange and join two other friends, John Isaacs and Cyril. John had had a drop too much but was fine. At about 8.30, in walked Leslie, who had been spoiling for a fight for some weeks. I am convinced he was determined to come in and have a drink or two, not to give him courage to fight John but to view the situation and to have an excuse if the police were called. Although deep down I felt I should have stayed, I had to go home to relieve the babysitter. I wasn't afraid for myself but I had an idea what was going to happen because when I got home I found myself praying for the friends I had left, particularly John Isaacs. About half an hour later I heard noises in the street and saw Leslie's silhouette in the doorway, calling to me 'Do you want to see him?' Then he went back out of the gate and I heard him taunting: 'Do you want some more?' I could hear another man's voice but could see nothing; a few minutes later Bill Hopkins came to the door, which I opened, bringing John Isaacs with him. He had seen Leslie deliver four blows to John and had called the police. John just lent his head against the doorpost until I finally persuaded him to come in.

The police arrived a few minutes later so I could not clean John Isaacs up since it was better for them to see the mess he was in. Bill Hopkins sat beside John Isaacs while I asked the police to interview Les in the sitting room. I didn't want them to wake little Johnny upstairs. As I tried to phone a doctor, Leslie was roaming around, talking about 'Johnny my son' to the police; when an ambulance arrived to take John to hospital, Les turned on me and said: 'If I see John Isaacs in this house again I will kill him.' The police then escorted him to the front door, shouting about divorcing his wife.

Leslie continued to park his camper van by the War Memorial and watch our comings and goings, frequently driving past us, smiling and waving, or following us slowly as we walked along the pavement. Johnny sometimes found this exciting, sometimes alarming; I tried my best to ignore the situation and carry on, but I found it distressing at best, and at worst, terrifying.

Finally, after months of living in fear, of incidents involving friends, neighbours, Johnny and Shirin – and the police, social services and solicitors – on 3 April 1967 a Court Order was granted, restricting Leslie to Saturday afternoons.

Les continued writing letters to me, sometimes in great anger, sometimes in love and desperation, but always leaving me feeling that he was unstable, unpredictable and to be kept at arm's length:

Letters from Leslie to Unity

One terrible time, when John was five, I took him for one of his visits to Les. As I left, I looked up at the house and saw that Les had placed John on a chair by the open attic window. Of course when I had gone he moved John away from the window, but I was beside myself with fear and rushed to phone a friend to seek her help.

I worried about the effect of Leslie's behaviour on Johnny. When he was only five he was being told by his father that I was a wicked mother, and Les was haunting our lives and losing his temper in front of Johnny and his friends and schoolmates.

At times Johnny would ask me about Les, or express his own feelings: 'Daddy asks a lot of questions', 'Daddy is a bit peculiar sometimes'. On one occasion, when I told him not to listen if he didn't want to, Johnny said 'Well, I ask him to stop but he goes on and on. Do you know why he's like that?' I said, 'I think Daddy wants everyone to love him and doesn't understand that you can love several people at the same time.' 'But he thinks I hate him,' said Johnny, 'and I want to be with Daddy more than four hours on a Saturday.'

At the end of another difficult day with Les Johnny asked me, 'Why do you and Daddy fight?' 'Because he was taking you away and you called out to me so I came to you.' 'Yes, Daddy was being a bit naughty, wasn't he?' I was relieved that he was so calm as he sought clarification and sorted things out in his mind.

At the beginning of March 1967 Leslie appeared at the kitchen window one morning and spoke to Johnny quite pleasantly. Johnny was cheerful, then Leslie said, 'Mummy won't let me see you'. I remarked cheerfully to Johnny that he was talking nonsense. I was standing by the wall so that Leslie shouldn't see me. Soon he went away and we started having breakfast. Leslie then returned and started growling at me through the window, 'What a mother! Yes, you can stroke his hair but you don't love him. I've done everything for you and what do you do? Solicitors' letters!' Johnny put his hands over his eyes, terrified, so we hurried out and he finished his breakfast in his bedroom.

Johnny and I stayed upstairs, I sorted out bedlinen and then the police arrived as a result of Mr Wickenden's letter. They took down details about Leslie's former wives and asked me about the ownership of the camper van. I had paid for it but it was registered in Leslie's name. They noted that the padlock on the back gate was broken. The police would like to have proven bigamy: when they asked if I wanted Leslie back at any time, I said 'Definitely not'.

From then on Johnny would jump for fear when he thought Les was

Letter from Mr Wickenden to Unity

This was one of many letters from Mr Wickenden. He was a great support and friend to me.

EWART PRICE & CO.
SOLICITORS.
COMMISSIONERS FOR OATHS.

C. D. WICKENDEN, LL.B. (LOND.)

TELEPHONE,
HAMPSTEAD 9866 (4 LINES)
TELEGRAMS AND CABLES:
WICKLEX LONDON, N.W.3

CDW/JD

1. Downshire Hill.
Hampstead.
London, N.W.3.

13th February, 1967

Miss U. Spencer,
Fernley,
High Street,
Cookham,
Berks.

Dear Miss Spencer,

re: Mr. Lambert

Thank you for your letter of 9th February. I am
indeed sorry to hear of the trouble you are having with
Leslie. There is no doubt that we could get some
protection for you from a Court of Law. I shall have
to write a warning letter to Leslie in the first place.
Can you let me have an address where I can reach him?
I am glad that both your friend and the Vicar witnessed
at least some of the incidents. I take it they would
be prepared to be witnesses if necessary? Could you
confirm this with them and let me have their names and
addresses and if they would like to write down in their
own language exactly what they saw and heard this would
be of great help to me and would save the expense of
my having to see them to take statements in the/first place.

It is possible that the best type of Court
application in this case would be to make John a Ward
of Court. This may surprise you, but the position is
that the Chancery Division of the High Court has very
wide powers to protect a child in circumstances like
this, and I think that the child needs protection as
much as you do. If the Court had full knowledge of
all the facts, it would, I think, be prepared to make
an Order giving Leslie reasonable right of access to
John, but also telling him not to embarrass you by the
kind of behaviour he has been indulging in lately.
They would, I hope, put him under some form of restraint
in that respect, and if he broke the Order he would find
himself in trouble with the Court, which might mean
contempt of Court and ultimately the threat of imprisonment.
That of course is only the final sanction, but it might
have the sobering effect on him which we need. Frankly
I do not think the local County Court, still less the local

/over

John and Leslie at Cookham Fair, about 1967

coming back, and warned me once or twice a day that he had seen the white camper van. He was obviously frightened of Les and told me in a subdued voice that he was nasty – and asked me why he was like this.

One day I was in the High Street on my own. Leslie drove by in the camper van and then came back on foot to follow me, talking to me and provoking me as I hurried along. I asked him why he wasn't at work but he wouldn't give me a rational answer. He was in an aggressive mood, walking as close as he could and shouting in my face about how he had done everything for me and Johnny and how I gave nothing. At one point he raised his hand as if to hit me. I crossed over the road and he did likewise. Eventually he made a parting remark and walked away, to my great relief. In the evening the police told me that they had 'nobbled Les' at the end of the High Street and gave him a talking to, until Les finally promised to keep away from Cookham.

Of course he had no intention of staying away: less than a week later, as John and I came out of the front door to go shopping, Les drove past the house, stopping opposite us and called out to Johnny, 'Hello … Do you want to come for a ride with me?' and 'Hello Darling' to me. Johnny stood looking at Les uncertainly. Les drove off with the back door of the camper van swinging open. Johnny told Mr Sims the greengrocer about this, and they agreed that it was silly of him. When we were in the butcher's Johnny started pestering me and I started to cry, to which Johnny said that Les 'can't help it'.

* * *

When I went to the probation officer at Maidenhead Magistrate's Court to get access defined so that Les could not keep on turning up at any time day or night, I paused in the middle of telling her about Les. She then said, understanding the reason for my pause 'I do believe you, you know.' To hear this from her was such a relief. I didn't expect anyone to believe me – I myself could hardly believe some of the things Les did to me. I needed protection from this man, protection for myself and for my son. I was my son's sole protector and provider. Little children are tiring at the best of times but being constantly under the pressure and anxiety from Leslie was exhausting. All my energies were used up in survival.

* * *

One day in late 1967 John returned home from being with his father and said 'I don't think Daddy is very well.' 'Oh,' I responded, 'do you mean has a cold or something?' 'No, I don't mean like that,' he replied. So then I knew that he was aware that his dad was mentally (or more accurately) emotionally disturbed.

On another occasion, when John was a little older, perhaps five or six, he returned home having been on the river in Les's 'boat', a rickety affair, and informed me breathlessly that Les said 'he did not need to wear his life jacket'. I could tell that Les had ordered John to tell me this, no doubt in order to frighten me.

By March 1968 I was beginning to feel that I had fallen from grace. It was all bound up with my inner attitude of mind, a truly humble approach, with the trust of a small child. From the beginning of that year I had known, without any doubt, of my need for God, yet as I felt stronger I found myself wavering in my belief, while feeling at the same time that if I didn't trust God completely he would do something drastic again, to bring me to my senses and my knees. When would I ever learn? I think the only times when we truly help others is when we are **unaware** of the help we are giving. We are vehicles without knowing it.

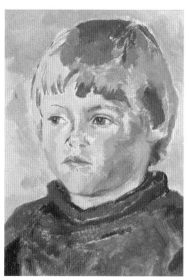

Portrait of Anthea Marshall, oil on canvas, about 1966

Painting Anthea Marshall's portrait, Belfast, about 1966

Anthea was Stanley's great-niece. On the wall behind are portraits by Stanley of her parents, Daphne and Johnnie Robinson.

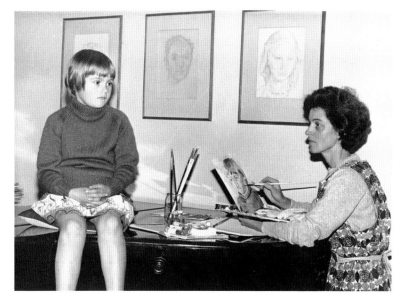

That spring I was beginning to feel that there was something more in me to be lived and experienced and given, that I should and could give more. That we should all love more and know the experience, the beauty of love. It is that extra understanding that makes one respond and see fully the other person's need; it also causes one, sometimes in a flash, to completely forget oneself and one's own wishes of the moment through concern for the other person. This is a beautiful thing in itself.

One day, when John was five, he turned to me and said: 'When you die I will bury you all by myself, very carefully, and when I die I will ask them to bury me with my arm over you.'

On 4 April 1969, a Friday, I informed the police that Les had told the vicar he was planning to keep Johnny. No time was specified, so I was instructed to keep an eye on Les in case he attempted to take Johnny abroad. The police informed me that they could not remove John from his father unless in an emergency, and then I would need protection from Les. John was due to spend that weekend with Les, so I was advised not to do anything unless Les did not return John on the Monday. When Les said he didn't know whether he would be able to cope with Johnny for the whole weekend, my solicitor pointed out that he was not expected to to have him all weekend and suggested he return Johnny to his mother. In the same breath, Les told John 'You don't want to go home to your mother', insisting that he was unhappy at home with me, and that he was prepared to give up work to look after him.

Leslie, John and a young friend in the Ford camper van, about 1968

For me and John life had become a matter of sheer survival, not helped by the loneliness of my circumstances. When John was about seven years old Les loomed up at us in the dark one evening. For a number of reasons this was the last straw for me. I phoned my solicitor, whose family offered to take us in. From then on, for the next three years, John and I moved from bedsit to bedsit nine times. Finally, in the summer of that last year, there was a High Court case before a judge in Chambers, to my immense relief. At the end of the hearing the judge addressed Les (who chose not to have a barrister as he could conduct his

own case, since he always knew much more than anyone else): 'If you attempt to see Miss Spencer or her son ever again, you will go straight to prison'.

I believe Les was convinced that deep down, I loved him, since love and hate are closely linked.

Leslie and John, about 1967

When I was near to despair I went to Quaker meetings in Maidenhead because, I reasoned with myself, if there was a God I would find him there without coercion or dogma. However, at this stage I still thought of God as a tyrant, whom I could not fully trust, so I did not find him. But I did experience brief, unexpected moments of peace and calm. Most of the time I found it very difficult to relax sufficiently to experience the inner peace I so much needed. Quite often I ministered in meetings and waited for the pounding of the heart before rising to my feet to say what came to me. It is a pity I did not appreciate the inner voice more at that time, as I had a lot to offer, but self doubt – and sometimes self pity – got in the way.

I joined a small group from this meeting to study some Jungian psychology and, in particular, our own dreams. I found it quite tiring writing them down, especially if I woke in the middle of the night, and I was often too depressed in the morning to galvanise myself (more fool me): as it was, I had to get my son up and ready and take him to school. The discussions were very interesting but depression undermined my full enjoyment, and in any case some of the others in the group were grappling with problems as well. Yet I tended to feel that mine were the worst because I lived in such a desperate state all the time. This is not to say that I did not listen to others or feel sympathy for them, because I did. But my desperation made it difficult to truly relax with the rest of the group. I felt that there was no time, that I would never be able to win through.

While I found myself getting through the horrors of life without sympathy, empathy, understanding or concern from my family, I did receive support from two Quaker friends from the Maidenhead meeting, without question or disapproval of my situation. When I was at my most desperate, they were my lifeline.

The church in Cookham was another matter. The vicar was completely taken in by Leslie, and took up his cause. Despite my very public difficulties, Leslie, who had been so cruel, was able to persuade the poor man of his good intentions for the first seven years of my son's life. How ironic that Leslie set out to bully me to such an extent that he hoped I would go mad so that he could then have our son for the rest of his life, and yet the vicar was writing on behalf of Les to recommend that John be taken away from me.

John in Cookham churchyard, about 1969

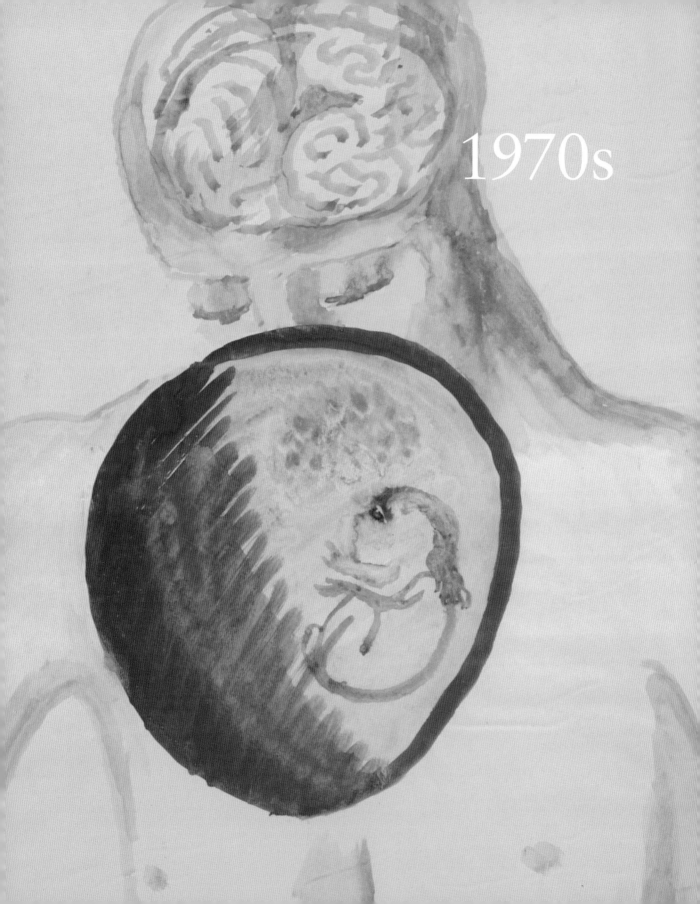

1970s

IN 1970 I WAS FACING A BITTER LEGAL BATTLE with Leslie over John's welfare. In May 1969 John had been made a Ward of Court, but the legal wrangling continued and letters were written to lawyers in support of both sides. The vicar of Cookham had become involved, and wrote on more than one occasion to suggest that John be taken into care.

In February 1970 Les replied to my solicitor, Mr Wickenden, demanding to see John:

L.J. Lambert
Wendy House
Raymead Rd
Maidenhead

Mr Wickenden 21 Feb. 70

Sir,
Your letter received today worries me beyond the point of no return.

The welfare of my son, John Spencer Lambert legally is bound with mutual love respect and understanding quote the judge 'A bond between father and son which should, must not be broken'.

The threats re contempt worry me no more than your previous threats to send me to prison.

Miss Spencer, acting on your advice is in contempt of court, Miss Spencer would not have left her home withdrawn John from School if guiltless.

I have seen the chief welfare officer three times who arranged for me to see Mr Wakeford with a letter from the vicar of Cookham. The vicar has stated and advised that in John Spencer Lambert's welfare, he should not remain with his mother. John Spencer Lambert is a Ward of Court, I have legal status, I have legal rights, I can justify every action, every word; I do not intend to be intimidated. Please make arrangements for John to see his daddy, immediately; if I do not hear from you by 28 February with access facilities, I shall, with all the facts, the truth take action with no doubts as to the outcome.

Yours sincerely,
L.J. Lambert

Contemplating the Love of his Wife's Womb, watercolour on paper, about 1971

Having lived in an attic in London for seven months, in 'exile' and incognito, I managed to find a place for John at a Rudolf Steiner boarding school. It was a great relief to know that he was safe. However, once he had gone I began to disintegrate. In 1971 our family doctor in Hampstead, Dr Hopkins, helped me to find the Marlborough Day Hospital (MDH), a marvellous institution off Maida Vale that was to guide and encourage me for the next ten years.

When I arrived at the MDH I joined a community of people who were all in different degrees of disintegration and from all walks of life and family background. I felt bewildered: I did not know that I was entering a community and was not sure what the MDH was about. It took me a month or so to realise that I had to bring everything to the group – doubts, anxieties, reticence, self-control, risk-taking, relationship problems, social problems – everything. Even practical problems, and there were quite a few, came up in group discussions. The experiences, relationships (and lack of them) and practical difficulties we were all experiencing and suffering found their way to the group, and we shared them as a community.

At one evening group session the leader, Dr Lederman, looked at me as I wept over a story in the paper, 'Exile & tug of love'. The evening group was an odd assortment of unfortunate souls, one with red lipstick and large red necklace. Others looking quite dowdy. Dr Lederman, in response to the matter at hand, said, 'And we can't decide which shelf to put our handkerchiefs on.' How he managed not to laugh, I don't know. Of course he was a professional psychiatrist with deep concern for his patients. Dr Lederman quietly absorbed what was going on in me, his face almost expressionless, looking at me with his quiet blue eyes. Through my tears I could well identify with the shelf problem. Here was a man who knew exactly which shelf to put his handkerchief on, yet empathising so well with our apparently pathetic or trivial, but devastatingly difficult decisions.

God was never mentioned or talked about (as far as I remember) because we were being constantly brought back to ourselves. This interested me and I tried to live it, but I found that I could not cope when it came to making more difficult decisions. I needed to feel there was someone greater than me who knew what I needed. The responsibility of being all alone was too much to bear. I so desperately needed support

and could not find an undefined Goodness, which I could lean on, inside me. In my need for a bedrock of security and authority, I related everything I learned during those sessions to Christ and his authority. Every now and then I got confused by the conflict I occasionally saw between what I thought was right and what Christ taught was right, and would feel guilty or ashamed.

I tried to resolve some of these conflicts in my diaries, seeking for answers in the Bible:

'Cast your bread upon the waters for it will come back to you after many days'

'The kingdom of heaven is within you'

'Out of the deep I'll call unto the Lord'

'Oh how amiable are Thy dwellings thou Lord of Hosts, my soul hath a desire and longing to enter into the courts of the Lord. Yea the sparrow hath found her a house and the swallow a nest where she may lay her young, even Thine altars, Oh Lord of Hosts, my King and my God...'

'Who going through the Vale of misery uses it for a well and the pools are filled with water'

'I know that my Redeemer liveth...'

'I came not to bring peace but a sword, to set Son against Father...' (read in a Wimpy bar near Paddington station)

I was still wrestling with how to live my life, how to find love, warmth and support – and fun. Perhaps most important of all was the need for fun and lightheartedness on the one hand and deep love on the other.

Although the MDH never mentioned God or Christianity – or any other religion – I felt at the time that it was the most Christian community I'd ever been in (having experienced a few in my life). There was an awareness of the need for honesty and courage to express ourselves, despite risking exposure and confrontation, to find healing. There was also total acceptance of anything except physical violence. For me the main problem was the speed at which change was expected: the minute you were accepted you had to change, almost in the same breath. I tried to take it all in and learn as much as I could about myself, and although I could understand it intellectually, I had great difficulty in truly accepting all that I learned, gaining the confidence to be more

adventurous or strong enough to take small risks. I remember discussing with a fellow patient that we seemed to be learning more about our weaknesses than about our positive sides, our strengths: 'Why don't they ever tell us what is good about us?' I knew that the MDH valued us, that everyone there genuinely cared and were trying to help us. This friend wisely replied 'we would not believe them if they did.' I acquiesced with what he said but later wished I'd had the courage of my convictions and perhaps helped towards an innovation. I needed to know, and have it confirmed by others, what I was good at, what was strong and positive about me, as well as being aware of all my weaknesses and faults. Still, we did grow in strength and we finally left, one by one. I left the MDH feeling that my nerves were all raw ends and was not ready to face the world. In retrospect, I believe that the MDH was a good, pioneering hospital but it didn't give me the tools to help me cope with the outside world. I was left to flounder far too much, which I believe was a mistake. I did my very best, but what little confidence I managed to regain there was nowhere near enough to help me begin to live life rather than merely survive it.

To make matters worse, on top of the many painful experiences I had suffered were many layers of neurotic behaviour on my part. Perhaps I suffered more in the end because of this – and maybe it is why I'm still locked in the past...

As a child I was not allowed to feel sorry for myself, so I didn't. After many troubles had befallen me, when my son was still an infant (this was many years later), a Quaker woman said to me 'cut out the self-pity' (it had crept up unawares), so I did. About five years later I said to my doctor, 'The trouble is that I feel sorry for myself.' He replied, 'You have a lot to feel sorry for yourself about.' By this time, 1970, I knew a lot about my life.

I was completely misunderstood by my family. Dicky said, 'Unity wants her pound of flesh.' I never wanted my pound of flesh. I wanted justice, but never my pound of flesh.

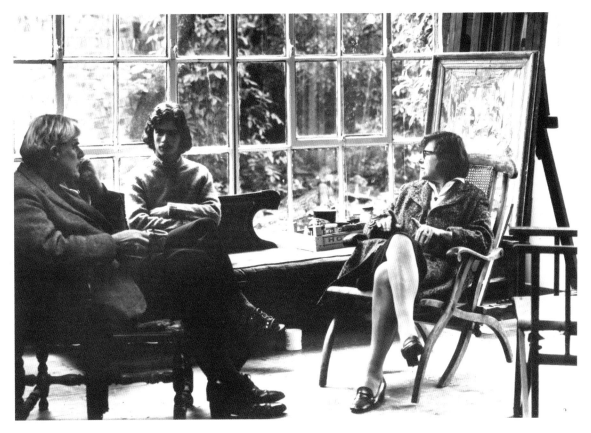

Dicky, Francis and Nancy in the garden
studio, Pond Street, 1968

When I was young I loved people and places. I painted out of loving
desire, hope, adventure and ambition. Later, love became painful to me,
therefore painting, being creative in this field, also became painful to
me. The flow of creation became blocked in some way. The demand it
made on me was too great.

From 1970 until 1973, during which time I was a day patient at the
MDH, I lived in nine bedsits in Maida Vale and Notting Hill. I would
have liked to tell Nancy what my time in hospital was about, in an
objective, slightly detached sort of way – unable to make demands
on anyone, feeling a sense of general frustration that I couldn't win
however hard I tried, and lacking self confidence in most areas of
my life but particularly with people, and utterly hopeless and grief-
stricken in the area of love. I was consumed with a sense of lack of

John's eighth birthday in a bedsit in
Maida Vale, 1971

At Fernlea in the 1970s

love, rejection, being ostracised, being unable to express myself clearly
over anything, and above all, of fear – of Dicky and Nancy and of life
in general. I was racked with indecision and an overwhelming sense of
worthlessness, that I had no rights of any kind in this world, however
illogical I knew this to be.

The pain of it all was terrible at the time, especially concerning
my lack of love and my experiences of rejection and being ostracised.
Grave misunderstandings with Dicky and Nancy were also deeply
painful to me, and still are: years later I still felt overshadowed by a great
sadness, anger and bitterness, and a deep regret at the powerlessness I
felt to express my feelings to Nancy. I also continued to have feelings of
resentment towards a few of my friends in Cookham for their lack of

understanding, preferring to remain blind to my plight, and my own impossible situation, determined to hide our problems for John's sake and therefore unable to cry for help. Had Les and I been in love with each other and got married before things had gone very wrong, it would have been appalling; if all this had happened when I was twenty-five years old, it would have been awful; had I had a few boyfriends in my late teens and early twenties who varied in suitability, but didn't work out until I met Les, it would have been difficult. But none of this is the case; the facts of what happened were so much worse.

<p style="text-align:center">***</p>

In January 1971, Leslie had a severe heart attack in January while decorating the Salvation Army Hall in Regent Street. He was found the next morning and taken to hospital. By this time I was suffering from another bout of depression and extreme anxiety. I feared that if I sent a message to him and he recovered, he would take a 'yard' from my 'inches'. If, on the other hand, he died and I had said nothing to a dying man, however awful he had been to me, it wouldn't feel right somehow. So I sent a message that I was thinking of him. Shortly afterwards he died.

I think Les was a far more frightened man than I realised and his bullying of me may have been a symptom of that.

<p style="text-align:center">***</p>

Les told my sister, when my son was a few months old, 'Unity can have John for the first nine months of his life, and after that he's mine.' Most of his behaviour towards me was driven by that intention. He reasoned that if he could torment and bully me enough, I would go mad and end up in a mental institution, and then he could take John away from me forever, with impunity. I did not realise this at the time, so I was utterly bewildered and shocked by his behaviour, which really got under way when John was four months old. I didn't know what had got into him. He was quite irrational, with his incessant threats and mental cruelty. He would ring on the doorbell day and night, bang the back gate until it fell off its hinges, post vile letters through the letterbox, break windows, cut off the telephone wire, spread gossip about me and bully Shirin.

My memories of how my mother suffered through the loss of her children gave me the necessary courage and strength to defend and protect John and myself against Leslie's onslaughts and to defy his repeated attempts to take John away from me forever, because that was really his intention and motivation. There were times when I would have gladly given up the ghost for a few months because the responsibility of everything was so heavy. I was coping with the complex family problems of the legal battle and so on at the time and feeling a very bad person and angry about it all, and desperately sad. But I somehow knew that if I handed John over to someone else, and did not look after him the whole time myself, I would go off my rocker.

My dear friend Bob Low, a fellow patient at the Marlborough Day Hospital, committed suicide in January 1972. Immediately I heard the tragic news of his death, I felt compelled to write him a letter:

> Bob you were quite a kind man, you understood, so we were sort of friends after that … holiday. You were testing me out as though I were a mother to you. I proved that I was. What you and I both needed was to learn to be the man and woman to each other. For you to be my kind and loving father sometimes.
>
> I wish I had been brave in that cafe in Sutherland Avenue, when you said 'are you going to invite me back to your place?' I flunked it. What was I afraid of? We could have comforted each other, sat on the sofa, cuddled up close to each other, rested together. I against you, that is what I needed.
>
> Finally you asked me into your bed. After ages of strain for me as I lay on your sofa, reading a ghastly book, I could not concentrate because I felt the tension so intensely. All I wanted was to be close to you in your bed. Just to be held and to be still.
>
> I have a feeling that out of sheer desperation and a bursting heart, after an hour or two struggling with that wretched book, I rushed over to your bedside and knelt down beside you. You said something like 'come in', which I did, and you put your arms around me. I don't remember much else, the moment was so precious to me.

I think after a while you fell asleep. I can't remember what I did, maybe I did the same. I do not remember waking in the morning, getting dressed. I do remember your flat in the daylight, and you sitting on the bed in your black jumper, and me alongside.

The letter goes on to recall my feelings of anger and rejection of the MDH, which by this time I was visiting once a month from Cookham. I never talked about Bob when I came for my monthly group sessions, but I often felt downcast, maybe because I could not fully accept myself or my grief, sadness and anger.

A little while after Bob's death I was standing in a pub in Windsor when I felt a sudden, unbelievable pain for him. Deep and powerful emotions can literally shake and erupt from the body, and this seemed to happen to me as I sat there all alone, people around me at various tables. I was practically jolted out of my seat as I thought of him: at least I was alive, although it was a deeply painful aliveness. I once had a similar feeling, for a different reason, when trying to feel angry with D. I was sitting at the front of the train and was nearly propelled from my seat with the anguish I felt. It was as though I would never, never, never get over the loss, my deep and long lost love for my dear father. Never, ever, *ever*, because I loved him more than anyone in this whole world and universe; why is it like this I do not know. My grief I had for Bob in that pub, where I stood at the bar for another pint, was terrible. My face was in anguish and streaming with tears, as though my heart would break into a thousand pieces. The kind psychiatric social worker I was with said to me as she stood beside me, 'Your love is real, your love is real.' This was a wonderful and deeply sensitive thing for her to say. To hell with whom the love is meant for, the love was real. This was what I needed to hear and have confirmed.

Three weeks after Bob died I was still in a state of shock and grief. I wrote to Aunt Gwen:

Dear Gwen,

I thought of you in particular the other day and again this evening. I thought I would write to you, not that my news is cheerful quite the reverse, tho' it affects nobody that you know.

I was thinking of what you wrote to me two years ago about

Sydney, it touched me so much, that you had him in your mind and loved him always. I was thinking of a friend of mine, have been thinking of him continuously for the past three weeks, because three weeks ago today, Sunday, he committed suicide. Somehow, even now, I and others can hardly believe it, it was such a terrible shock. I just couldn't see any point in it. I just feel I've had so many terrible shocks in life and I've had to bear so much pain. This seemed the final blow.

I have been going to the hospital nearly every day for the last week, although I was discharged at the beginning of November. I talked to one of the patients who was able to sense how I was feeling and I didn't have to pretend anything. The friend accepted my feelings of hopelessness and that I felt somehow broken and mutilated but still have to go on surviving.

In the afternoon I spoke to one of the occupational therapists; she was wonderful and so understanding. She understood the relationship between this man and me. I began to feel a little less tormented. Bob had a sense of humour, was droll at times, he was often withdrawn and had his feelings too well under control and buttoned up. Sometimes he tried to tell me what he felt or what he was afraid he might do.

I have been watching two mice in my kitchen – they are so reviving and as good as going to the theatre. They were quite delightful.

You couldn't ignore a man like Bob. No one knew that Bob and I were close because I never told anyone about my feelings for him except my doctor. I wish I had been able to tell Bob a little of my experiences with Leslie as it would have helped him to understand some of my fears, founded or unfounded, with him. He found it difficult to express his feelings of affection or love, but I know now that he did carefully in his own way and that he knew I cared about him.

On 10 February, a month after Bob's death, I sat at home listening to Bach cantatas: I found that Bach could revive and support me in a way that no other music could. I felt utterly wretched, cut off and isolated, and had lost all sense of joy: if I heard people talking about the spring coming, I felt sad and held back within, as though part of me remained

Posthumous Portrait of Bob Low,
watercolour on paper, January 1971

*I was in love with Bob Low. I painted this
a few days after he committed suicide
and I was afraid to express what I felt,
However, after a few attempts and having
seen some paintings by another artist,
I realised that I could say exactly what
I felt and spare no one. When I painted
this man I didn't fret about how to paint
him. The portrait seemed to paint itself.
It seemed strange to me to paint a squash
of red on his body, but I saw it there, and
afterwards it occurred to me that it was
his life blood. But it is also where his heart
is, and expresses love.*

with Bob and when I no longer remembered him, he would no longer
exist. Everyone who knew Bob was shocked. He was very ill, in a way
that was not fully obvious – but then perhaps psychological matters are
never obvious. Bob was a man who kept all his emotions and feelings
well under control, so much so that he believed that he was made up of
bad feelings rather than good. His potential was very great, but he was
an idealist: if he couldn't reach the top, achieve what he wanted, then he
felt his life wasn't worth living. I wrote of my feelings for Bob in a letter:

> It is not often in life that you get such strong feelings for someone as
> I had for this man … Around about Christmastime he was putting
> out feelers … and almost appealing to me, although he was proud
> and didn't like to ask for help. And I was trying to force myself into

the world, to so-called 'healthier' men. I kept on going against my instinct where he was concerned… I felt so ashamed of myself for loving him and having feelings towards him.

When John was at boarding school he would regularly come back to Fernlea with a crowd of friends. They seemed to me a very mature bunch, which made me feel ancient: even as teenagers they seemed to know so much, whereas I felt a hundred by comparison and knew so little.

Most of the time, however, I was living alone in Cookham, and often felt isolated. I was a single woman living alone in the country, without a car, and didn't enjoy country pursuits – golf, squash, tennis, boating, swimming, amateur dramatics, Women's Institute, British Legion, etc. – most of which required money and a partner. People would say 'Go to evening classes' – but that is not exactly relaxation and there's no time to make friends, and everyone goes home afterwards. I went to various

Portraits of John at Fernlea, oil on canvas, 1972

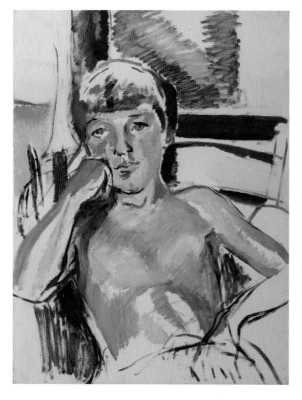
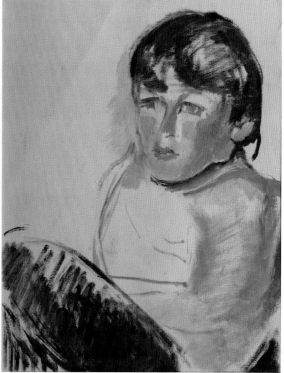

Unity and John at Fernlea, late 1970s

Portrait of John at Fernlea, oil on canvas, 1976

entertainments at Cookham's Pinder Hall over the years, and afterwards a kind person would usually offer me a lift home; as we got to my gate I would sometimes ask them in for coffee, which would be met with hesitation followed by polite excuses. One of the joys of going to an entertainment is being able to mull it over together afterwards over a cup of coffee, but it was always 'Goodbye, Unity, take care and see you soon.' I would go into my empty house and a vacuum enveloped me as usual, with no one to converse, discuss or share the experience with. 'You've got your Son,' some would say in a slightly accusing voice. Well, if companionship is to be found in a baby, a little boy, a teenager, I would like to know more.

There was a time when I said to myself, 'Well, Unity, it really is very wrong of you not to be married. Of course the solution is to be married, and then you would not be lonely, and you would also be more socially acceptable' (this I hardly dared admit to myself).

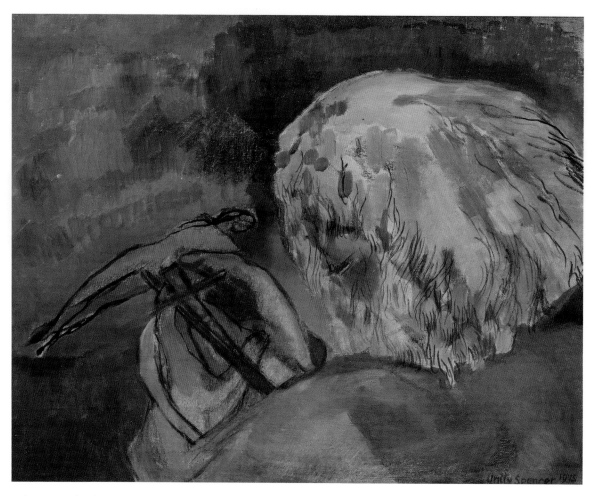

Before our Birth, oil on canvas, 1976

* * *

In 1975 I was visiting John at school and they mentioned they needed another housemother. So, needing a job and wishing to get out of Cookham, I found myself helping to look after forty boys and girls in the junior boarding house. This involved supervising breakfast, making the beds and, after the children went off to class, re-cleaning the already clean and tidy bedrooms.

I drew a picture of the Christ Child sitting on his mother's lap on a large sheet of paper for the Common Room wall. Nat Bowron, one of the teachers, thought it would make a nice Nativity scene but there wasn't room on the paper for the shepherds. So Mr Bowron kept adding

more sheets as the Nativity scene grew. After Christmas I was asked to change the shepherds into kings by drawing crowns on their heads. I had drawn a figure in the distance. 'What have you got there?' Mr Bowron asked. I wasn't sure. Legend has it there was a fourth king, who spent his life searching for the Christ Child.

Hairdressing Student at Langley College of Further Education, ballpoint pen on paper, 1977

Having left the Rudolf Steiner School, in 1977 I taught art to hairdressers at Langley College of Further Education in Slough. My class was not a very enthusiastic mix of young students. The idea was to help them understand colour, design and the construction of the head. One of them drew Botticelli's Venus riding on a cockleshell, which I remember as a nice naïve study.

The following year I enrolled on a course at Woodbrooke Quaker Study Centre in Birmingham. Here I struggled with projects on international affairs and peace studies.

I became a bit manic during my time at Woodbrooke, so in the holidays my doctor prescribed drugs to calm me down. I was on Valium for a while, to help with my depression. It was calming but on returning to Cookham the Valium and Thames Valley air only added to my depressed state – and strengthened my resolve to leave Cookham again for London. I had no idea where I wanted to live, but knew that it wasn't Hampstead. Friends suggested places to me but I decided I just had to get there and see for myself.

Children of geniuses tend to have a rather hard time of it. And then if the genius and spouse split up when the children are little, then life gets very difficult indeed for them, left to struggle with emotional insecurity and hardship. I'm thinking of my own experiences and those of my sister, Shirin. Her emotional hardship stemmed from the fact that she was separated from both her parents at the age of five.

Many of my life memories concern the lives of my parents, and dramatic events in mine and Shirin's. But I believe that Shirin and I are often considered just as a useful resource, being the offspring of a great artist.

Since childhood my family, my ideas and my experiences have made me feel unordinary. This is a great pity as it compounded my lack of confidence and zest for living. I have enjoyed some things tremendously and entered into them with a great wholeheartedness and enthusiasm, but inhibitions and an almost permanent sense of guilt, plus paralysing lack of self confidence and my habitual timidity and nervousness, have made it all rather sad, and often very difficult.

Whenever people come to me about D. or my family in general, they naturally are not aware that history repeats itself. They are focused on what my father thought and felt, and I do my best to be helpful. But anything about my family touches me so closely and disturbs my inner equilibrium and peace (which is hard won) so much, that I wish these people wouldn't come near me when they really want to hear my story! It isn't that I'm not content in my parents and family in general, but that I know deep things about various members of my family which probably no one else knows, and because it would be disloyal to say anything.

My parents were both idealists, but they were idealists in slightly different directions, which seems to have exasperated them. I think this may have caused a lot of the upset between them. They could not see the essence of what it was that was coming between them. I had to learn to be less idealistic, but it was hard – and still is.

I am not a well-established person, although my acquaintances and friends probably think that I am. I am not in the fortunate position of having a choice, of being able to decide which invitation to accept when they clash. I am always grateful for every invitation because I get so few, considering that I believe myself to be sociable and friendly, and that on the whole people seem to like me. If I were to arrive with a presentable man, things would be very different. I find it so tiring and demanding living on my own, an anxious experience as well as hurtful.

I never tell anybody that I was brought up by three different families, and that has no doubt had a lot to do with the deep inner confusions

Deep Unhappiness, watercolour on paper, 1970s

and bewilderment that I have experienced. As someone said recently, most of my life's energy has been directed towards unravelling it all, and suffering the feelings of disloyalty that go along with such things. In my youth I was also used as a very handy rubbish bin for various adults' personal problems. My parents don't come into this area of my life, because my father faced up to his wrongdoing (this sounds harsh but isn't meant to be); he tried to make amends and put things right. My mother was being treated pretty cruelly, from my point of view, by various members of the family who either didn't, couldn't or wouldn't understand what she was going through. It is only in the last year or so that I have fully realised that I do not have to take on the responsibility of other people's problems and that I have enough of my own without having to carry theirs also. But it has been a long, dreary haul carrying all these burdens. I felt that the doctors I saw while I was at Woodbrooke would not accept any of this, though I can't imagine why not. I would have been a less exhausted and weary person at Woodbrooke if they had been prepared to take me seriously and to look at what I was trying to say to them, particularly at a time when, like many others, I was nervously inarticulate.

I had to wait for Pellin, a therapy course, in 1985 to cotton on to many things without my having to point them out, or to have my own perceptions accepted. The great value of Pellin is that through them, you discover your strengths and are given the tools with which to work

on yourself. It makes sense. We forget, of course, that psychology is still very much in its infancy.

I think that maybe I feel guilty about expressing my feelings and my hurt. It's very selfish to express your feelings to anybody. I did not have parents to confide in when I was young. However, I do have my art. It is strange how unknowingly we express some of our deepest experiences in our drawings and paintings. I want acknowledgement for my life: I think this would make my present life a bit easier.

There have been so many disruptions in my life and such a lack of normality that it's difficult to know how to pick myself up and start again. Moving from Pond Street was a disruption. Leslie was a disruption. Moving to Cookham was a disruption; having a baby was normal, but even that didn't go smoothly. My life has been a struggle, a long journey. An Italian woman looking at a small drawing of mine said, 'She walked a long way. Her feet look tired and worn but the rest of her looks bright and hopeful.' I had drawn a woman looking like me in my late thirties or early forties. Her hair was not all grey. She wore a dress with a full skirt and a delicate pattern round the yoke. It glowed with golds and pinks. Her right hand was on her chest and her left hand out a little, as if leading the way.

I'm forever striving to be optimistic, but I find it very difficult to have faith and be optimistic. I'm afraid of being let down; it has happened so often.

I can only suppose that most people couldn't care less about natural beauty, about the trees and plants and the earth from which we all get our sustenance. People very often respond to beauty without even knowing that a lot of it is based on balance and proportions, particularly in architecture. And we all have a sense of physical balance in ourselves. Do we really want to devastate and destroy our civilisation? We can't afford to hate to that extent! How can we see to remove the mote from our brother's eyes when there is a plank of wood in our own? I'm quoting Jesus here, of course.

At the end of March 1979 I felt utterly exhausted. I listened to a great deal of music – Vivaldi, Purcell and Bach's Brandenburg Concertos – as I thought of my friends in Woodbrooke and missed them very much. John was due to come home from school at the beginning of April, so I struggled with various jobs and mustered as much energy and courage as I could to do some painting. I found that the urge to be creative made colossal demands on me, yet I needed to carry out my ideas and bring them to fruition.

In my exhaustion and isolation I turned to reading a little from a copy of *Quaker Faith and Practice*. I found the faith of the Quakers intensely impressive and moving, and felt mundane by comparison. I was particularly taken with the words of Pierre Cérérosole: I was interested but not surprised to discover that he had been a Quaker.

The fact is that I was – and am – a very strong woman but I did not realise it at the time. In my near despair I was always praying for strength and was frequently in tears in the latter 1960s and throughout the 1970s and early 1980s. I was profoundly depressed, and it was to be another sixteen years before I found true happiness.

Separation, oil on canvas, 1979–80

She is saying a sad goodbye to him. The blood on the ground is partly dry and partly wet.

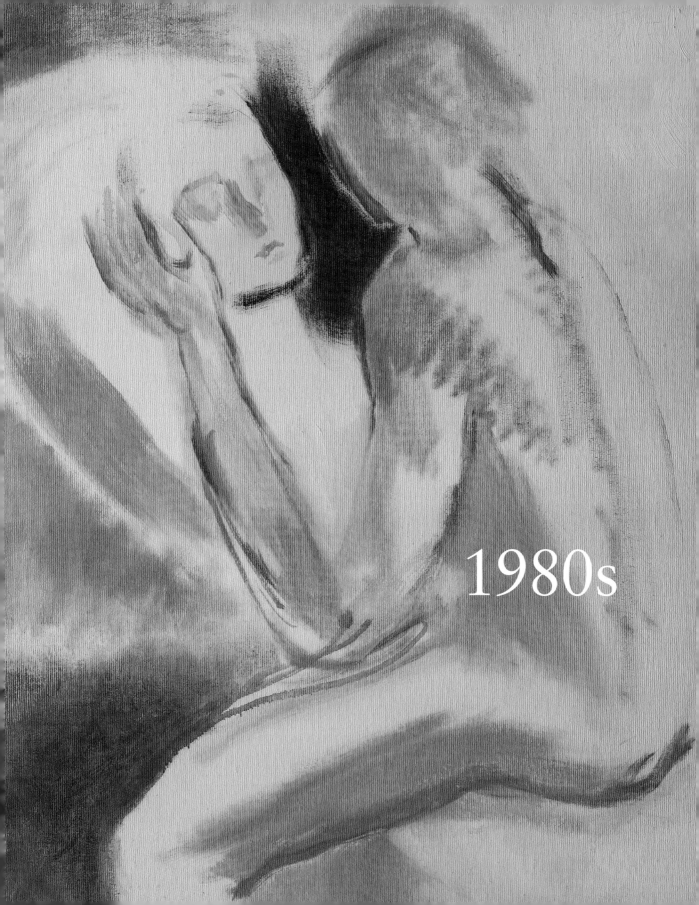

1980s

I N 1980 JOHN LEFT SCHOOL, began work and spent much of his time in the King's Arms. I felt even more isolated in Cookham:

There is no feeling in me as I write this, this is just a memory of a feeling. Could the dear Lord, I wonder, grant me the opportunity to love and be loved truly and deeply, so that I could experience joy instead of only sorrow? At present I am afraid of loving anyone except my own son. I would like to go out with a few nice men but keep them at arm's length. Deep down I want to be held close, by the right one. If only I could cry and cry and cry. I don't need to cry over John any more. God grant us peace. My son has always been my dearest love and closest to my heart. I am so grateful for him.

John is growing up and only needs me when he thinks he does, therefore I have to be flexible and bear his comings and goings with fortitude. He is the best thing that ever happened to me and yet I feel with deep regret that I have not been able to concentrate enough on him, because I have a desperate need for a man to be close to. I have loved my son with all my heart and done my best for him. I will always love him, he is a part me and he is such a fine person.

This evening I walked down the gravel path to Lindworth. I knew I was experiencing something special to me, which I had experienced when I was a tiny child of three. I saw the garden gate and the old cement wall. I remembered M. standing by the yew tree. There used to be chickens running loose among the laurel bushes. Even now I look at it through veiled eyes, half wanting to recall the full flavour and atmosphere and half afraid to, for fear of pain.

When I was eight I visited Cookham with M. We walked on Odney Common and came across a stag beetle in the grass. When John was three I took him to the same area. He was wearing his little brown coat and we sat down and looked at each other. I knew that for this short time we were safe and alone together, at peace in the open air in a sacred spot.

For me parts of Odney Common are sacred. The kissing gate leading from the churchyard down to the river is sacred. Was that the one my mother and I kissed through when I was little? Another sacred place was by the side of the old boathouse, where the cockatoo used to say 'good morning' as I went by …

Beyond Suffering, oil on canvas, 1989

I think he is trying to wake her up, or bring her back to life.

God creating Eve, oil on paper, 1980s

I have been feeling stronger but frustrated. Have sent off my provisional driving licence form and hope to renew lessons soon. Feel that in my present mood I could drive at 90 miles an hour! This is a dreadful admission, but I want to get away and spread my wings.

The problems that beset people who are not brought up in a loving home … I can look back on a bit of 'home' lasting for my first five years. I would not look back or even think about it were it not for the fact that I am still looking for 'home' – which is why I liked Woodbrooke so much. Also, everyone needs to feel part of a community.

At Fernlea, early 1980s

During the two weeks when I was involved in visits to Epsom around my aunt Gwen's death, I realised for the first time in thirty years that I am a 'whole' person, not in need of a man to supply the other half of me or the part that I think I am not. The only other time I felt this was when I got angry with my therapist and for a few days afterwards I felt free and liberated. Most of the time I feel slightly under a cloud and lacking in real respect. I seemed to have grasped hold of some other part of me I'm not familiar with. The inner part of me was secure. I didn't have to worry about it, so I was free to smell the blossom, feel the sunshine, chat with Doris and enjoy Mary Fox's pictures. But back at Fernlea I slide into the old syndrome and feel desperate and despairing and angry at God.

In August 1981 I spent time in north-west France, first staying with friends who were slowly renovating a house and then in a small hotel. The house was large, old and beautiful, but in a very sorry state of repair. There was no bathroom or loo and the windows had no glass to keep out flies and moths. I found the little birds that sometimes flew in rather lovely, as long as they could find their way out again. One evening a small bat came in while I was in the house on my own: charming though he was, I found his low, darting movements a bit unnerving.

The house needed a huge amount of work: clearing out grain and the odd sheep, pigeons (and their droppings), rat nests and cobwebs. New ceilings were being put in, walls plastered and floors repaired and electricity installed. The only running water was a cold tap over an old stone basin set into the wall. I got quite used to using the 'hole in the ground' public loo in the village and we all slept in tents in a field about ten minutes' walk from the village. One lovely sunny morning I decided to get up out of my little tent, get dressed and walk to the village. I arrived there at about 7 o'clock in the morning. No one was around apart from a grim-faced lady emptying her buckets and mopping her kitchen floor. I went and sat on a terrace with beautifully tended flowers and a lovely view of the hill across the valley. One or two people began to appear, and then Madame Olier, wife of the patriarch of the village and a really nice woman, offered me some coffee, which I accepted gratefully.

I spent much of my time painting and drawing: in two and a half weeks I managed to complete two small landscapes and a number of drawings. But I had to admit to myself that I found the work irksome: I knew that I had a talent, but that it was a great pity I found so little joy in it. I tried to analyse these feelings in a letter to a friend on 25 August:

> It's all rather a mystery … painting requires so much nervous energy; and I can't quite rise to the heights required, though the feeling is in me to do so. Sad to say, it would seem that … it all goes back to my Father, not because I'm trying to attain his heights, but because he preferred his painting to me.

Although very hot at first, the weather settled into pleasant summer heat, so it was good to be able to wear very few clothes, and walk about in flat sandals, scrambling up and down dusty pebble paths. Swimming nearly every day and coping with very mundane matters (the simple life

can be complicated), plus three children, two of whom were under five, certainly did body and soul a lot of good. By contrast with Cookham, where appearances were important, it was liberating in our isolated village to dress for our own comfort and pleasure.

At first the hillsides appeared to me rather dry and arid, but after a few days I realised how luscious the valley was by comparison and the beauty of the countryside really grew on me. The earth was a beautiful, deep red, even darker and more crimson than rich Devon soil. There were a lot of delicate and pretty trees, which looked to me like mountain ash, and when the wind blew their leaves became a silvery grey. There were many other trees in the woods nearby – chestnuts, walnut, oaks and figs – creating a wonderful variety of shapes and different greens. Apparently wild boar lived here, although I never saw one – but I did enjoy seeing hares and rabbits and beautiful butterflies, dragonflies and crickets. One evening we found a beautiful, large green grasshopper on the floor of the house. I also have a drawing in my sketchbook of three mummified rats which fell out of the wall when the old plaster was being removed.

Domestic animals were less in evidence: I saw no cattle or chickens, for instance, although no doubt there were chickens at the local farm. There were a lot of friendly stray dogs that spent their days lying on the village rubbish dump. Monsieur Olier had a lamb that followed him around, and one day I watched him cutting small branches from a tree to make a sheep fold.

Despite the warmth and kindness of the people I was with, I continued to feel cut off and isolated:

> I have no faith. I don't trust God. I've tried to many, many times, but it's no good. The Devil (if we believe in him) must have had me firmly in his grasp for most of my life. Not because I am all bad, for I know there's a great deal of good in me, but because I find life so tedious … I no longer know, what to hope for or live for. And 'life' is too insecure. I need a solid rock to be attached to. To be 'held' before I can be free!

Having left my friends' rural retreat I travelled via a number of small towns to Paris. I found the city somewhat overwhelming, but did manage to visit Eugène Delacroix's house before setting off on my journey home.

In November 1981 a group of John's friends were staying with us for the weekend at Fernlea:

> I could have done with a little company of my own age either last night or today. Most of the young people were charming and considerate; a few were a bit too casual. But no one behaved badly. But I envy them their naturalness, ease with each other. There were one or two shy boys and maybe girls, but I do envy them because I was exceedingly shy and nervous with boys when I was young. M. was a passionate, idealistic woman and I was full of feelings and her ideals and my own, but my amorous feelings were sublimated and repressed.

The state of art education in Britain in the early 1980s seemed to me to offer a great range of possibilities. The little I read and picked up from conversation or the occasional visit to a school had shown me that. But I believe that what matters is to be able to give children in one's own school variety: to help them find a sense of freedom one minute and a sense of limitation the next; to discipline them to draw carefully and accurately and then to allow them free expression with colour. Or to discover different ways of drawing, not using line at all perhaps, just shadow lines, as Steiner teachers do. Or to find a way of drawing from the inside of an object or animal towards the outside, instead of defining it from the outside with the continuing line. Some of the line drawings that children do, on the other hand, are very expressive and full of character.

I was never too sure how much I should train the children in my art class at Long Close School, where I'd been teaching since 1980, to try to paint accurate colour in a still life. Colour seems such a personal and emotional thing, one hesitates to correct them if their colour has its own quality and beauty. Why then do we strive for accuracy in drawing? I sometimes find it difficult teaching people to draw because I don't like to interfere with the expression of their way of drawing. Some can be quite wild in their method of drawing, and others very sensitive. I would not want to interfere with either of these qualities. But I would be failing them if I did not point out proportions to them, or an understanding of tonal values, or an understanding and means of drawing things seen near to you

and others seen further away; the intensity of shadows or their subtlety or a feeling for space in a drawing, or a sculpture, for that matter.

For a while I had to try to forget my ideas about reality in art, and see that paintings could express another, equally valid reality. The twelve- and thirteen-year-old boys in my class at Long Close School were focused on their common entrance exams and learning and remembering facts. They were easily distracted in class and not used to art lessons. But during the time that they did these paintings they were totally absorbed in their own discoveries and I felt that it gave them a sense of peace and that they were able to breathe freely.

An art teacher in primary or secondary education really has to be very versatile. A child who only does collage, or free expression, during an entire school career, can be missing out on developing an ability to understand the constitution of everything around us. A child cannot play a piece of music well and with expression without studying scales and arpeggios in order to gain command over fingers and hands and develop agility and flexibility. This also applies to children's artwork. And I do not think that children's art is produced solely to give us jaded adults pleasure, or so that parents can go around an exhibition saying 'How clever!' It is for the child himself to have an experience and to learn and discover things that are already in him.

One of the ideas I've seen painted and drawn in colleges of further education is not only drawing the objects in a still life but also drawing the spaces in between. This is an interesting and exciting exercise, but sometimes students' paintings are reduced to flat designs. This sounds like a criticism. It isn't really; the only criticism I have is that it would 'stretch the muscles' more if those students could also define the shape of the spaces, but paint through those spaces, really feel themselves into those spaces and what is beyond.

I think that a lot of artwork these days lacks depth or form. It may be described, but it is not always felt. It is a very difficult thing for some of us to express depth or form on a flat surface. It requires strength of feeling and imagination (my mother taught me this). Some people are put off by the art they see in Steiner schools, the work produced by the younger children up to the age of fourteen or so. They use pure colour on wet paper, they don't mix colours much at this stage, but blend them. This gives a very brilliant and buoyant feeling to the work. But it offends some people. I found it hard to take when I first came across it. But I have thought about

it and asked questions and learned something from it, both for myself and in general. What I find in this kind of work is a lifting of the spirit. If I am feeling low and dispirited, to look at these colours and paintings freshens me up and makes me feel more together, more harmonious.

Art is not for display. It should be a sincere form of communication. To quote from Kahil Gibran's *The Prophet*: 'no man can reveal to you aught but that which already lies half asleep in the dawning of your knowledge. And even as each one of you stands alone in God's knowledge, so must each one of you be alone in his knowledge of God and in his understanding of the earth.'

In January 1982 I looked out at the garden where a man was putting up a garden shed for me. I hoped it was all right – the planks of wood seemed very thin. As I watched him I began to look back on the past. I didn't want to forget it altogether, for that would be to wipe out the whole of my life. That day I wrote in my diary:

> ... of course if there have been a lot of bad experiences, then no one wants to know. This is sad because within the bad experiences have been good things, such as forbearance, endurance. An effort to understand. Trying to love and in fact loving despite the feelings of anger, almost hatred and despair. There have been moments of fun, but underlying most of these moments have been feelings of discomfort, and disease – dis-ease.
>
> I now feel more 'on top' and more accepted by society in general, although I fear there is usually some difficulty here. My feelings are my feelings and I acknowledge that this is not always society's fault. Just their lack. I also lack. We must be aware of this and then we can improve.

I continued to seek comfort in art and in prayer and contemplation, particularly through the Quakers. At times I discovered in art an inner peace that I struggled to find through organised religion, as I noted in my diary in March 1982:

I would have thought that to meditate or contemplate means to gradually become 'at one' with the object contemplated upon. How can you contemplate anything in a service like that, sincere though it was? Too much rushing around and activity, but no inner peace, leading to positive activity as a result of the inner peace. The Saints were often active people and many Quakers are also, and active with a positive intent towards society as a whole.

When I look at a masterpiece of religious art, I find that gradually the spiritual power and warmth of the painting takes over and I begin to meditate on it and begin to feel whole inside, because my ego-centred concerns are taken over by something that can heal and bring wholeness to me, admittedly only for a short period of time.

Today I saw the wonderful painting of Sarajevo by my Father. It is only little, in lovely beautiful soft greys, grey-pinks, dark grey-greens. It is so tender and charming. It carries right to the end of the room. You see the light shining on the minaret, and in the sky, shining softly, as you take your leave of the gallery with a last long lingering look…

This reminded me of an occasion when D. showed me a reproduction in one of his art books of Sassetta's painting *The Marriage of St Francis to Poverty*, where the three maidens, Poverty, Chastity and Obedience are rising up to heaven. D. pointed out Poverty looking back at St Francis over her shoulder: 'You see,' he said, 'she is married to him.'

I love Filippo Lippi's *Annunciation* at the National Gallery, with the little brown dove leaving the hand of God in the arched doorway between the two figures of the Virgin on the right and the angel on the left. It looks like a female blackbird, and seems to be twirling around, making ready to dart into the Virgin's tummy. The artist has made a little opening in the Virgins's dress, just below the tummy button, where the bird can dart in.

I remember seeing the Post-Impressionism exhibition at the Royal Academy with my friend Jo-Anne Fraser in the early 1980s, and was particularly taken with the work of Ensor. His early still life shone and vibrated in a way that I've never seen before – everything in it, including the ham, was translucent and transitory, yet it was *there*.

I am aware of my awful inability to communicate properly. I have never been able to let people know what I wanted or needed at the time when I needed it. Partly – but only partly – for that reason I was unsupported in Cookham for all those years. The pain of loneliness became so awful in the late 1970s and early 1980s that it became a physical pain as well as emotional. Physically, it was located inside the centre of my chest. I winced every time this part of me was touched. I was extremely vulnerable, and this vulnerability made me a target for other people's problems. If anyone had a problem for which they had not taken responsibility, they would 'attack' me: the scapegoat syndrome.

Starting when I was a child, I was given to understand I had to put up with 'everything'. Not because I was good or strong or worthy, but because I was 'bad' and 'undeserving' and a nuisance. Knowing that I was shameful, I learned to put up with these attacks, and with daily acts of aggression and minor cruelties. I was brought up to never complain about anything, and therefore to feel guilty if the pressure became so great that I did feel the need to complain. I have had plenty of valid reasons to complain over the years, particularly in my youth, when the seeds were sown for the years of suffering later on. The adults around me all seemed to assume that I had no reason to complain or to feel unhappy. I really had to learn to put a brave face on things.

Some depressives like myself have to learn how to ask for what we want (reasonably, of course), to accept fully what is offered or 'given' to us, otherwise our state remains the same. Depression really is one of the more cruel illnesses around. It is a terrible vicious circle; it does not bring you the comfort you need, it keeps people away from you, and some of them can be so unkind in their attitude towards you, even if they don't know that you suffer from this illness.

I realise too that I'm no weakling, and I could have tackled more constructive therapy earlier on if it had been available. So a lot of my time and energy has been wasted, not only through just being depressed for twenty years for many reasons but through some inadequate therapy. Those twenty years have taken their toll on me, and although I now take up my cross and my life and forge ahead, and although I now live in the present within reason, the past rears its ugly head from time to time (as it surely does with many people).

Getting immersed with work and forgetting myself is good up to a point, but it doesn't help me to protect myself.

For years it has been my opinion that everyone, even hardened criminals, needs someone to love. We are conscious of our need to love, and in this I include closeness as well as caring for and supporting another. For me, the ideal marriage symbolises closeness, intimacy, a relationship where the deepest feelings can be expressed.

I was very close to my father until that closeness was severed when I was three. I was very close to my mother until that relationship was severed when I was eight. I continued to care very deeply for her and was a support to her in my childlike way. After that there was no deep closeness with anyone until my son was born.

This does not mean that I did not care about my sister or my uncle or other friends or relatives. I loved my grandmother, for instance, and she was a difficult old thing. I loved our housekeeper, Miss Arnfield. For two years I was 'in love' with a youth, without him knowing it. He committed suicide at the age of seventeen. For three years I was 'in love' with a fellow student at the Slade, without him knowing it. He married and I had to endeavour to put any further thoughts of him out of my mind. I was 'in love' with a fellow teacher at my first teaching job. This, too, never got off the ground. So by the time I was twenty-seven I had experienced three major rebirths. People used to refer to this kind of love as 'calf love', but as Shirin said to me years ago, while they may say it in a derogatory tone of voice, for the person experiencing the feeling of being 'in love' (and this certainly goes for Shirin and me), it is a deep and sincere feeling. In my case this deep and sincere feeling was rejected. I was young, friendly, kind and attractive, so I was left feeling hurt and bewildered.

In between these three major 'loves' I had various boyfriends who took me out from time to time. I yearned for, but was really apprehensive of, any physical closeness with any of them. This feeling in me, plus my unstable state of mind, put them off me and they all married other women, thereby increasing my feeling of rejection by the opposite sex.

One evening after choir practice I went to retrieve my jacket from someone else's chair and saw a respectable-looking man, a father (even

more respectable), talking to another choir member while about to stack his chair, with my jacket dangling over his arm. There was something terribly familiar and poignant about this whole scene, the way he was looking after the jacket – or me – in the way husbands do sometimes. The vague way he looked at it touched my heart. I was family. I wish we could have gone home together the way husbands and wives do.

During a period of depression in July 1982 I recorded my sense of my own inadequacy at developing healthy relationships with other people. This led first to anger, and then to a crippling sense of grief:

> ... my greatest conscious anger is with myself, in that I have never been able to analyse what is going on between myself and another person at the time that it is going on. This is because my need to be liked is more important to me than the need to put the record straight at the time. I also fear being in the wrong. I can accept from a therapist where I am wrong but from no one else. So I have built up over a life time an accumulation of false records. This is where my depression lies. This is my anger which is the same thing. For the past four days I have been crying inwardly, even when holding a rational conversation; on my own the tears come to the surface. They are tears of grief but they are also tears of anger...

I also felt betrayed by my art: I was finding the business of drawing and painting a distressing experience, and was not getting a feeling of warmth and pleasure from it, as I had in the past. Nor was I finding any sensuous or aesthetic pleasure or sense of joy in achievement in it. I felt angry, bitter and in pain. The anger, in particular, rose like sap as I thought of the cruel irony that my father, and to a much greater extent and more innocently my mother, could have contributed to such a loss in me. I knew that I had talent, and a gift to be an artist and a mother. I had the potential to be a good, interesting, sometimes charming – but far from perfect – wife, but I found that men evaded me and art was so often a misery.

John told me that the thing that kept him going was that he knew I loved him (and we were together), even when he was a weekly boarder. My God, what a struggle it has all been. I don't think that even Shirin quite understands, even though she sees so deeply into things.

Kensington Carol Singers, watercolour on paper, late 1982

> *Oh little one sweet*
> *Oh little one mild.*

The man in green upper right represents down-and-outs.

The young are encouraged to be selfish in subtle ways. When they're bored they're given games to play, sport to improve themselves, their minds, but what does it achieve? Are all young people selfish? Have they no feelings for others? Do they not care how others live? A little heart and a little imagination could sort the matter out. We should not be so fearful for our young ones, that they will be taken advantage of. It does them no harm to experience feelings of vulnerability; indeed, it will help them recognise suffering in others. As it is, everything is tough and modern, clever gadgets, space age toys, no communication or sharing – it's my right! And yet people are kind sometimes.

Having been through the crisis of a further realisation of the build-up in our country towards nuclear war, by the beginning of 1984 I had become aware of the fear and anxiety of people in my area about this possibility. What now worried me deeply was the defeatist attitude they all seemed to have. I found it slightly reassuring to find that ordinary people were concerned, at the back of their minds, but this negativity was alarming and deeply disturbing. Why did we all believe the communist threat to be the only threat, when there were so many threats to society and to our way of life in general, not only in our part of the world but in other parts of the world too?

I believe in freedom, but it must be freedom with justice.

In 1984 I decided to leave Cookham and move back to London. The decision was not an easy one and was reached after a long period of careful thought.

> I know John needs this home, Fernlea, and that he is beginning to make friends in this area. No matter what he does or where he goes, I feel brokenhearted and angry because I know how much I love him. Almost too much. Dr Horsey said to me nine years ago, 'I know he is very precious to you, but…'
> What really angered me was John saying that it's too late for me to move back to London now. I seem to live with my 'if onlys'

and missed opportunities, my failure to strike when the iron is hot, to make the right move at the right time.

I feel angry towards my sister. I feel angry towards my son but my anger towards John has cut me to the quick. You can love someone deeply and still be angry with them. I said to a friend, 'Nobody knows what I have suffered.' She replied, 'And nobody will ever know.'

The youthful high spirits of my son are making me feel very old, and I'm jealous of his freedom, which I have given him, which was not given to me when I was young.

I am beginning to discover that I am an artist after all. I want to make a name for myself, to make my own mark, nothing to do with my father. I need time to paint, I need to teach and I need time to care for others. I need plenty of time to have fun. I need to be on warm, sandy beaches where I can go in and out of the water with pleasure. I need to run along the beach, as free as a bird.

I am torn in two. I don't know which way to go, Life is short, when will I find the way?

While Fernlea was on the market and I was trying to find a home in London, in an area that I could tolerate and also afford, I was permanently exhausted: I had no car and had a number of people coming to view the house in Cookham. I felt very much for John, who found the whole thing extremely upsetting and became very angry with me. The fact that I had had to draw on a great deal of courage and determination to carry out the move seemed to change me in his eyes: he said that I had become harder. I was hurt at the way he expressed his anger towards me: not being in contact with me and not visiting me for months on end, completely rejecting me. He no longer confided in me about things that worried him. Perhaps this was partly due to not being the same gender. I felt angry that I had had no family support for the whole of John's first twenty-one years, which meant that he also had no one to turn to: no uncle, no elder male cousin, no-one but me.

I was aware that John was driven by a desire to become a self-made businessman so that he could buy all the machines and gadgets he wanted to fill the house that he would eventually buy and in which he would presumably at some stage install his wife and children. But all this was good: it showed that he had a sense of responsibility about

himself and his future, and if he was successful he wouldn't be a burden on me or anyone else. What saddened me was that he hadn't given himself a chance to expand and was still very young and naïve. But the real reason for my depressed and angry feelings towards John was that I knew that he and I were separating, moving in different directions, and that I could no longer muster up the effort to appear enthusiastic about all his enthusiasm, especially since I had no one near to me with whom to share my own enthusiasm. He would get rather aggressive with me at times, so that I felt that I was the child being made to give an account of myself. But to give him his due, when I came to my senses and pointed out to him what was happening, he endeavoured to stop himself.

When we were planning a twenty-first birthday party for John, he cheekily threatened me with nearly a hundred of his friends. I got so alarmed that he whittled it down, so that with twelve 'adults' and relatives and about fifty of his friends it turned out to be a very happy party. I really didn't know how many would turn up, so catered for a limited number and it all went very well. John was amazed when relatives brought him presents or cheques, because he wasn't expecting it, and this was really lovely. A friend brought a cake in the shape of a key, which neither of us expected, and everyone sang 'Happy Birthday' so I felt that his coming-of-age had been truly celebrated and I was very happy for that. At least twenty of John's friends and two of mine stayed the night, and John and I were left with most of the cleaning up. The cleaning up soon became spring cleaning, because I felt so ashamed of the shabby appearance of parts of my house, especially when is was being inspected by house-hunters.

I was looking forward to leaving Cookham, and the knowledge that it was the right thing to do helped me with all the uncertainties and problems. I knew that it would be a tremendous relief when I finally found somewhere else to settle, where I could, I hoped, begin to live a happier and more constructive life than the one I had led in Cookham for so many years. Apart from being a mother to John and providing him with a home, I felt that I had wasted twenty years of my life. Trying to come to terms with this fact, and with many other pains and problems, was very hard – as it is for anyone who faces up to themselves in this kind of situation.

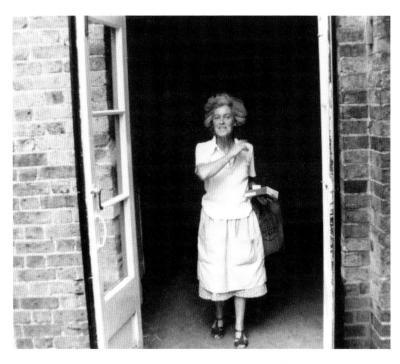

Happily leaving Fernlea for the last time,
1984

Before we left Cookham I made a note in my diary of a delightful
encounter with an old friend:

I have just bumped into my dear old friend Su outside the veg shop
across the road. It is so lovely to see her again. I hadn't seen her for
years and John and I used to wonder about her. John loved her when
he was a boy of 12, 13. She was a little puppy when I had her; she
was dumped on me by Bill [a friend who was a local chef] and I had
to look after her. She was a darling, but it was tiring, like looking
after a baby. She was a … greyhound type of dog. Beautiful, with
a lovely nature. Bill knocked some of the stuffing and vitality out
of her, he loved her, but he needed her as a scapegoat for his pent-
up feelings. He would not examine his feelings so Susie suffered.
When he left this area, he handed her over to a man and his family
living in the village but, strange to say, I never saw her again apart
from one brief meeting. I was delighted but she obviously didn't
recognise me and seemed rather subdued. But this summer she
seems more responsive, and as we looked at each other almost nose
to nose, and I stroked her head, I wondered if she could possibly
pick up some vague memory of me, perhaps from my tone of voice,
I don't know. It was lovely to meet her again. When you have cared
for a dog as a puppy you can never lose the feeling for it.

I don't like to be pinned down. Somehow the spirit leaves me when I am pinned down. Flashes of insight or thoughts and instructions from God come to me as I'm momentarily standing on the landing between one action and the next. This is partly due to all the hard work I put in to self-examination over two to three years as a result of my frequent attendance at the Pellin Centre in 1985, which was infinitely more efficient and helpful than some of the so-called therapy that I had in the past, where I was, like many others, merely a patient with a problem.

Curiously with the Pellin counsellors I have found a great similarity with the way Jesus comforted people in the New Testament. He had a directness and total lack of sentimentality, and above all an acceptance of people, which seems to me to be the key to any kind of change. He was so human, so ordinary and everyday, yet at the same time he was – is – Jesus Christ, the Son of God, who inspired Bach to write music that transcends this world.

Painting Marianne Helwig John's portrait, July 1989

Like my father, I tend to begin a portrait with the eyes; it seems a sensible way to go about it. I draw the face in paint, mixed with linseed oil and turpentine to get a pale outline and carefully build the colour and form as I observe them.

I look at the face, find something about it that interests me. If you don't find the face interesting, observe it carefully. I hope to capture something that enlivens a little spark inside me. I have to be truthful and honest about what is in front of me and express the feeling of the sitter, even if it is very quiet. I must always be aware of the sitter and her surroundings, relating the two as I go. Thus I have a two-way relationship with the sitter, who has to be alert to me just as I have to be alert to what I see in them.

Painting a portrait is like making breakfast. You have the bacon and eggs, and have to know when to add the tomato, while not overcooking the egg. How do I know when it's finished? There comes a point where adding something else will spoil it.

After the Service, oil on canvas, 1989

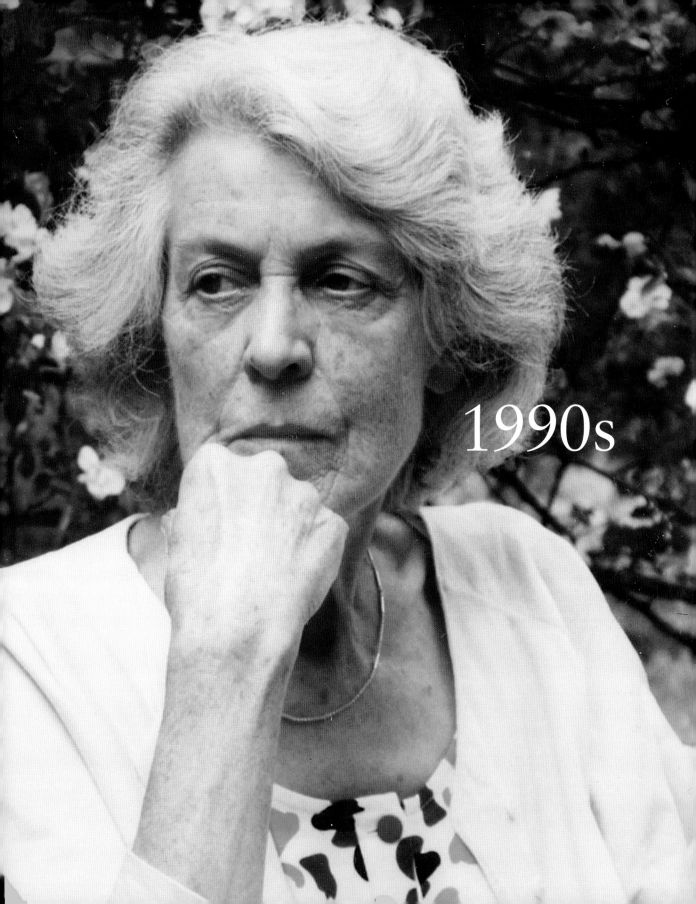

1990s

Oⁿ 24 MAY 1990 it was my sixtieth birthday. John was living in a small cottage in Cookham Dean, in the garden of a large house owned by the artist Ralph Thompson. I thought it would be a lovely setting to celebrate my birthday. I was worried, though, that we would not be ready in time due to John's lack of planning, as there was a lot to do. He was working on a BBC film at the time, but at the last minute he did get it together.

We laid rugs on the lawn outside the garden studio. Some friends contributed a variety of dishes for a picnic.

A few friends read poetry: Shirin recited 'Bards of Passion and of Mirth' by Keats; Margaret Pleming recited Hilaire Belloc's 'Matilda' and her brother, the actor Robert Russell, performed extracts from his one-man show on Charles Dickens. Margot Young (Shirin's great friend) sang 'My mother bids me bind my hair' by Haydn. A group of us danced a historical dance on the badminton lawn under the mulberry tree.

Cousin Peter, Gilbert Spencer's son, took his granddaughter, Abigail, 'on safari' through the orchard to look for Mr McGinty, the tortoise.

A few weeks before my birthday the Stanley Spencer Gallery in Cookham had had their spring exhibition opening. Carolyn Leder gave the welcoming speech, in which she said how nice it was to have Unity, Shirin, John and Peter (Coppock) Spencer present. John later said how happy he felt when he saw the joy in Peter's face – he seemed to swell with pride, filling every inch of his 5' 7" frame. This was the first time in Peter's life that he had been recognised in public as a Spencer.

Many years earlier, Uncle Gilbert and Auntie Ursula invited me to tea at the English Speaking Union. They also invited Peter Coppock. Gilbert didn't introduce Peter to me as my cousin, but when I got home I said to M., 'Peter Coppock looks just like Gilbert.' M. said, 'He must be your cousin.' I rushed out of the house, down Haverstock Hill to the flats where Peter and his wife, Dizzy, lived. When he opened the door I said 'Are you my cousin, Peter?' 'Yes!' he replied. I was thrilled to bits.

Dancing on the grass at Unity's sixtieth birthday party

Peter Coppock with Mr McGinty, the tortoise

Unity thinking and observing, 1998

Country Scene with Dangly Bits, etching, late 1990s

In 1991, depressed, I kept my diary as a way to help me examine and control my feelings…

I go to Quaker meeting on Sunday not because I am religious but because I need comfort. The thought of spending yet another Sunday on my own is unbearable.

My Father's exhibition in the Barbican has been a big, big disappointment for me. The Gulf War was terrible. Thank God for the ceasefire. And then all things in my own life which I really can't get together. To feel so uncertain about my talent is hard, an awful waste of time.

How do I get people to come to me? I am so bored and have been for 27 years. What is the point of a family that knows so little about its members?

But loneliness is a killer. It just kills you. It's a dreadful thing … There is no one to love and care for and no one to relax with and no one to reflect from or bounce back to and fro. There is no reflection

of yourself, so you don't know what you are. Living (I think) in a bad relationship is even worse because the self-destructive element is doubled, whereas on your own you only have yourself to blame.

I cannot keep up with everything all the time; it's like being on a treadmill. My life doesn't seem to be real or exist. My feelings are real and exist but my life is rather non-existent. So my feelings are all over the place, without anything to shore them up.

Life and love have passed me by. This is an awful and difficult admission, because I feel responsible for my life. At the same time, if I had a kinder and more supportive family – I'm not counting my parents in this, but my other relatives who considered themselves my guardians – and more supportive friends, I might not have fallen so deeply by their side. But I am a flawed person – there we are.

What I need is protection. This I have not had. Hence so much of my illness over the years. If a wound is left unprotected, how can it ever heal? Surgery or medicine is like the therapy. True sympathy is like the ointment that soothes and comforts. Now that I am so much better I can look back on matters of love, my sense of loss and neglect, and years of so many other deep, sad things. I can wrap these feelings up and tuck them away in a drawer, and unwrap them in a happy, positive way. But I also feel an awful bitterness. I no longer experience this as I did in my youth, but I'm left with a kind of emptiness, which I can't fill, because of a lack of continuity, a kind of missing link.

In the garden, 1990

This was the day after my sixtieth birthday party.

The idea of redemption means more to me than resurrection because I know that I will resurrect at sometime, if not fully at the end of this life, then at the end of some other life. But the idea of redemption is about being redeemed now. I can be lifted out of the scene now, if I am willing. I need to recognise that I am somehow acceptable, warts and all. As I learned, among many other things, in the Marlborough Day Hospital, I needed – as we all do – to learn to love myself, which means accepting myself. Accept myself first before I can be redeemed. Without acceptance of myself and how I am, or was, without feelings of forgiveness of myself and others, I cannot be fully redeemed. I love the sound of the word, it's so expressive of its meaning, the 'ee' sound

seems to rise up out of the mire. Forgiveness was difficult for me. I have always found it difficult to forgive, not realising that if I don't, quite apart from the damage I cause others, I'm damaging myself, by falling into the trap of being a victim in the situation.

If I can realise without pointing the finger or blaming others (and I have to be very careful here that I'm really not holding anything against them), then I free myself up, and I free them up. But this has taken years and years to realise fully and be able to take on board and act on. A waste maybe, but as they say, nothing is wasted, because all our experiences, especially the painful ones, if we can turn them around, only enrich our lives for ourselves and others and give us even more compassion and understanding. My anger and my subsequent depression were a lot to do with the way I felt about myself, because much of the time, most of the time, I really did think I was a bad person. My anger was on account of the injustice I felt around my perception of myself, my perception of how my remaining family seemed to view me, and my uncertainty about how others saw me. Often I had no anxiety on that score, but they only had to make a chance remark and a sharp knife would twist in my gut somewhere.

But redemption is a 'lifting up out of' and is for everyone with the willingness to be lifted up in this way, not from willpower but by relinquishing that part of the will that really needs to let go, from the heart. Somehow inside myself over a period of nearly forty years I have been endeavouring to redeem myself, with help from the MDH, therapists of various kinds, and so on. It might seem a strange occupation, some may think it self-indulgent, but there is nothing, absolutely nothing self-indulgent about really facing up to yourself. Sometimes it is literally a matter of life and death, or it is a matter of not just surviving, but actually learning how to live, and understanding what the word living actually means. How many of us really know, feel, realise, how to live in the present?

On 20 June 1992 I went to a service at Southwark Cathedral. I arrived late because I wanted to take my time and not rush. I said goodbye to John, who was having a well-deserved lie-in, and did not get to the cathedral until about 11.20am. I thought I had missed most of the service, but in fact it went on until 12.45, so it was over two hours long.

I was feeling depressed and tired but I sat quietly at the side with some others and inwardly prayed about my conflict. In fact, I sat and rested more than I stood.

At some stage two Indian children danced and this did the trick. Watching them finally broke the little chain that bound me and that I was trying to release. Watching dancing – real dancing – is always a joy, allowing me to go completely out of myself. But that is not exactly what happens, as I explained to a friend later, sitting on a low stone seat in the cathedral precinct. You can only pray to something you trust. You can only really deeply love someone whom you trust. So when people say 'do this or that, it will take you, or him or her, out of themselves', it isn't necessarily the case. I can't prescribe for you in a perfunctory fashion the thing that will take you out of yourself. In any case, what's so wrong with you yourself anyhow? I think you meet up with your true self in the thing that takes you out of yourself; that is your own particular joy. We find ourselves in things; we don't lose ourselves, but we find release from our nagging selves when we find the thing and work at the thing that truly matters, that has meaning for us.

Doing a son's laundry – and wearing his jumper and tracksuit – 1992

Maybe I inherited my love of scrubbing floors from my Father. I notice dirty floors and pavements/streets more than dust on ledges and surfaces. It isn't that I want to be constantly scrubbing floors. It's just that there is something about a clean tidy floor that makes me feel better. Everything else can be clean upwards from the floor. In some places or countries floors are sacred or semi-sacred. You take your shoes off to enter a room. In the Old Testament it says, 'Take off thy shoes from off thy feet, for the place whereon thou standest is holy ground.' That is a strong, powerful injunction.

God certainly does exist inside you. Goodness, the essence of all that is good in its broadest and deepest sense, its known and its unknown way and expression, the seed of all this and the possibility of realisation, are inside you – inside you, me, everyone. You see and recognise it everywhere, in small ways and larger ways. You see it in a friend quietly acknowledging and saying they are sorry they have hurt you, to Dietrich Bonhoeffer quietly and bravely walking to his death in a Nazi concentration camp.

The Pianist, etching, 1990s

It seems to have become increasingly difficult to define a work of art in the second half of the twentieth century, and presumably this is none too easy for art critics, dealers, tutors, lecturers, art historians and others. I have tried to keep an open mind in order to learn from people in the art world, and this approach has helped me respond to a greater variety of present-day art. At the same time, it is important not to lose sight of standards; yet standards are also difficult to define. You could ask where art and therapy begins, or where art and and cleverness begins.

Art and therapy can be closely intertwined, as they are in the paintings of Edvard Munch, or perhaps even Goya, where their psychological expressiveness are beneficial for both the artist and the viewer. Where I balk, or become lost, is where the artistry or craftsmanship seems to be almost totally sacrificed for the sake of self or self-expression. This is a tricky area to write about, but the apparent slackness that comes from the abandoning of craftsmanship – technique might be a better word – leads to all sorts of misunderstandings and problems among the general public, as well as among amateur artists who call themselves professionals. People feel misled, deceived, when they cannot understand or 'read' a picture, and if the importance and

value of a work of art is to humanise, uplift, stretch and delight us, what is the point if people simply turn away because they are mystified and feel foolish?

The British public still has great difficulty with modern art, often feeling inadequate, confronted or offended, and so dismiss it all. People can happily absorb the French Impressionists, whose art they have grown or matured into appreciating, even though in the nineteenth century the French Impressionists were scoffed and jeered at in their turn. By the same token, they can cope with and then enjoy representational art, because they can 'read' the subject of the painting fairly easily. But the trouble with true art (as also with music, literature, etc.) is that it requires some effort to be appreciated. Experiencing that work of art may be very enjoyable, and then all of a sudden it changes direction, which is a bit unnerving, and it is easy to 'switch off' at that point, for whatever reason. This is very obvious in the case of music; and with modern music it is even harder and more taxing to follow, so that one has to let go of past ideas and experiences in order to try to open up to something quite different. Change is often uncomfortable, so we resist it. It is the same with art.

Out for a Jolly Evening Together, etching, 1990s

The chap in the middle is nervously trying to entertain the others, who all look rather miserable.

In the past, the creation of art was governed by strict rules, as were music, literature and so on. The 'golden mean' became the basis for good composition. Colours were used symbolically, but at the time of the Renaissance were beginning to be used realistically as well, and usually harmoniously, although they could also be startlingly interesting. Good drawing was essential, and understanding of tone values and composition were also important. Realism was a sign of ability and good painting. There was also a need to be clear: in the case of medieval art it was often about teaching Christianity to ordinary people, while in the cave paintings at Lascaux and Altamira it may have been about defining the animal and how to catch it. The curious thing is that the creative spirit breathes out of these works without the medieval artists or cave dwellers being primarily concerned about producing a work of art. It might seem nowadays that the artist has become more arrogant and does not seem to care whether the public understands or whether he or she is clear enough.

Perhaps a good deal of present-day artwork cannot be that clear; sometimes the artist is prepared to explain the work as best he can and it is up to the public to try and understand. Some people have a deeper appreciation of art than they realise, so it may be up to the artist to question rather than instruct them. This exercise can often be very revealing and interesting.

The definition of art as opposed to craft seems to me to depend on whether it has an idea, a concept, and whether the idea is worth conveying in the first place. Gwen John's depiction of a wicker chair in the corner of her room (painted in 1907–9) seems to me to be as much about the tender colours and the striking, almost abstract shapes of the shadows, windows and ceiling as it is about such a humble object as a wicker chair – no doubt one she was fond of and sat in. Its emptiness is meaningful, as with Van Gogh's chair of 1888. John's is a very strong image beautifully and sensitively painted and a great work of art.

How does one define sensitivity? I suppose one can only sense it; so it is important that we do not desensitise children or each other and that we show compassion and understanding in our search for truth. Ultimately the scientist and the artist have an important matter in common, because at their best they are both seeking truth.

Another aspect of a true work of art is the spiritual intensity and passion with which it is carried out. These qualities are very evident in

the early Renaissance paintings, such as Fra Angelico's frescoes in San Marco, Florence, or Giotto's frescoes in the Arena Chapel, Padua – or, again, in the work of another, much later painter, Murillo. When I was young I tended to dismiss Murillo's art as sentimental, but had my eyes and heart opened when I saw the marvellous exhibition of his work at the Royal Academy of Arts in 1983. He succeeded in combining intense religious feeling with gentleness, while managing, by a narrow margin, to avoid sentimentality, thus giving us a true sense of love and compassion.

Sometimes, in the case of early mosaics and murals in churches, the spiritual intensity of the subject was such that it affected not only the composition but the design of the painting as well. There were certain religious rules that had to be observed, but the inspired artist could also bend the rules, or put his heart and soul into the way he defined such pivotal details as the head of Christ. In fact these murals or mosaics are often imbued with more than rules of religious faith. The marvellous animals in the cave paintings in France and Spain are so not only because of the accurate drawing of the animals, but because of the individual characterisation. The drawing of those animals is so authentic it takes one's breath away. You feel there is a close, instinctive knowledge of the animal depicted; they are wonderfully observed and drawn.

Clapham High Street, pencil on paper, early 1990s

Catharsis, etching from a 1997 sketch, 2005

I was angry with Fiona McCarthy for her article in the Guardian.

The difficulty with authorship of any creative work is that once standards of drawing, composition, etc. have been established, the final quality of the work of art depends on a feeling or sense of the rightness of the painting, maybe not on account of its beauty, but in its sense of integrity. In this way I can make sense of the contemporary land artist, Richard Long. When I saw him on film gouging out the earth with the heel of his boot in an arid landscape, doggedly moving in circles in and out, and the way he later quietly settled himself with some rocks in his rucksack, what he was doing and expressing began to have some meaning for me. And of course with photography around, it is possible for art to have a greater physical dimension.

Nowadays, since various rules have been put aside for the sake of psychology or the power of the emotions in a more overt sense, I sometimes find it more difficult to estimate quality in art. Sometimes the power of a piece is so strong that one cannot ignore it, so that despite possibly disliking the work itself, one has to take notice and learn. Even so, within an apparently chaotic picture, a harmony of composition can be discovered; what can appear to be rough drawing can have an energy and vitality important for conveying the idea or message.

Contemporary artists are constantly introducing new ideas and new concepts which at their best emerge from the tradition into which they were born; innovation here comes from a deep need to change direction and for self-expression. Traditionally the truest convictions have often impeded the production of saleable art, because art is about truth and you can only express truth from your inner experience, coupled with a study of what is true. This is a tricky one because many of us unwittingly deceive ourselves, which is probably why many of the great artists of the twentieth century are such a confrontation for us. These geniuses may also unwittingly sacrifice quite a lot of their personal lives in order to preserve their integrity in their quest for truth. They may thus convey important things to us which gradually we grow into over the decades of generations. What continues and lasts has true worth.

Of course, it is also difficult to define phoniness because we often view art subjectively. We have prejudices. But I think this comes back to whether a work has content, an idea or concept that warrants our consideration. The woman in black bra and underpants on all fours supporting a transparent tabletop looks 'gimmicky' at first, until you look into it more closely and see that it takes on meaning of various

kinds. It is no longer art in the old sense, because it is not totally created from start to finish by the artist, but it is art of a kind.

On 15 September 1997 Shirin and I were distressed to read a long article by Fiona MacCarthy in the *Guardian*, part of which said:

> … in 1973 the Spencer Papers were acquired by the Tate. Access to the archive has since been rigorously controlled by Stanley and Hilda's daughters. In practice, it has been limited to those who, in the estimation of the sisters, will stress Spencer's joyfulness and childlike love of life.
>
> Spencer's daughters, through their agent, also control the repro-duction of his paintings. One of the reasons why he is sometimes seen, so wrongly, as a quaint and bucolic Berkshire painter is their policy on the reproduction of the nudes, which show Spencer at his strongest. The nudes are the highlight of the US exhibition, but they cannot appear in the publicity material. You can gaze at Spencer's painting on the walls of the Tate, but you cannot buy a postcard of *The 'Leg of Mutton' Nude*.

We strongly refuted this suggestion in a letter to the *Guardian* published five days later.

A voyage around our father

ACCORDING to your article (Rude awakening, Weekend, November 15) Stanley Spencer's reputation as a serious artist has been, to an extent, jeopardised by us, his daughters. This is not true. His powers of concentration, empathy, wonder and fun have always endeared him to us, but have never prevented us thinking of him as adult. We realise he had faults, as we have, but he was essentially a good man.

That is why the paintings that contain sexual imagery are never obscene. The love-making is generous and no-one is dominant. The great nudes you mention should be seen in the context of his whole life work, whose main themes are resurrection and redemption. They have been included in shows of his work for about 20 years and we have never stopped them being reproduced in catalogues.

The double nude portrait, The Artist and his Second Wife (1937), known as The Leg of Mutton Nude, is a special case. It portrays a non-event. Nothing has happened. Our father looks distressed, bewildered and very vulnerable. We have a right to protect our father in this one instance in the small way available to us.

We are deeply upset at the misunderstandings expressed about our father, and would ask how your writer would feel if one of her nearest and dearest was portrayed in such a manner? We write this in the hope that relatives of artists in the future may not have to experience the discomfort and the pain that we have.
Shirin Spencer.
Unity Spencer.
c/o 25/26 Hampstead High Street,
London NW3 1QA.

Letter to the *Guardian*, 20 September 1997

Gainsborough's double portrait of his two little daughters (*The Painter's Daughters with a Cat* in the National Gallery), with their heads close to each other, is so strong and so sensitive that you feel the bone structure of their heads pressed together. He painted their expressions with such tenderness, such feeling and such beauty! There is a harmonious rhythm and flow to the composition, like a dance: an oval and an upright rhythm and also a great stillness that is full of energy. Poise contains energy. The

sisters' little bodies and their arms are equally expressive; and of course the drawing and form are perfection.

Carlo Crivelli's *Virgin and Child with Saints Francis and Sebastian*, also in the National Gallery, has a beautiful little detail beside the Virgin: a vase with a red rose and a white rose and a bud beginning to open. The roses have leaves, a few of which are dipping into the water. This is an exquisite painting, not just because of its incisive and accurate drawing but because of the strength and great sensitivity with which Crivelli expresses himself. His originality means that, however exalted the subject he is painting, there are always ordinary things going on that in a strange and everyday way belong to the theme.

I fear that Crivelli may have been quite a neurotic man, with some sadness and hurt in him that expresses itself in 'sly' expressions or occasional scenes of torment. In this painting, the elongated fingers of the Virgin and the very incisive lines have a certain painful expression. This is quite different from the work of Jan van Eyck, whose masterly drawings and paintings seem to express warmth and love and earthiness and spirituality all together. But Crivelli is also a genius and his compositions and wonderful perspective have a grandeur about them that rises above neurosis, and expands us and fills us with wonder.

I was saddened to read a review of the marvellous exhibition of the work of Frederic, Lord Leighton, at the Royal Academy of Arts in 1993 in which the critic dismissed Leighton's work as sentimental. There was one painting, among many beautiful ones (why are people embarrassed by beauty?), of a young dark-haired youth with flowing locks and dark, downcast eyes. He's gazing into the eyes of a beautiful blonde mermaid, who is ardently pressed close to the length of his olive-skinned body, her arms encircling his neck. His position, with arms resting on rocks on either side, is slightly reminiscent of the crucified Christ; she could be Mary Magdalene. The waves swirl around them. It is utterly beautiful, with a glorious mixture of loving innocence and an erotic undercurrent. I think it is ravishing – which it actually is, as they are in a sense ravished by each other.

It was suggested that there should be an exhibition of my work at Lauderdale House, Highgate, in March 1993. John helped me hang the

Unity hanging pictures for her solo exhibition at Lauderdale House, Highgate, March 1993

show. At first we didn't think there would be enough space for all the paintings, but after trying various combinations the pictures seemed to find their own places on the wall.

I sat in during the week, watching visitors to the show. One day a woman came in, looked around and made a rude remark about the work looking like Stanley Spencer's. I said nothing.

Adrian Glew of the Tate Archive wrote a piece about my work for the show:

A feeling of tension and a sense of detachment permeates many of Unity's works, and yet there is always a metaphorical outstretched hand urging the onlooker to enter the inner realm. Gradually, the viewer becomes participant – an active witness to the drama unfolding – an extension of the picture plane. Are we part of the queue waiting at the bus stop? Are we the invalid on the bed whose feet are the only physical sign? One cannot help but become immersed and, like a detective, search for clues to make sense of this other world. So, although there is often a denial of physical intimacy, there is, conversely, a strong desire for closeness and understanding. Contradictions abound. For many artists these would be sublimated and anaesthetised to create a more acceptable and readable image; but at what cost? Unity is not afraid to depict dichotomies she and many people feel in their daily lives. Thus, far from being ephemeral, Unity's paintings attain a timeless, universal quality. Tenderness, warmth and compassion are the ultimate victors.

Unity and Shirin with Stanley's cut-out figures, October 1998

Unity and John on the opening night of *Stanley Spencer: An English Vision* at the Centro Cultural-Arte Contemporaneo, Mexico City, February 1997

In January 1999 a retrospective exhibition of my mother's work opened at the Usher Gallery, Lincoln, and subsequently travelled to Exeter, Kenwood House (London), York and Swansea, before closing in November. I was dismayed to find that so many reviewers of the exhibition concentrated on trying to blame my father for things he did not do. So many people think that they must find somebody to 'blame' for everything. Perhaps it makes them feel more 'comfortable' if they can blame someone else; it tidies things up and appears to absolve us from all responsibility. The reviewers found a superficial reason why M. didn't paint much, but I believe they got it wrong. M. didn't do

any housework because both my parents employed maids to do the housework, the shopping and the cooking; M. looked after Shirin and, four years later, me. She may have done some household things, but she didn't have to because Elsie, our maid, was so competent.

In fact, none of the newspaper articles mentioned my father's admiration for my mother's work nor do they say that when he first knew her, he actually bought one of her paintings – and he wasn't well off. Nor did they say that when my mother was in New End Hospital, Hampstead, in 1950 with her final illness (cancer), on one of his many visits to her all the way from Cookham he brought with him two beautiful drawings to show her that he had bought at an exhibition and thought they were very good. On looking at the drawings, M. said, 'Oh Stan! They're mine!' D. was surprised and very pleased but I sometimes wonder whether he actually knew they were by M. all along but didn't let on, in order to please her even more. Either way, he would not have bought them unless he had genuinely admired them.

There are other important factors in all this. D., of course, was a genius and had enormous vitality and energy. M., on the other hand, even before she ever knew D., was inclined towards lethargy and mild depression from time to time. My grandmother, Annie Carline, was quite a dominant woman, very lovable, and an interesting character, but without any formal education: when she met my grandfather she was a lady's maid in Oxford. I don't think she ever really understood my mother, who was highly intelligent and gifted. Also, M. was the only girl in a family of five children so Granny expected her to do the kind of chores and jobs for the household that daughters were expected to do (although they also had a housekeeper and a maid came a few days each week). M. did her duty whenever required, but no doubt found it irksome at times.

Certainly life wasn't always easy for M., but not for the reasons the papers tried to make out, which were a mixture of exaggerations, mistakes and untruths. I felt particularly irritated with the feminist lobby, whose members have an axe to grind and a hidden agenda. These people were all sweetness and smiles, taking up time and energy over a period of several years, supposedly in the cause of putting on our mother's exhibition, and then what happens? Hardly any really informed comments about M.'s work but they try to make out that she was a victim.

I find some of these feminists rather dangerous, and I feel let down by one woman in particular, who has taken up most of my time. Before

the exhibition over a period of two years at least, she was often on the phone to me and wrote many letters, some very helpful. But after the opening of the exhibition at the Usher Gallery in Lincoln, and following the publication of the newspaper articles, I didn't hear another peep from her, not even to ask how I felt about the articles, or to express any concerns that I (or Shirin) might be hurt by them.

Most people probably have a stereotypical view of what they imagine a genius is like. They forget, or are unable to grasp, that all the geniuses of this world are individual people, unique in exactly the same way that you and I are unique. But then again they stereotype them: artists are all like that, scientists are all like this, inventors are all like that, composers and architects are all like that, and so on.

At a concert at a friend's house in Wandsworth, in February 1999 I began to draw the musicians on my programme. During the interval my friend David was interested and got me some paper to draw on. I got really involved; it was so exciting drawing these young musicians. As a student at the Slade I went to the Royal College of Music once or twice to draw the orchestra and musicians there; how it moves me to see them (combined with their music)! During the second half, which was Dvorak, I got deeply immersed in drawing the young and sturdy woman pianist, who was wearing a plum-coloured velvet dress; she had ruddy cheeks and a strong face and vigorous movements. Behind her, turning the pages, sat a fair-haired young man in dark dinner jacket, looking slim, elegant and purposeful. When the concert was over a white-haired man (an actor) came over and sat by me to talk about the music: 'I see you were making notes,' he said. 'I was drawing,' I replied, and then said that the best performers are those whose egos are moved to one side. I remembered Keats's words about ego, 'negative capability', how when you create something you 'become' what you create. John Keats did that constantly.

Looking back on my life, I decided to make a list of all the positive things:

1. My courage when teased or bullied at boarding school. I was subdued but I put up with it. On one occasion, when I felt it was the right thing to do, I confessed a small misdemeanour to the headmistress, who made light of it by saying I took things too seriously.
2. I stood up for one young girl against another very difficult girl.
3. Dancing very well as an understudy, to the amazement of the girls who watched the dress rehearsal.
4. Being appreciative (aided by my mother's attitude and pleasure) when my headmistress told my mother that I appeared broadminded.
5. My constant endeavours to be a better person.
6. Not wanting to 'join the crowd' when teasing some other unfortunate girl (although joining in nonetheless, in a half-hearted way).
7. Feeling from our headmistress's approach to us and our education that the world was our oyster. I felt it was mine. I had the ability to recognise this about her, though many others experienced her in quite a different way.
8. Always putting up with pain and discomfort without complaining. As a younger child I complained a bit more.
9. As a teenager I had great appreciation for beauty, culture and people, and entered into the spirit of all the things we did – carol singing, school plays, dancing – with enthusiasm.
10. As a young child when living with Mrs Harter in Epsom I tried to stick up for myself, despite being repeatedly crushed and frightened by her.
11. The virtue of Hope has always been with me even through the very worst times of my life. Although frequently submerged, it is always there: despite feelings of despair, I know that I must not give in to negative feelings.
12. My support for others: the local mother who had been battered by her husband, who stayed with us with her two small children to have some peace and respite; Angie, who stayed with me for nine months with her little baby. Taking Diana, who was disabled, to a camp by the sea for a week. Steering Bill Smith home in his car when he was drunk: Phyllis, on my left, was very nervous; my presence of mind was excellent.

13. I have attempted to keep my integrity throughout my life.

14. I have always acknowledged God's help in this endeavour.

15. I have tried to act on the therapeutic skills offered to me over the years by counsellors and psychotherapists.

16. My endeavours over the years to become more aware.

17. The words of my friend Mary McColm, who said to me, 'Vengeance is mine sayeth the Lord.' This pulled me up sharp. I was grateful to her as she reminded me that I must not seek revenge, which at a subconscious level I had been doing, and I realised how truly terrible revenge is.

18. I have a great sense of humour and find unobvious things in human and natural life very funny and comical. John can make me laugh quite spontaneously, with his individual sense of humour.

19. Love of beauty.

I knew that deep inside me I had all the knowledge I needed to help me, I was gentle with myself and was asserting myself more. I wished to feel settled and find my 'home'. Then I could begin the creative aspect of my life without feeling nervous and anxious. I wanted my friends to understand that if I feel isolated and alone I cannot properly function: I could no longer expect my family, what's left of it, to understand my needs or feelings. In order to leave my doors open, I need protection.

John and Unity at Cookham Dean, 1992

2000s

Iʜ 2001 I ᴊᴏɪɴᴇᴅ ᴀ ʟᴀɴᴅᴍᴀʀᴋ ꜰᴏʀᴜᴍ ᴡᴇᴇᴋᴇɴᴅ. We all had to get up on the platform and say who we were and what we were giving up. I introduced myself as the possibility of daring, joy and love and that I was giving up being the victim. As I said those words, the depression that had dogged me for most of my adult life left me in a flash and I never suffered it again.

I'm not sure why people buy my paintings. What do they see in them? I was discussing this with Adrian Glew in 2004. He said that the reason he liked my painting of the marketplace in Yugoslavia (near Mosta, I think) was because of the 'feeling' in it: how the people in the picture express their feelings. We discussed the 'painting scenery' picture, the party one with the reds and greens in it, the Madonna and Child on a chilly landscape and strange bed head and beside the bed, which, though uncomfortable, Adrian said reminded him in a way of *The Angelus* by J.F. Millet. I was so touched when he said that; that is high praise indeed. I adore Millet. He also said of Paula Rego (because I mentioned that I could never be in her category) that her work is more 'up front' whereas mine is more 'inward', which takes courage. I appreciated this very much and said that I painted the pictures more as a necessary expression of feeling rather than from bravery. My braveness has to do with survival and getting through

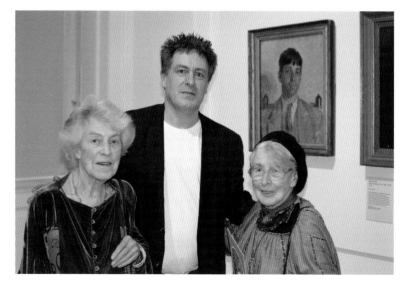

Unity, John and Shirin at the opening of *Stanley Spencer: Heaven in a Hell of War*, Somerset House, November 2013

Unity with Jon Snow, Sandham Memorial Chapel, Burghclere, July 2014

– and having the courage to work at it. So this is why most people say very little about my paintings other than the ones that mean something to them, which makes sense. I suppose that people do find my work a bit confronting. Not all of it. Just some of it. But they don't say so to me.

Shadows are the hardest thing to paint. Around me are many charming pictures but the long-term values can spoil a potentially good painting. The simplest advice I would give is to avoid using black at all costs. Black only deadens a colour and shadows are full of life, although a very subtle form of life indeed. It has been said that familiarity breeds contempt but in the case of painting it is often the most familiar subjects that prove the most meaningful: this does not mean repetition, because that is boring, it is about the things we love.

'It must be wonderful being able to paint,' people have said. I know that it is meant as a compliment, but underneath you wonder if they realise the amount of hard work, application and sacrifice that goes into a painting. 'I have no gifts at all,' they say. This is nonsense: they were given many gifts but because they are not visible they think they don't

À la recherche du temps perdu (Marcel Proust), etching, 2014

Kiwi, lithograph, 2001

A shoe polish poster on a wall of the London Underground.

exist. One gift in particular comes to mind: the person who is a good listener and who is prepared to stand on the street corner listening to what someone else needs to say, even if they are in a hurry.

People say to me, 'Oh Unity, it must be so relaxing to be an artist'. Absolute rubbish. Art is hard work. I am lucky to be an artist.

Unity working in the lithography studio at Putney School of Art and Design: inking the stone, lifting the print from the stone and checking the print

Esau asking Isaac for his Birthright, lithograph, November 2014

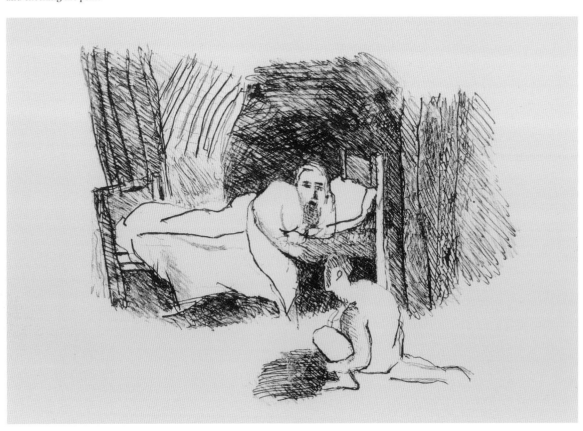

On 31 March 2009 I wrote a long letter to my father:

Dear Daddy,

I'm writing to give you some idea of the things that have happened in my life, as well as the various interests that have developed during this period. I remember you were always interested in my thoughts and were very perceptive about me. I remember you looking at my writings in the 1950s which I called reflections. You said 'You see, you didn't reflect.' Well, I have done a lot of reflecting since.

You will remember my singing the duet in 'Dido and Aeneas' and dancing in 'The Merry Wives of Windsor'. During the '70s and '80s in Cookham it was difficult to find somewhere to dance and sing. Back in London in 1985 I joined a choir; I learned Polish dancing and then historical dancing, which I loved.

An important event in my life was the birth of my son, yours and Mummy's grandson. I remember when he was tiny and lying on his tummy on a rug, how I longed for you both to see him and be with me at that time. There was a lovely nursery school and then he attended Holy Trinity School in School Lane, where he was happy.

The circumstances of my life were such that I had to leave Cookham, with John in one hand and a suitcase in the other. I was fortunate in finding a Rudolph Steiner school for John, with a different and interesting approach to teaching. I first attended the Quaker meeting when John was two. I believe you attended one in Belfast with one of your nieces. Through Rudolph Steiner thought and Quaker belief it came to me that philosophy is an interesting subject, not that either of the above are actually philosophies; perhaps they are so on a spiritual level.

In 1960 I joined the IVS, International Voluntary Service, and off I went to Germany, to Bonn, where we dug trenches with pickaxes and spades and built houses for refugees from Hungary. It was hard work: for light relief I turned to filling the cement mixer.

My IVS experiences opened up a new world for me, away from beloved Hampstead, which at this time I was having mixed feelings about. I needed to find out what the world was about. Also around

Stroking her Shin, etching, 2007

A Peculiar Romantic Situation, etching, drawn about 1954, printed 2007

Strap-hanging on the Bus, coloured etching, 2005

Wimbledon Art Students listening to Music, etching, drawn 1949, printed 2013

this time, having had therapy myself, I was offered the voluntary job at Hampstead General Hospital of helping psychiatric patients express themselves through painting.

I went on the second Aldermaston March and various protests and demos against the Atomic Bomb.

I tried to keep up with my art, but with my attention very much on bringing up my son I found it hard. I did do a few portrait commissions, of which I was proud, and gave lessons at various different places. My last teaching job was at a boys' prep school in Slough for eight years until 1990.

Your exhibition at Tate Britain in 2001 was a great success, and when the exhibition went to Belfast I was asked to open it. I was able to point out your wonderful small painting of the

Crucifixion which you had set in three ravines in the Macedonian hills. It is such a gem of painting. At your 2001 exhibition I felt for your vulnerability and wondered what you would have thought of it, perhaps surprise and relief, because times have moved on and people appreciate and value your work in different ways now.

After you died, dear Daddy … I became somewhat inundated with visits by people writing books and articles about you, or letters from pupils doing A-level art, students writing theses about your work and so on. To begin with I was happy to help – it felt as though I was helping you – but after a while it became a pressure. We now have some of the burden taken away from our shoulders by a professional body.

I am grateful that we have a few good people who we can refer to to help us, and I am also grateful that so many people are genuinely interested in your work and love it, and that so many people who knew you and loved you still do. We all enjoyed your sense of humour, which never gets into the books or films … The TV films about you and Mummy were carried out by people with a genuine interest in you and your work and came across well. Even so, it was strange to see you and your life interpreted by others.

There have been some frightening and deeply distressing experiences in my life, which have required a lot of working on with the help of psychotherapy, a good solicitor and courage to get through it all. However awful they may be, these experiences add richness to one's life. I returned to London in the mid '80s. John, who is now grown up, preferred to remain in the country.

Eugene Onegin (Pushkin), etching, drawn 1958, printed 2014

Tatyana is on the bed, confiding in her nanny, Filippyevna. I don't know why I have given the nanny three heads and three arms...

Floating Nude, etching, 2014

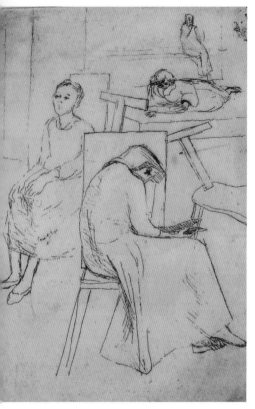

Slade Students, etching, drawn 1952, printed 2008

House with a Large Tree, etching, drawn 1997, printed 2005

I added the figures after the drawing was finished.

Self Portrait sitting on a Wall in Hampstead, etching, drawn 1955, printed 2000

In London there was more choice and variety of things to enjoy and take part in, and, having never managed to pass my driving test, it is easier to get about in London. Being a friend of Keats House has been a joy, his house being just down the road from the house in Downshire Hill where I was born, which I always felt was my real home. To comfort you I would say some of my earliest memories are of Cookham and the garden at Lindworth.

During the past 16 years I have had three solo shows of my work. It was a bit nerve-racking putting on the shows as I had to do most of it myself. I am pleased that I sold most of the work. In more recent years I've travelled quite widely, including three visits to Russia, which would have interested you. John and I went to New York in 1979 to visit Lisl Malkin, who remembers you vividly. In 1998 John and I, courtesy of the British Council, went to Mexico City for the opening of your exhibition there. I was asked to show the Ambassador around but as he had nothing to say on looking at your late Crucifixion painting I turned to your amazing painting of gypsophila, where every tiny flower is carefully related to every other tiny flower, creating a true design. I thought this might be easier for him and more appealing. He looked at the painting for a moment or two and then, turning to me, said, 'Do you know, I could never get it to grow in my garden!'

Whatever the ups and downs of my own art, I'm absolutely devoted to the cause of true art. On occasion I take small groups of people around the National Gallery and once I gave a talk at Leeds City Art Gallery, which owns your painting 'Hilda, Unity and Dolls'. It is strange that I don't actually remember you painting it. After my talk the Friends of the Gallery thought that Sonia Rose, the doll (which I still have), should be given the freedom of the city. Her full name is Golden Slumbers Sonia Rose.

In 2004 I went, almost on a whim, to New Zealand. It was at the time of a lovely exhibition of your work. It was a great experience to see your paintings and drawings in the Dunedin Art Gallery.

Since about 1997 I have been going to etching and lithography classes at Putney Art School, where I can carry out my own work away from home in an energising environment. I have been attending Westminster Quaker meeting. I am very fond of this meeting and feel supported by it, and I hope I give support too.

Writing this letter has been strange. I feel as though I am writing to people in general rather than to you specifically. At the same time, the thought of writing a personal letter to you feels almost impossible, perhaps because I felt so much grief when you died. This lasted a long time in various ways. I'm so glad that's far in the past, and maybe getting too close would feel unwise. But my love for you, Daddy, is deep and enduring for always, as is my love for Mummy. If someone told me you were both at the bottom of my road now, I would run like the wind to you both and envelop you in my arms and hug you and kiss you. All I can do now is say goodbye, God be with you, and to give lots and lots of love to Mummy and to you … and to send you your grandson's love (even though he does not know I'm sending it to you). This is getting like the ending of some of Beethoven's works, where he can't decide how and when to end a piece of music.

Letter to Stanley, 31 March 2009

Unity and Shirin at the opening of
Stanley Spencer: Heaven in a Hell of War,
Somerset House, November 2013

Index

All works are by Unity Spencer unless otherwise stated.

Numbers in *italics* refer to illustrations.

Acknowledgements

I thank Jon Snow and David Inshaw for their kind words; Jo-Anne Fraser for her careful, close reading and transcription of my many diaries, letters and random writings; Chris Roantree, Jenny Leach (etching) and Simon Burder (lithography) of Putney School of Art and Design; Anne Matthews, Christine Green and Jane MacGuinness for their sage advice; Chawan Karim for transcribing my writings; Joanne Trinder for listening; Rymans, Clapham and Waterstones, Clapham for putting up with John.

Thank you Harriet Bridgeman and Simon Erland for initiating this project; Johanna Stephenson and Andrew Esson for making this a painless journey; Ian Strathcarron and Lucy Duckworth at Unicorn Press for believing in John and me and producing this book; Alan Cowie of Robert Holden Ltd for his generous support and advice; Adrian Glew of Tate Archive, Carolyn Leder and all at The Stanley Spencer Gallery, Cookham, for looking after Stanley's legacy; Robert Upstone and The Fine Art Society, London.

And thank you to my sister, Shirin, and my son, John.

Picture Credits